SARASOTA

SARASOTA
A History

*For Wonderful "New"
Sarasota residents
Merry Christmas
Barbara and Jim*

JEFF LAHURD

Charleston · London

History
PRESS

Published by The History Press
Charleston, SC 29403
www.historypress.net

Cover image: U-Pick, Midway Groves, 1952. "Luggage? What luggage?" *Courtesy Sarasota County History Center.*

First published 2006

Manufactured in the United Kingdom

ISBN-10 1.59629.119.2
ISBN-13 978.1.59629.119.5

Library of Congress Cataloging-in-Publication Data

LaHurd, Jeff.
 Sarasota : a history / Jeff LaHurd.
 p. cm.
 ISBN-13: 978-1-59629-119-5 (alk. paper)
 ISBN-10: 1-59629-119-2 (alk. paper)
 1. Sarasota (Fla.)--History. 2. Sarasota County (Fla.)--History. I.
Title.
 F319.S35L338 2006
 975.9'61--dc22
 2006022130

To my parents, Fred and Mary Ellen LaHurd,
who gave my sisters, my brother and me the greatest gift of all:
the foundation upon which to build a happy life.

CONTENTS

ACKNOWLEDGEMENTS

This book was made possible by a grant from Pete and Diane Esthus.
The author would also like to recognize the contributions and assistance of:
The Sarasota Alliance for Historic Preservation
The Historical Society of Sarasota County
The Friends of the Sarasota County History Center
Joyce Waterbury, Deborah Walk, Kathy Ziarno, Patty Edwards, Jo Ann Mixon
The staff of the Sarasota County History Center: Dave Baber, Ann Shank, Lorrie Muldowney,
Dan Hughes and Mark Smith
And thanks to Ed Lederman for taking the time to photograph some of today's Sarasota
landmarks for this book.

INTRODUCTION

S ARASOTA—A LYRICAL NAME FOR a lovely and lively area always moving forward. While many longtime residents regret the loss of a less hurried, casual and intrinsically beautiful county, newcomers arriving in ever increasing numbers fall in love with the many amenities they find here today.

Perhaps a full-page advertisement taken out in the *Sarasota Herald* by the local Chamber of Commerce at the peak of the 1920s Florida land boom said it best: "Sarasota's Growth Cannot Be Stopped," it boldly and proudly proclaimed.[1]

Like the stock market with its history of peaks and valleys, Sarasota's growth (which, for many, equates with its success and for others its doom) bears out the chamber's proud assertion. A simple graph would show that Sarasota County has grown steadily and sometimes, as today, dramatically throughout its relatively brief history. There are some downward spikes to be sure, but the graph line rises steeply, ever upward.

Sarasota's most defining commodity, the thread that runs throughout its entire history, is real estate—the selling, buying and developing of property in one of the most beckoning areas on the Gulf Coast of Florida. It began with the Homestead Act of 1862, which allowed settlers 160 acres of free land if they came and settled in "America's last frontier" for five years; continued with the Scots' colony, who were falsely promised an awaiting community where they could be gentlemen farmers; to Bertha Palmer's large purchases in the 1910s; to the speculation fever of the Roaring '20s; to post–World War II resurgence; and on to today's phenomenal, county-wide growth.

Over the years of her existence, Sarasota County, which counts among its natural assets the Gulf of Mexico, numerous bays, the white sand beaches and lakes, creeks, rivers and state parks, has been discovered, left temporarily alone, only to be rediscovered again and again and again.

Yesteryear's builders, developers and even fast-talking real estate agents of the Jazz Age would have to marvel in wide-eyed disbelief at the goings-on of the last few years, which pale every previous yardstick of measuring growth.

All of Sarasota is conspicuous with construction cranes raising ritzy condominiums. What had been pasturelands and citrus groves not too many years ago are now filled with homes, condominiums, golf courses and clubhouses. The massive pre-planned, self-contained community Lakewood Ranch in east Sarasota has every imaginable amenity and plans to incorporate into its own municipality. There are no more "outskirts" of Sarasota. North, south, east and west, we have become one continuum. The two-lane roads of yesteryear—Fruitville Road, Beneva Road, Bee Ridge Road, Clark Road—are now six- and seven-lane highways filled, sometimes bumper-to-bumper, with fast-moving cars.

Growth, too, has taken hold in Venice, Englewood, Osprey, Longboat Key and North Port, all previously sleepy communities now caught up in the whirlwind of development.

Karl H. Grismer wrote the definitive Sarasota County history, which was published in 1946 by the M.E. Russell Company. His homey tome, *The Story of Sarasota: The History of the City and County of Sarasota, Florida*, is a must-read for anyone interested in an overview of this county from "the days of long ago," as he put it, up to its publication year.

Grismer had been a member of the Associated Press during World War I and later wrote for the *Akron Beacon Journal*, the *Akron Times Press* and was editor of the *Tourist News* in St. Petersburg, Florida.

Before *The Story of Sarasota* had been published, Grismer had penned *The Story of Kent, Ohio*, *The Story of Fort Myers* and *The Story of St. Petersburg*. He would go on to write *The Story of Akron*, (his hometown), producing what he called his monumental work, which was completed by his wife, De Trew Grismer, and published after he died in Sarasota on March 3, 1952. He was fifty-six.

As a writer and historian who has relied on *The Story of Sarasota* for much of my research, I marvel at Grismer's accomplishment and also at how the community rallied to assist him. His book is truly a testament to the pride that "the Land of Sarasota," as he calls it, had both in itself and in the citizens whose hard work built it.

I had wanted to be the person who "updated Grismer." But the task seemed so daunting that I suppressed the idea in favor of books that have been mostly pictorial/nostalgic looks at the Sarasota I grew up in and loved so much.

Enter Pete and Diane Esthus who approached me to take up the task of bringing Grismer's work forward, a task eased by my previous books and research that gave me the foundation to tackle the project.

Pete Esthus, many of you know, has done more to document and preserve Sarasota's history than any other individual. The photographs and memorabilia he has collected over the years have been used by me and numerous other writers in relating the history of this community.

For me, the request was high praise, and I hope this story of Sarasota lives up to his and Diane's faith in me.

I have spent all but five years of my life here. I was schooled here, worked here for thirty-two years, raised four children here, retired here for two years and rejoined the workforce as a history specialist for Sarasota County.

My wife Jennifer and I love Sarasota and appreciate the many amenities that are offered, but how much better it would be if more of Grismer's version was still with us.

GETTING STARTED

A CCORDING TO A.B. EDWARDS, THE first settlers to this section of Florida came as early as 1838 and located on the north and south banks of the Manatee River. They lived in close proximity to each other in order to fight off marauding Seminole Indians who sometimes sought revenge for their mistreatment. It was the white race, after all, who tried to decimate them, ultimately sending the survivors of the three Seminole Wars to desolate reservations out West, while others, approximately three hundred, were shunted off to the Everglades. To this day a treaty has never been signed between the U.S. government and the Seminole Indians.

The first settler to come to what today are the city limits of Sarasota was William Whitaker, who fell in love with the beauty of Yellow Bluffs, which he had seen from Sarasota Bay and determined to build there. His first home was a shanty located just north of today's Tenth Street and it was burned to the ground by a group of Indians led by Seminole Chief Holata Micco, aka Billy Bowlegs.

Whitaker would rebuild, marry the diminutive but hardy Mary Jane Wyatt and raise eleven children, many of whom would play prominent roles in Manatee, Hillsborough and Sarasota Counties.

Florida entered the Union in 1845 as a slave state, seceded on January 10, 1861, and fought for the South in the Civil War, the War for States' Rights as they saw it. Of the fifteen thousand volunteers from Florida, a full five thousand would die in battle or from disease and wounds, and many returned from service to find they had to rebuild their homes as well as their lives.

Wearied by battle, they were desirous (as are all returning soldiers, no matter where the war or why it is fought) to start their lives anew.

Some men headed south into Florida, living near the shore, while others saw the potential of farming and raising cattle further inland at Bee Ridge, Fruitville, Miakka, Osprey, Venice and Englewood on Lemon Bay.[2]

Edwards applauded these early settlers for "planting the sprig of democracy in this our glorious county," and singled out John Helveston, Jesse Knight, John S. Blackburn, Sebe Rawls, Jack Tatum, Jesse Tucker, Peter Crocker, Issac A. Redd and of course their hardworking families.[3]

Edwards knew of what he spoke. Born in the area on October 2, 1874, his father, John L. Edwards, a Confederate soldier who was wounded in the Civil War, first visited Sarasota in 1867 and later operated fisheries and began trading salt-cured fish, dried venison and other food products with the settlers further in the interior of the state.

Edwards recalled that slowly but steadily other settlers trickled into the Sarasota Bay region: Professor T.C. Callan, the first educator; J.J. Dunham, the first medical doctor; Charles M.

Robinson, a sailor who would become the Siesta Bridge-tender in later years, his heart, perhaps, aboard each of the sailing vessels he let pass through.

Edwards, who sought to honor these first among us, said of them, "These were the men who broke through the jungle, blazing the trail for us to follow and enjoy the beauties, and the great natural resources they had discovered…"[4]

In the mid-1880s, Sara Sota experienced the turmoil, bloodshed and lawlessness often associated with the land grabbing of the Wild West. Settlers, some with legitimate claims on their property, others whose property rights were more difficult to prove, found that their homesteads were in jeopardy.

Those whose land was on a portion of the four million acres purchased by Hamilton Disston for a paltry twenty-five cents per acre, or on land meted out to the railroads Florida was enticing to the state, were particularly fearful of losing the land they had worked so hard for.

As a result, the Sara Sota Vigilantes was formed in 1884. Also known as the Sara Sota Democratic Vigilantes, they joined together for "mutual protection and the punishment of those whom the law could not reach, or, in other words, the removal of all obnoxious persons."[5]

Taking the law into their own hands, they killed Harrison T. "Tip" Riley, who had been gathering information that would help the land companies dispossess the settlers. Riley, considered "a land-stealing Republican," was bushwhacked as he rode from his home in Bee Ridge to visit his friend Charles Abbe.

Abbe was the postmaster and United States land commissioner and, as far as the settlers were concerned, "a hireling" of land-grabbers. Abbe was next on their hit list.

His murder was planned on December 25, 1884, by approximately twenty-two men who gathered at the home of Alfred Bidwell to celebrate Christmas with their families.

Two days later, Abbe was shotgunned, his throat was cut and his body was loaded onto a boat, taken to the Gulf and thrown to the sharks. It was never recovered.

The killers of both men were soon rounded up by a posse from Manatee and at the beginning of May of 1885 the first of three trials was held at the county seat at Pine Level. Ultimately prison sentences were meted out; some of the men escaped, three were sentenced to hang but never did.

The case drew national attention in the press. A story in the *New York Times* was headlined, "An Assassination Society. The bloody work of a band of Southern murderers," and went on to recount the tale of the killing of Postmaster C.E. Abbe by, among others, Alfred Bidwell, "a former citizen of Buffalo, in good repute, who now lives at Sarasota, Fla."

The paper noted that Bidwell was charged with "being a member of the notorious Sarasota assassination society," and expressed amazement that such an upstanding citizen as Bidwell— "well known as a former prominent and upright business man"—could be involved in a society that existed "for the purpose of the secret murder of political opponents, and is composed of 20 members, bound together by terrible oaths to perform the bloody work of the band and to keep its secrets inviolate."[6]

The convictions of the participants spelled the end of the Sara Sota Vigilantes, and while the animosity lingered between the settlers in Sara Sota and the more established folk in Manatee, there were no more assassinations.

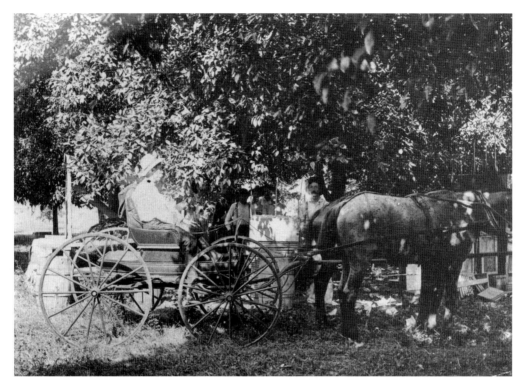

A.B. Edwards, considered by many to be "Mr. Sarasota," showing property in his horse and buggy. *Courtesy Sarasota County History Center.*

In the spring of 1885, when Edwards was eleven years old, he and his father came upon some strangers in what was the jungle near today's Five Points. They were men from a surveying company hired by the Florida Mortgage and Investment Company, a Scottish land syndicate that purchased fifty thousand acres to sell to their countrymen "and establish a state of their own at the southernmost tip of the American continent."[7]

The men had set up a camp in the woods and were about the task of platting Sarasota. The chief engineer of the group, Richard Paulson, upon seeing father and son with their musket and hunting dogs declared rather grandly, "We will lay out the town of Sarasota from this hub." The transit line ran from the high-water mark of the bay and stopped at the very center of Five Points.[8]

The plat for the Town of Sara Sota was filed and recorded on July 27, 1886, at Manatee County in Plat Book one, page thirty-one. Neatly laid out were in-town and out-of-town lots of five-, ten-, twenty- and forty-acre tracts, a cemetery (Rosemary Cemetery), the Florida Mortgage and Investment Company Experimental farm and a few streets: Main Street, Gulf Stream Avenue, Palm Avenue, Strawberry Avenue, Banana Avenue, Pineapple Avenue, Lemon Avenue, Mango Avenue, Cocoanut Avenue and numbered streets. The naming of the streets for fruits underscored the chief selling point: that this was "a land of milk and honey where gold grew on trees."

Thus was set in motion one of the most significant events of Sarasota's formative years: the coming of the Scots.

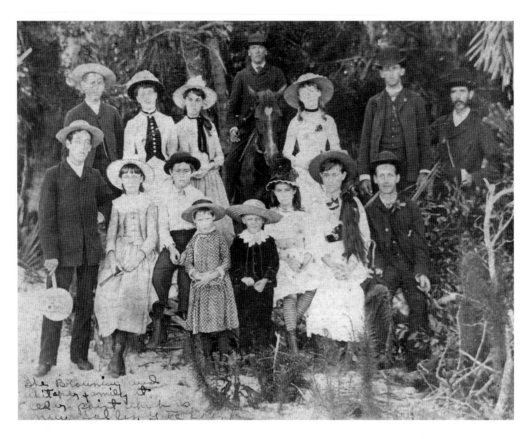

The John Browning family with the William H. Whitaker family at Cedar Point, circa 1886. *Courtesy Sarasota County History Center.*

They named themselves the Ormiston Colony after the home of Sir John Gillespie, president of the Florida Mortgage and Investment Company. The group had been persuaded by promoters that an inviting community on the sunny shores of Sarasota awaited their arrival; they were expecting a "little Scotland" where they could be gentlemen farmers.

Approximately sixty men, women and their children (there were a few Brits among them) sold their belongings and on a dreary evening set off from Glasgow. One of the party, Nellie Lawrie, then a child, wrote of their departure: "It was a terrible, dark and rainy night when the people left Scotland. A large crowd gathered to see them start for America…Many felt very sad and worried. Such a long journey in those days to a new country was quite an undertaking."

A launch took the group out to the 5,495-ton Anchor Line steamer *Furnessia* and they began to sing louder than ever. "As the tender slowly pulled away, the colonists and the people on the pier started to sing together as they never sang before. Few of the crowd could sing the last verse, 'We'll meet again soon ither night, For the days of Auld Lang syne.' There were tears in their eyes and a sob in their throats."[9]

The colonists could not have known it at the time but that bleak night and the difficult passage across the Atlantic were harbingers of what lay ahead. Landing in New York City where they did some sightseeing, the group set off a few days later for Fernandina, Florida, aboard the *State*

John Hamilton Gillespie shortly after he arrived in Sarasota to rekindle the fortunes of the Florida Mortgage and Investment Company. *Courtesy Sarasota County History Center.*

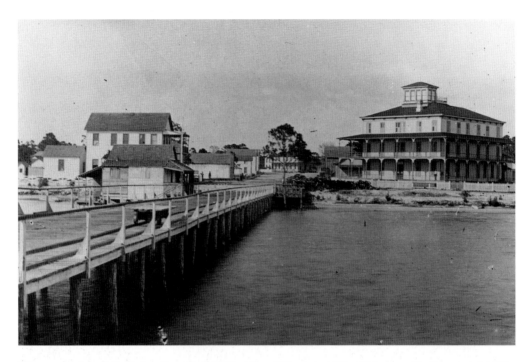

The construction of the DeSoto Hotel by John Hamilton Gillespie in 1886, which opened in February of 1887, caused a bit of a boom, Sarasota's first. *Courtesy Sarasota County History Center.*

of Texas steamship, then on to Cedar Key by train. It was in Cedar Key that the first inkling of trouble surfaced. They were informed by one of the colony promoters, Selven Tate, that they would be delayed, as the lumber for their homes had not yet arrived in Sarasota—the Sarasota that was supposed to have already been built and awaiting them.

The colonists, now anxious by the news, bided their time, all the while their misgivings rising. Deciding to wait no longer, on December 27, 1885, they crowded aboard the small steamer *Governor Safford* and headed to what they had been sold as their tropical paradise.

Even before disembarking on planks near the foot of today's lower Main Street, they could see from the deck that their worst fears were confirmed. It was December 28, 1885, and they were dropped, bag and baggage, in a wilderness with which they were ill prepared to deal.

The group, of course, knew practically nothing at all about the real Florida. Living an ocean away, their privations in Scotland were of the monetary variety as an economic depression had taken hold and forced some to seek opportunities in the New World.

They surely would have never have heard of Sarasota, nor sought it out as a place to begin anew had it not been heavily promoted by the Florida Mortgage and Investment Company as a surefire panacea for the economic woes sweeping Scotland.

Their initial shock and plight was mollified somewhat by area settlers like the Whitakers, who helped them as they could with temporary shelter, food and advice.

Alex Browning summed up the feelings of the colonists when he wrote: "Of course there was much discontent, being dumped, like this, in a wild country, without houses to live in; tired and hungry, one can imagine what it was like."[10]

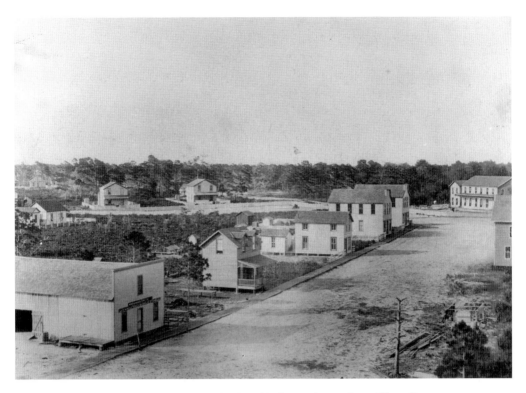

Looking up lower Main Street toward Five Points in 1890. *Courtesy Sarasota County History Center.*

Another colonist, Dan McKinlay, echoed the bewilderment: "Picture us alone in the woods in our little log hut. It's a queer experience and I can't describe it. I am going to light my pipe for I feel very sad."[11]

Within a few months the hardships proved too much and most in the heartbroken group went their separate ways, moving to established communities. Only a few remained. A descendant, John Browning Jr., still resides in Sarasota.

Even though the colony had failed, the company still owned fifty thousand acres here and was intent on realizing a profit. John Hamilton Gillespie, son of Sir John Gillespie, head of the Florida Mortgage and Investment Company, was sent to take on the responsibility of building a viable, if rudimentary, infrastructure that would make Sarasota an appealing town to settle in, and attract buyers for the company's property.

He took over from A.C. Acton, the Florida Mortgage and Investment Company's agent, and initiated a building program that included the laying out of roads and a sidewalk in the "downtown" area, starting an experimental farm off Fruitville Road (it soon failed), building an office and most prominently, constructing the DeSoto Hotel on Main Street and Gulf Stream Avenue overlooking glorious Sarasota Bay.

The building program drew many workers from around the state, accounting for a boom-like atmosphere. Although it was short-lived, at the end of it Sara Sota had what it should have had when the Scots landed—the semblance of a bona fide community. Had the Ormiston Colony arrived in 1887 instead of the end of 1885, they could have undoubtedly made a go of it.

Plat map of Englewood. *Courtesy Sarasota County History Center.*

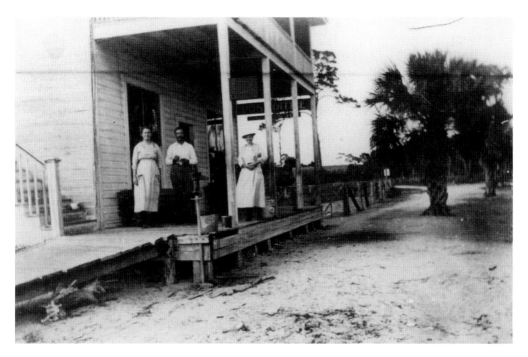

Florence and Peter Buchan, circa 1917. *Courtesy Sarasota County History Center.*

In 1888 the Florida Mortgage and Investment Company thought there was enough in the improved Sara Sota to advertise the area through a promotional booklet. Aimed at "all who are seeking homes or health, investments or recreation, the Managers…offer the following facts in relation to Florida in general and Sara Sota in particular…" The brochure touted the weather, which accounted for "Florida's low death rate" due to "health-giving and invigorating breezes"; it pointed out that while Massachusetts's death rate was 1 in 254 and New York's death rate was 1 in 473; Florida's was 1 in 1,457. How these numbers were arrived at was not explained.[12]

Testimonials included fishing opportunities ("from its waters are taken, in great abundance—the mullet, the pompano, the grouper, and the sheep head—oysters, clams and crabs") and farming ("the soil and climate will produce almost anything"). The booklet beckoned, "Come to Sara Sota, where we think, can be seen the prettiest place on the coast of America…not only pretty as a place but with substantial and costly improvements being made."

As to how much starting a new life in Sara Sota would cost: "A few hundred dollars, judiciously invested in a farm, well located, forms the nucleus around which a man can gather happiness and fortune."

Photographs of downtown Sarasota during these formative years show the boardinghouses, Sarasota House at Five Points and The Inn at Main Street and Palm Avenue (The Inn is noteworthy because in 1894 it hosted Sarasota's first convention, a group of Baptists); a few homes and businesses on a wide dirt Main Street; the thirty-room DeSoto Hotel; a company store; a pier; livery; and blacksmith shop. Soon there would be a one-room wooden schoolhouse downtown near Palm Avenue.

At the center of Five Points a trough provided water for citizens and the livestock that roamed freely. At the center of Palm Avenue and Main Street another fountain, topped with a statue of a bird proudly stretching out its wings, was donated by J.H. Gillespie. Wandering livestock would be a matter of contention between the ranchers and newly arriving townsfolk.

After Gillespie's building program, construction activity halted and the workers scattered to seek other job opportunities. Sarasota went into a malaise.

In 1897 the General Directory of Manatee County listed Sarasota as "a charming location, containing some two hundred inhabitants."

The directory also listed the other small communities in Manatee County of which Sara Sota was a part. Among them were Braidentown, Cortez, Duette, Ellenton, Fruitville, Gillette, Hayden, Parrish, Riley, Terra Ceia, Manatee, Oneco and Osprey, each struggling to be successful and attract newcomers to their particular area. In the twenty-four villages, only sixteen names were listed in the telephone directory—and none of them were in Sara Sota.

Other than dirt roads (which alternated between soft sand in the dry season and mud bogs when it rained) and difficult trails, Sara Sota's main link to the outside world was by water. The steamer *Mistletoe* came in from Tampa on Wednesday and Friday, arriving at the downtown dock at 2:00 p.m.—or thereabouts. Daily mail was carried by a hack from Braidentown, which was ahead of Sarasota in development, proudly boasting the Warren Opera House, which could seat up to eight hundred and had "forty pieces of scenery and requisite stage settings and properties."

In the southernmost part of what is now Sarasota County, Herbert, Howard and Ira Nichols of Englewood, Illinois, planned a town that they hoped would become the lemon capital of Florida. Their two thousand-acre-plat included room for ninety-eight grove lots and advertised that only those who bought ten or more acres for a lemon grove could buy a lot in the city. The property sold for thirty dollars an acre.[13]

Unfortunately a freeze soured the lemon tree dream and the brothers went forward instead with the notion of promoting Englewood as a winter resort. They built the Englewood Inn, a store and a post office and drew snowbirds from Chicago.

After the inn burned down, Herbert Nichols sold the store and post office to Pete Buchan and Englewood became a fishing village.[14]

As the roads around Englewood were rough trails, the primary link to the outside world was by water. Buchan built a 250-foot dock on Lemon Bay and supplies to Englewood were off-loaded there. Captain Wade "Hamp" Lampp captained the *J.W. Booth*, which brought in supplies and provisions from Tampa for Buchan's store. The boat could bring in as much as twenty tons of supplies.[15]

Later Buchan built his home, store and a post office at the landing. When Sarasota became its own county, Buchan served on the county commission for twenty-one years and was responsible for a number of improvements, including a road that linked Englewood with Sarasota, acquired the property for what is now Blind Pass Park and led the county to buy land for an airfield that was named in his honor.[16]

As small as Sarasota was at the end of the 1800s and as unpromising as its future might have seemed, in 1899 a newspaperman named Cornelius Van Santvoord Wilson and his wife, Rose Wilson, saw enough potential in its beauty to begin publishing a weekly newspaper, the *Sarasota Times*, certainly a worthy addition to a community wishing to legitimize itself.

As Sarasota inched slowly forward, a rift surfaced between the fishermen and cattlemen, and progressive folks like Harry Higel, A.B. Edwards, J.H. Lord and others—including the Wilsons—who saw the potential for money and community success not in fishing or farming or raising cattle, but in real estate and winter tourism.

By October of 1902, Sarasota felt confident enough about itself and its future to vote to incorporate as a town. Fifty-three men gathered for the vote and elected John Hamilton Gillespie as the town of Sarasota's first mayor. For the town motto they chose the hopeful, "May Sarasota Prosper." It proved to be prophetic. (Governor William Jennings signed the validation order on April 30, 1903.)

Another spike upward in the town's fortunes occurred on March 22, 1903, when the United States and West Indies Railroad and Steamship Company, later known as the Seaboard Air Line Railway, laid tracks from Tampa to Sarasota. In those days of arduous travel to and within Florida, train service was as necessary for drawing newcomers as lodging and recreation. Its arrival sparked some interest in Sarasota, but it was fleeting and it would be six years, two months and a couple of days before the community got the kick-start it really needed to move forward.

THE LADY FROM CHICAGO

A LOOK THROUGH THE FEBRUARY 1910 editions of the *Sarasota Times* reveals numerous advertisements among the news for patent medicines and real estate opportunities (then as now, ever-present in Sarasota's publications) as well as a host of businesses and professional services, such as the Sarasota Furniture Company, which offered carpets, rugs, reed and rattan furniture; Highsmith & Prime, noting that it had added to their staple and fancy groceries, furniture, hardware and undertakers' supplies; the Sarasota Lumber Co. managed by C.C. McGinty who stocked lumber of all kinds as well as lead, oil and ice box paper; the Sarasota Drug Co., W.F. Knight, proprietor; the Sarasota Transportation Co. of John Savarese, a well-known Tampa business man, which connected with the Atlantic Coast Line Railroad at Tampa; the Bank of Sarasota, which offered among its services the transmission of money by telegraph; the Seaboard Air Line Railway; Doctor Jack Halton—eye, ear and nose specialist; and attorney E.B. Drumright, who practiced law out of Tampa and specialized in attention to real estate and land titles.

Sarasota was a friendly, frontier-type town that numbered approximately 840 residents. They would have no way of knowing it at the time, but the arrival of Bertha Palmer, widow of millionaire Potter Palmer of Chicago, would set into motion a series of events that would forever alter the course of Sarasota's history.

Although her visit here did not immediately spark a boom, her positive pronouncements about the area's beauty, covered in the press throughout the nation, interested several other Windy City residents who followed shortly thereafter. When the frenzied land boom struck Sarasota in the '20s, these midwestern capitalists would help guide the community toward its destiny of being a haven for wealthy snowbirds.

A.B. Edwards called the arrival of Mrs. Palmer "perhaps the most important event in the history of Sarasota." He described her as "a gracious...and successful businesswoman [who] gave great impetus to the city of Sarasota and the Sarasota bay district."[17]

The cursory account of the Palmer arrival in the *Sarasota Times* belied the significance of her visit. On February 24, 1910, buried on page three, over a five-paragraph column, "Arrival of Mrs. Potter Palmer," an article noted, "The most distinguished party [consisted of] Mrs. Potter Palmer, her son, Honore Palmer, her father, Judge Honore, H.H. Honore and A.C. Honore all of Chicago."

Readers were told that accommodations were sought at the Belle Haven Inn (Gillespie's old DeSoto Hotel) but as the rooms with baths were already taken, arrangements were made for the party to stay nearby at Dr. Jack Halton's Sanitarium, outfitted for their comfort. (According to local lore, the real reason for the switch in accommodations was that the DeSoto Hotel had run down to the extent that it was not in good enough shape to receive such dignified guests.)

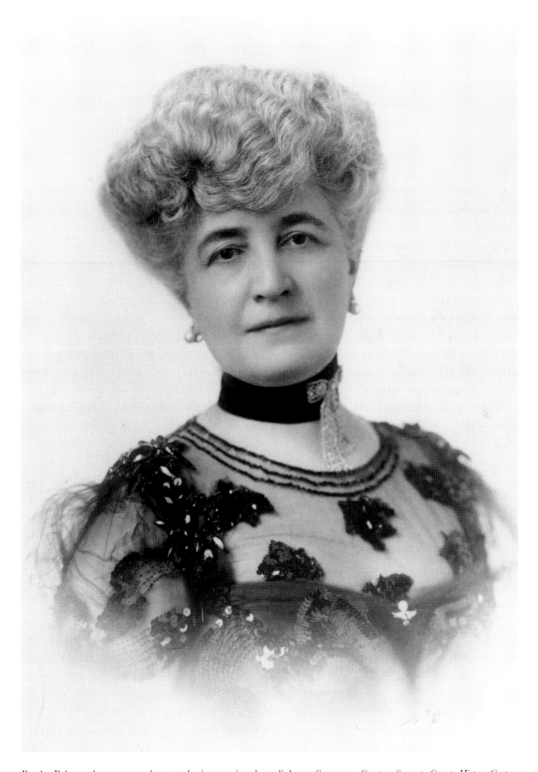

Bertha Palmer, the woman who cast the international spotlight on Sarasota. *Courtesy Sarasota County History Center.*

Mrs. Palmer's bona fides as one of the world's society queens was spelled out for any of the locals who may not have had the opportunity to follow her much publicized lifestyle among the rich and famous of her day. "Mrs. Palmer is one of the widest known American women and is almost as well known in London and Paris as her home city, Chicago. She is a beautiful woman and her portrait often appears in periodicals as an example of American beauty."

While in Sarasota, the Palmer party was shown around the area by A.B. Edwards, whose real estate partner, J.H. Lord, a transplant lawyer-businessman, had put the ad that caught Bertha's eye in the Chicago paper.

When the Palmers left, another brief column appeared in the *Sarasota Times*: "These noted visitors found such excellent services at the Halton, our superb climate and the boating and fishing advantages so attractive, they extended their stay from three days to eleven."[18]

It was reported that Mrs. Palmer did not buy any property, and after promising to return, she boarded her private railway car and chugged away, leaving Sarasota for London to begin entertaining society at her residence, Carlton House Terrace.[19]

A year later the *Sarasota Times* happily reported: "With a foresight equal to that one might expect from the shrewdest financier of modern times, Mrs. Potter Palmer has just closed a deal that gives her complete control of Florida's richest virgin soil." And lest there be any doubt that it was she and not "some clever business man" running the show, the paper noted, "Mrs. Palmer has demonstrated a shrewdness in handling business propositions that some of our Napoleons of finance might adopt and at the same time improve their financial standing."[20]

Mrs. Palmer soon interested herself in agriculture and ranching, and at Meadow Sweet Pastures, her ranch along the Myakka River, she introduced new methods, including dipping cattle to eradicate the Texas fever tick, and fenced in her range. Local ranchers were skeptical of her new ideas.

Although Mrs. Palmer's initial design for a home was an opulent mansion, she decided on a less ostentatious, two-story house on Little Sarasota Bay, The Oaks. Architect Thomas Reed Martin of Chicago, who had come down at her behest, redesigned it, adding rooms and columns and surrounding it with formal gardens, walkways, ponds and buildings for servants and work crews.[21]

Having led a full and eventful life, Mrs. Palmer died at The Oaks on May 5, 1918. She had accumulated ninety thousand acres and increased the $8 million fortune left to her by her husband to $20 million. Her legacy can still be seen at Historic Spanish Point in Osprey.

Her sons, Honoré Palmer and Potter Palmer Jr., were active in the family affairs, with Honoré an official of the Sarasota-Venice Company. Both brothers planted out the 1,200-acre Hyde Park Citrus Groves and aided in the formation of the Sarasota-Fruitville drainage district, which made 8,000 acres available for cultivation. After Mrs. Palmer died, Potter made The Oaks his home while Honoré stayed at their 140-acre "Immokalee."[22]

Grismer credited Honoré, who was the chairman of the board of the Palmer Bank, with being "the directing force which has caused the Palmer organizations to be potent factors in the development of Sarasota."[23]

Bertha Palmer purchased the property for her home from the pioneer John G. Webb family who had settled in what he named Spanish Point. Webb came there in 1867 looking

John G. Webb, the founder of Osprey, and his wife, Anna. *Courtesy Sarasota County History Center.*

for a better climate for his wife, Anna's health (she suffered from asthma) and at the same time a beautiful place to build their home. Webb had been a successful druggist in Utica, New York, and had been told about this idyllic spot near a large Indian Mound in Manatee County by a Union soldier.

Naming the area Osprey after the osprey bird that once flourished in the area, Webb began entertaining guests from his hometown, ultimately opening the Webb's Winter Resort, said to be the first winter resort in Manatee County, which he operated for thirty-eight years. He soon established the Osprey post office.[24]

John Webb died in his home on April 3, 1908, by which time he had served as a Manatee County commissioner for two terms and also as a Manatee County judge.

One of Webb's resort guests had been John S. Blackburn and his wife Belinda, who were impressed with the area and homesteaded just south of Osprey in what would become known as Laurel. Blackburn and his sons, George and Ben Franklin (known as Frank), who came down later, homesteaded on the bay and played important roles in Sarasota's early development. George was one of Sarasota's first merchants, while Frank was a commercial fisherman who also delivered supplies along the Gulf Coast in his boat, the *Sea Turtle*.

In 1868, another pioneer family, Jesse Knight and his wife Caroline and their fifteen children, came to the Nokomis area, then called Horse and Chaise, to raise cattle. Knight's herd grew to several thousand head that roamed on the open range. By the time he died at age ninety-four, he had donated land for the Venice-Nokomis Methodist Episcopal Church and also donated the land, lumber and helped build a school in the Venice-Nokomis area. When a larger school was needed he donated land for that also.[25]

Into this area also came Frank Higel and his six sons from Philadelphia. Higel was a chemist who had found a method to turn the roots of the cassava plant into starch. He had interested landowner Hamilton Disston (who had purchased four million Florida acres at twenty-five cents an acre) in the process. Disston sent down the necessary manufacturing equipment and came to observe. Unfortunately it was the coldest winter on record, and Disston became disenchanted with Florida and decided to pull out of the venture.

Higel would go on to produce cane syrup, citrus and guava jellies and marmalades. His sons played important roles in the success of Venice and Sarasota. It was Frank Higel who gave Venice its name.

LIFE AS A STRUGGLE

W HILE MRS. PALMER'S SOCIAL STATION allowed her to be catered to—her husband had given her the famous Palmer House Hotel for a wedding present—life for the settlers who had lived in Sarasota up to the time of her first visit was often a labor-intensive hardship. In old photographs you can see the travails of daily life etched on the faces of the men, women and children—no one is ever smiling.

Practically everything we take for granted was a challenge for these early settlers. Transportation to places even as nearby as Bradentown was a difficult journey especially when it rained; food had to be grown, hunted and preserved; mosquitoes were a threatening menace during the rainy season and arrived in black clouds with the potential to do real harm. In a letter written to a friend in 1887, early settler Anton Kleinoscheg wrote of their "bloodthirstiness," calling them "a terrible plague…Enough to drive one mad!" They had killed two of his dogs, he said.[26]

In another letter he bemoaned, "I sleep under a mosquito bar of course, otherwise sleep would be impossible, but in the miserable hut in which I am living I have no screen; therefore, it is impossible to burn a light; I go to bed at half past seven as soon as it grows dark…"

Fires were also an ever-present concern and several times the little town was nearly destroyed. Homesteaders were threatened by fast-spreading wildfires. Dan McKinlay a Scot colonist, wrote in his diary: "Feb. 3 [1886], Prairie on fire all around us…grand sight…fires miles in extent burning up everything in their way." An entry on February 7: "Growing more and more of opinion that we can't make a living here. Evening—prairie again on fire and close to us…creeps close upon us…fire close around us…almost as soon as it is done the wind shifts and threatens to burn us out…"[27]

Edwards related how the pioneers made a living:

> *Mainly off the natural resources of the land and water. The hollow trees were full of honey; the woods full of game; the waters teeming with all kinds of fish. The jungles and the wild forests were full of all kinds of wild berries. No [commercial] canning or processing in those days; everything was fresh off the hoof, off the vine, off the tree, out of the soil, or out of the water or wrapped up in hide or feathers.*[28]

During the rainy season, even lighting a fire could be difficult, with the use of gunpowder sometimes necessary to get a flame going.

Recreational activities were limited, and with the entire family working sunup to sundown just to survive, hardly any time or energy was left to spend having fun. They looked forward to family gatherings, church socials, swimming and picnics. "Uncle" Ben Stickney, the gentleman

for whom Stickney Point Road and Stickney Point Bridge are named, was loved throughout the community for hosting well-attended beach picnics.

In many ways Ben Stickney personified the best of Sarasota during its formative years. Born in 1842, he had been in the hotel business before arriving in Sarasota in 1894 and in fact managed the DeSoto Hotel for a year. But as the *Sarasota Times* pointed out rather obliquely, "while his genial, kindly nature made him a favorite, there were other characteristics which prevented any desirable result."

Mostly what Uncle Ben seems to have been was a true Christian gentleman whose practice of the Golden Rule made him much loved in the community. "He was everyone's friend," noted the paper upon his passing, "His utmost strength was at the service of anyone who needed help...His nature was transparent, his spirit genial, his hands open and his heart kind."[29]

He lived on Sarasota Key (Siesta Key today), in a home surrounded by oak trees. As his front porch faced the water, he was often seen sitting there by passing boaters who were always given a friendly greeting and a smiling wave.

Another Sarasota pioneer singled out for his acts of kindness was W.H. Locklear, known as "Uncle Henry Lock." For sixteen years he carried mail from Braidentown (the spelling would change later) to Pine Level, the first seat for Manatee County, and also planted many of the palm trees along Palm Avenue. When he died the *Sarasota Times* called this father of twenty-two children a "beloved character [and] a friend to all mankind." Locklear Park on South Lockwood Ridge Road is named in his honor.

At the downtown pier, hardworking Dave Broadway, who drove the mail hack from Manatee to Sarasota, opened up a business that sold seafood, specializing in oysters. He recalled that entertainment in the old days consisted mostly of "city boys fighting with country boys at country dances, or country boys fighting with city boys at city dances."[30]

By the end of 1910, the community had the look of a legitimate, albeit small, town with a two-story schoolhouse, churches, downtown stores to shop in, offices and a bank, and began attracting out of town visitors who came for the fishing, hunting and the salubrious climate. On Indian Beach Road, across the street from the bay, the Tarpon Club became a popular destination for wealthy Northern fishermen who began coming to Sarasota in 1891.

A brochure issued by real estate agents Chapline & Chapline showing the assets of the Sarasota vicinity during this era indicated, "The best fishing; the most beautiful scenery and the most desirable climate in the world." Along with strings of large catches of fish and game from successful hunts, the booklet showcased the homes, buildings and farming opportunities available in Sarasota. And lest there be a concern about the weather, "The breezes from the Gulf arise every evening about dusk, and one is fanned gently to sleep, awaking in the morning feeling refreshed and invigorated." The mosquito menace was not mentioned.

Another area with great potential that was striving to be discovered during this period was a piece of Sarasota Key, platted as "Siesta Key on the Gulf" by Harry Higel, Captain Louis Roberts and E.M. Arbogast. Roberts homesteaded on the key in the 1870s and opened the popular Roberts Hotel (later the Siesta Inn). Arbogast was a seasonal visitor, a real estate broker from Marlington, West Virginia.[31]

Higel was a driving force. He served five terms as a member of the Sarasota town and city council and was mayor for three terms. He then shifted his attention to the key and became as hardworking at making Siesta a success as he had been in driving Sarasota forward.

Early settler Anton Kleinoscheg and his wife, Carrie Abbe, whose father, Postmaster Charles E. Abbe, was murdered by the Vigilantes. *Courtesy Sarasota County History Center.*

According to Grismer, the financial depression of 1907 temporarily killed the Siesta venture; only twenty-three adults and three children were listed on the 1910 census. But after the town was replatted in 1912, progress quickly followed.[32]

When Higel began advertising Siesta on the Gulf circa 1915, the key was not yet joined by bridge to the Sarasota mainland. But that did not stop him from pushing forward with the development. He noted, "It takes only 20 minutes to run from Sarasota [to Siesta] on a ferry," and began a massive dredge and fill operation on the key. In 1913 he opened bathhouses for those who came by boat for swimming, picnics and fishing.

In 1915 he built the Higelhurst Hotel on Big Pass. Two stories tall with columns all around and a large screened porch, the hotel was the crowning glory of his work on Siesta Key. Rooms rented for $2.50 a night and offered hot and cold running water, large baths and gas and electric lights, unexcelled views, a sugar sand beach and superlative fishing. For the grand opening, Higel ferried over two hundred well-wishers for a festive evening to show off his hotel.

Harry Higel, Sarasota and Siesta Key booster and developer. *Courtesy Sarasota County History Center.*

Just before the first bridge to the key was completed in 1917, the Higelhurst burned to the ground and was never rebuilt; but Higel's faith in the key as "A Place to Rest and Have Peace and Comfort" was borne out. He had envisioned a Siesta "that appealed to the well-to-do who wish to leave the snows…and get down here for five or six months of continuous good weather."

Tragically, Higel was murdered, bludgeoned to death on Siesta Key on January 6, 1921. His killer was never convicted. The second bridge to Siesta, completed in 1927, was dedicated: "To the Memory of Harry L. Higel. A beloved Citizen of Sarasota County."

Chapter IV.

SETTING THE STAGE

JOHN HAMILTON GILLESPIE MUST HAVE been happy at Owen Burns's arrival in Sarasota. Burns bought from him the remaining holdings of the Florida Mortgage and Investment Company for $35,000 and took title to what would be approximately 75 percent of the city of Sarasota. Gillespie, who was fifty-eight years old, could now devote more time to his first love, playing golf, which he had introduced to Florida shortly after he arrived in 1886. He had worked hard for Sarasota for a quarter of a century and deserved his leisure time.

Owen Burns, forty-one years old when he arrived in 1910, probably did more to make Sarasota a successful city than any other single individual. His involvement in the community began shortly after Bertha Palmer cast the international spotlight on this unheard of and difficult to reach town. Burns immediately saw in the area's intrinsic beauty the potential to make it a desirable destination for wealthy snowbirds.

He was a dynamo whose activities in building and boosting Sarasota never ceased. He aligned himself with the progressive members of the community, sought to clean up and modernize the town and also lobbied to break away from Manatee County, which was finally accomplished in 1921.

Burns set up several companies through which he conducted his business: the Burns Realty Company, Burns Dredging Company, Burns Dock and Commercial Company, Burns Transportation Company and the Burns Supply Company.

His early projects offered a preview of what lay ahead when the Florida land boom swept through Sarasota in the early 1920s. In 1912 the Burns Realty Company began selling lots in the First Addition to Inwood Park, "Sarasota's most beautiful residential section," offering them for $125 and noting in a full page ad in the *Sarasota Times*, "Do you realize that the prices for Real Estate that today seem high will look rediculously [*sic*] small in a few years? Today there is Real Estate in and around Sarasota that can be purchased for only a few hundred dollars that will, before long, be worth a few thousand dollars. You can get some of it. And JUST NOW is the time to act."[33]

The promise of quickly escalating prices and the necessity of fast action would become the dominant themes of the '20s land boom. (And the boom of 2000 as well.)

Burns's early development skills were described in the *St. Petersburg Independent* and reprinted in the *Sarasota Times*: "He purchased a tract of earth which the natives considered of little value, filled it, graded and ornamented it, cut it up into lots and put down paving—and then they waked up to find that Owen Burns had made a small fortune and had given Sarasota the greatest boost in the history of that pretty place. Since then, Owen has been keeping things moving and we have heard more of Sarasota than ever before."[34]

Being a part of Manatee County began to rankle Sarasotans whose tax dollars were going north, with very little coming back down in the way of public improvements.

A committee was formed in 1920 to study the issue and propose how a separation could be effected. Chaired by John F. Burket, the committee included: A.B. Edwards (on the committee to collect data), Frank A. Walpole, A.M. Wilson, J.H. Lord, Owen Burns, A.L. Joiner, L.L. May, John Savarese, W.Y. Perry, George B. Prime, W.M. Tuttle, Frank Redd, Clarence Hitchings, A.C. Honore, Frank Pearce, Dr. Joseph Halton and E.O. Burns of Sarasota; W.L. Dunn of Nokomis; W.E. Stephens of Venice; J.R. Mason of Manasota; P.E. Buchan of Englewood; Vic Saunders of Osprey; Bryant Taylor of Bee Ridge; Emmet Tucker of Fruitville; Will Hancock of Myakka; F.P. Dean of Indian Beach; and John A. Graham of Bradenton.[35]

At a September 1920 meeting, Edwards reported,

> *the territory comprising the proposed new county is paying considerably more into the county treasury in the way of taxes than it is receiving back; the area which comprises one-half of the present county is represented by one commissioner, while the other half is represented by four.*[36]

Owen Burns intoned, "We're being taxed to death and we're getting practically nothing in return... We're being treated like a step child. The people in the Manatee River region have had their own way long enough—the time has come for us to become independent and chart our own course."[37]

Edwards noted that of the $300,000 for schools, nearly one-third of which came from the south section of Manatee County, only $35,000 was received back.

The *Sarasota Times* reported that several women were in attendance at the meeting. Having recently been franchised, they would "have the privilege and duty of expressing themselves on such questions by their ballot." Mrs. Wilson, who had taken over the publication of the newspaper upon the death of her husband in 1910, was a progressive who had campaigned hard for the rights of women. The *Sarasota Times*, under the leadership of Rose Wilson, was 100 percent in favor of the Manatee breakaway.

At the suggestion that Sarasota would lose much-needed advertising if it split from Manatee, Mr. Burket assured that Sarasota "was much better advertised throughout the country than Manatee."[38]

The gathering concluded with Frank Walpole calling for "more pep and enthusiasm."

After several more town meetings, a resolution was put before the Florida legislature at its eighteenth regular session entitled, "AN ACT Providing for the Creation of Sarasota County in the State of Florida, and for the Organization and Government Thereof."[39]

First word that the resolution passed unanimously was wired on May 11, 1921, at 7:00 p.m. from Tallahassee to the *Sarasota Times*'s Rose Wilson: " SARASOTA COUNTY WINS BILL JUST PASSED HOUSE BY UNANIMOUS VOTE." Signed, John F. Burket.

Frank A. Walpole, sent a telegram on May 14: MRS. C.V.S. WILSON: "SARASOTA COUNTY BILL SIGNED BY GOVERNOR AT ONE OCLOCK IN PRESENCE OF SENATOR COOPER AND MYSELF."

The next step in the process was a vote in the affected area, scheduled for Wednesday, June 15, 1921. Six precincts were involved: Sarasota, Osprey, Venice, Englewood, Miakka and Manasota.

The excitement was pervasive. The *Sarasota Times* put aside misgivings some may have had, noting that there would not be an increase in taxes, but that taxes created in the new county would stay in the new county.

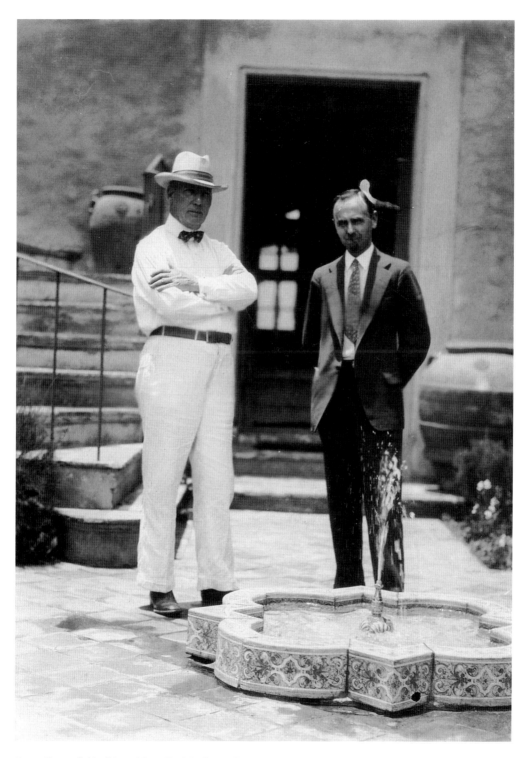

Owen Burns (left) with architect Dwight James Baum in the courtyard of the El Vernona Hotel. The duo teamed up to design and build some of Sarasota's most important 1920s boom time buildings. *Courtesy Lillian Burns.*

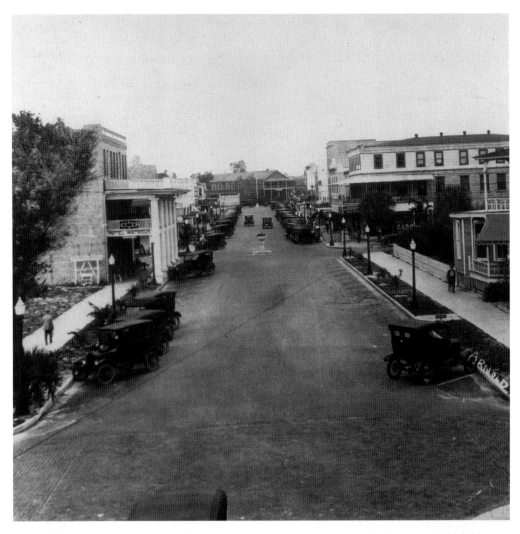

Lower Main Street, circa 1915. *Courtesy Sarasota County History Center.*

Another selling feature was that the new county would be represented by five county commissioners from five districts, and as a consequence "the roads and bridges of the entire new county will be better cared for than ever before."[40]

The special election was the talk of the area. Sarasota's destiny was a vote away and, as expected, it was ratified by nearly four to one.

Rose Wilson wasted no time reflecting the area's new status. The next day she proudly rechristened her paper the *Sarasota County Times*.

The vote ran 518 for and 154 against: Sarasota 406–118, Osprey 37–2, Venice 22–30, Englewood 25–0, Miakka 7–0, Manasota 11–4. The Venice vote was a surprise to some and, interestingly, after the bill passed, Venice lobbied to have the county seat put there instead of Sarasota.

The new county's celebration was loud and colorful. Horns sounded, whistles blew, sirens wailed. Downtown Sarasota was filled with townsfolk, and a large American flag was hung

In the doorway of the *Sarasota Times* newspaper, Rose Wilson and her husband, Cornelius Van Santvoord Wilson. *Courtesy Sarasota County History Center.*

from the center of the city hall building at the Hover Arcade, where a temporary sign proudly announced, "Sarasota County Court House."

A celebratory parade, led by flag-draped cars and the Sarasota Brass Band, marched from the new, albeit temporary courthouse, up Lower Main Street toward Five Points and beyond.

Having cast off the yoke of Manatee, Sarasota County was on its way. As Mrs. Wilson put it in the headline of the new *Sarasota County Times*: "Hurrah For Sarasota County!"[41]

LIGHTNING STRIKES

IN MANY WAYS THE FLORIDA land boom typified the raucous Jazz Age during which it occurred. It was Florida's answer to the California gold rush, the Oklahoma land rush, the Texas oil rush and the Dutch tulip bubble of days gone by.

The "era of wonderful nonsense" spawned a carefree attitude and anything seemed possible. In Sarasota, the "anything possible" included making a fortune in real estate. Longtime Sarasota resident Lamar Dozier recalled in a speech to the Downtown Kiwanis Club that Sarasota was "electric with excitement." Real estate agent Roger Flory reported that "the cash registers were singing."

As Will Rogers aptly put it, "You can't whip this prosperity thing."

The Sunshine State was billing itself as "An Emerald Kingdom by Southern Seas," while the Sarasota Chamber of Commerce, trying to snag their fair share of newcomers pouring into the state in black Tin Lizzies, pegged Sarasota the "Land of Glorified Opportunity." Asa Cassidy painted one of the era's most colorful symbols: the "Spirit of Sarasota" as a smiling lass in a red bathing suit astride a tarpon, waving happily from Sarasota Bay.

Typifying the dream of the wealth that could be had in Florida was a gentleman named Walter V. Coleman, said to have left Detroit in 1915 with eighty dollars in his pocket, a wife, five children and "an overpowering ambition." By 1926 he was a millionaire real estate man whose "note at any bank in Florida would be honored for almost any amount." Coleman, "owner of acre upon acre of land [and of] buildings so numerous one loses count of them," developed the Bay Haven and Riverside subdivisions and built the Bay Haven Hotel, known today as the Ringling School of Art and Design. Along with his ambition, "a great deal of pluck and plenty of energy" made Coleman a success.[42]

The beckoning brochures, reaching out to other "would-be" Colemans, could not adequately show the multihued glories of Florida's beauty in black-and-white photographs, but this lack was more than made up for with colorful prose promising newcomers the good life and the likelihood of making money—big money.

Examples of the local hype: Whitfield Estates promised, "Values are rising amazingly—yet prices are remarkably low, so that investors still have the opportunity that awaits the pioneer"; Longboat Shores beseeched, "NOW IS THE TIME. Buy now before the first price advance, ahead of the great rush of investors. When Owen Burns tells John Ringling his famous causeway is completed…you will see some activity and some PRICE CLIMBING. Let your profits go up with the climb."

Throughout the state, cities and towns and their chambers of commerce vied for their share of newcomers. The *St. Petersburg Independent* offered a free newspaper on any day the sun did not shine. West Palm Beach, billing itself as Nature's Youth Land, promised, "The rejuvenating

influence of ocean breeze and balmy sunshine makes life worthwhile in the land where flowers grow." Health, wealth and happiness were the staples of life in the Sunshine State. Okeechobee crowned itself "The Chicago of the South;" Cocoa by the Sea, "The Friendly Land that Loves a Playmate;" DeLand, "The Athens of Florida."

Tampa produced a cigar box calling card with a picture of a key to the city on it and assured: "Tampa Police are your friends. We realize that you are not familiar with all our traffic rules. If you violate some minor regulation, just show the traffic officer this KEY TO TAMPA. He will smile pleasantly and wish you a delightful vacation in our Land of Sunshine and that will be the extent of his penalty."

For its part, the Sarasota Police Force was giving "politeness" lessons to its officers. The Chamber of Commerce gave officers small cards of welcome to attach to automobiles from other states allowing them to park their car any place for any length of time, until they became familiar with our ordinances.

The statewide hype was pervasive. So laden with advertisements were the Miami newspapers that James A. Cox's *Miami Daily News* swelled to 504 pages in twenty-two sections and Frank B. Shutts's *Miami Herald* set the world record for ad space in 1925.

Advertisements showcasing Sarasota were placed in the major Northern newspapers; Sarasota brochures were mailed out en masse; billboards in important cities were erected wooing newcomers to "Spend the Summer this Winter in Sarasota"—as opposed to Palm Beach, Miami, Miami Beach, Coral Gables, Tampa, St. Petersburg, et al. Postcard week was established, with a gold cup trophy going to the city that mailed out the most cards boasting Florida's charms. The *Sarasota Herald* began printing an enlarged annual special edition, the "Mail It Away Edition," encapsulating everything that was going on in Sarasota County. The Chamber of Commerce sponsored radio station WJBB, the Voice of the Semi-Tropics. A listener who picked up the station's signal in Oregon wrote, "Sarasota seems to be a live city and will derive great benefit from your programs."

An important advantage Sarasota enjoyed over any other Florida community was the national advertising campaign by Ringling Bros. and Barnum & Bailey Circus, which placed forty-eight-by twenty-eight-inch posters of "Sarasota by the Sea, Florida's Most Beautiful City" on billboards wherever the circus traveled. Sarasota was also advertised in their circus programs.

Unlike, say, Okeechobee, striving to be "the Chicago of the South," there was more here than the sizzle. For one thing, Sarasota truly was fantastically beautiful. As A.B. Edwards remembered it, "The landscape was much more beautiful than it is today…The tropical jungles and islands were greener, the water in the bays, bayous, creeks and rivers was bluer and clearer; the shore lines were straighter and cleaner; the beaches, both on the Gulf and inside waters were wider and much whiter."[43]

During these effervescent 1920s years, the Sarasota that Grismer documented in *The Story of Sarasota* came into being just like throwing a switch on a fluorescent light, a flicker then sudden brightness.

In his interview with Sarasota historian Dottie Davis, Edwards, who was a major player during the boom years and many years thereafter, said, "Ordinarily it would have taken one hundred years for the average American city to acquire the same amount of public and private improvements as did Sarasota during that two and a half year boom period." Grismer put the

number of years at fifty. In either case, a remarkable transformation had taken place in an unbelievably short time.

Everywhere one looked buildings were rising, developments were being laid out and all the other elements of a thriving and prosperous city were put in place: schools, churches, banks, hotels, restaurants, theatres, paved roads, bridges. Newcomers were pouring in, some for a look-see, others to make Sarasota their new home and still others to make as much money as they could, as quickly as they could and move on.

Real estate offices opened throughout downtown as "binder-boy" salesmen, usually outfitted in knickers pants and also known as the Knickerbocker Army, scurried around trying to seal deals. The major real estate companies included Bacon & Tomlin; C. Roy Kindt Co.; Longmire & Williams; C.A. Bird (who advertised, "Buy from us. Make your dollars have more Cents. Real Estate is the Basis of Wealth. Honesty the Foundation of all Business."); Brown & Crist; Conrad Bros., Inc.; Davis, Reuter & Flory; A.S. Skinner Co.; and Clark Warren ("He Knows Where Money Grows").

Forty real estate companies advertised in the 1926 R.L. Polk Sarasota City Directory, each with its share of agents. The A.S. Skinner Company had a sales force of sixty-six.

What Sarasota lacked at the beginning of the 1920s was a major-league hotel that would attract wealthy snowbirds—a shortcoming that was not lost on the city fathers.

Enter Andrew McAnsh.

In return for building a luxury hotel, Sarasota would grant McAnsh certain concessions. Mayor E.J. Bacon, city attorney John F. Burket, the Sarasota city council and the Sarasota Chamber of Commerce offered not to levy taxes on the property and provide free electricity and water for ten years. McAnsh accepted.[44]

McAnsh was given a rousing welcome when he came to Sarasota. Business leaders met him in Rubonia and drove him into town, where the Sarasota Band led him from Main Street to Palm Avenue. Red fuses along the way were lighted on both sides of the street, "casting a soft glow over the scene which lent the effect of a truly gala occasion." The fire siren wailed, whistles went off and horns blared, "Welcoming McAnsh as one of the most important developers to come to the city," intoned the *Sarasota Times*.[45]

Construction began on the Mira Mar Apartments on October 6, 1922, and, working round the clock, the project was completed in sixty days and was called the sixty-day wonder.

The Mira Mar Hotel facing Sarasota Bay was set behind the apartments and was dubbed the Gem of the West Coast. It and the Mira Mar Auditorium were completed shortly after the apartments.

McAnsh was hyped as "priceless to any community where he determines to start any construction."[46]

The apartments, hotel and auditorium on Palm Avenue and, later, his Mira Mar Casino on Siesta Key signaled that Sarasota was a bona fide contender as a go-to destination in Florida. Generally pictured in the newspaper in a vested suit and straw hat as "a Chicago capitalist," the *Sarasota Times* enthused, "It is safe to say that the erection of the Mira-Mar hotel has meant as much to the development of Sarasota as any one enterprise that has yet located here."[47]

A cartoon on the front page of the *Sarasota Times* pictured Sarasota as a smiling young man in a bib, holding a spoon he was about to dip into a large bowl marked McAnsh Capital. The caption read, "This Growing Lad Relishes The Dish Before Him And Is Eager For More."[48]

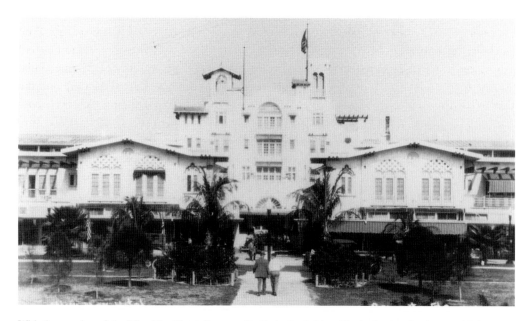

With the opening of the Mira Mar Hotel, Sarasota finally had a fashionable destination for the snowbirds. *Courtesy Sarasota County History Center.*

Asked why he did not choose a larger city in which to build, McAnsh said of Sarasota, "I liked this town from the first moment I came here. It grows upon me. It is a beautiful city with a bay that is the equal of anything in America and I am sanguine that Sarasota has a great destiny."[49]

His construction projects attracted others from Chicago and the North—developers, financiers, snowbirds and salesmen all adding to the foundation that was begun by Sarasota's earlier progressives—Owen Burns, Harry Higel, J.H. Lord, A.B. Edwards, Calvin Payne, Ralph Caples, the Ringling brothers and numerous others.

Of the Cinderella-like transformation of Sarasota, the R.L. Polk Sarasota Directory of 1926 noted,

> *Two years ago one wooden structure and two smaller hotels were sufficient for the winter trade of Sarasota, and in summer one of the smaller hotels kept open to accommodate the traveling public. There were two small restaurants where you could get a square meal for fifty cents. Today towering structures, built mainly for the tourist trade are filled to overflowing every day in the year and the cry is for more hotels.*

Even a partial list of Sarasota's development between the time of the erection of the Mira Mar Apartments and Hotel and the real estate crash is staggering. Joining the already established hostelries, including the Belle Haven Inn, Watrous Hotel and Hotel Weida, were new establishments led off by the Mira Mar Apartments and Hotel, El Vernona Hotel, Sarasota Terrace Hotel, Hotel Sarasota, Villa Goodrich, DeMarcay Hotel and the Pasadena Hotel. The American National Bank and First Bank & Trust ("The Big Bank at Five Points that carries the Five Points of success: reliability, efficiency, courtesy, resources and personal services") joined

the Bank of Sarasota and the Ringling Trust & Savings. Sarasota's bank resources rose from $861,861 in December of 1920 to $7,712,250 by June of 1925.[50] Twenty-five restaurants had been added by 1926, including the Tip Toe Inn ("Food As You Like It"), The Plaza (a perennial favorite for many years), Busy Bee Café, DeLuxe Café, DeMarcay Café, Gem Café and the Diana Tea Room. A new Sarasota High School, Southside, Bay Haven and Central School were also built. The *Sarasota Times* was given competition from the *Sarasota Herald* and *This Week In Sarasota* ("We Cover Sarasota Like the Morning Dew"), each housed in new Mediterranean-styled buildings. Countless numbers of housing developments were being platted and the newspapers were filled with full-page advertisements for them, fueling the excitement and generating sales: Sylvan Shores, "Autocrat of All Home Sites," on Whitaker Bayou off of the Tamiami Trail; Midway, "Restricted-Exclusive-Finished," on Bradenton Road (not yet called Old Bradenton Road); Silver Beach, "any man you may question in Sarasota will tell you that once the causeway is completed values will soar in Longboat Key"; Emerald Isle, on the Tamiami Trail, midway between Sarasota and Bradenton, "The Jewel of the West Coast," had a trust fund of $100,000 "for the perpetual maintenance of the landscape" and a caretaker available on site to answer any questions; Indian Beach Estates, "Where Dreams Become Realities," advertised their pricing rationale, "Desirability created the demand, demand made possible the price"; Avion, ten minutes from Five Points, blared, "ACT NOW! Present Prices Can Not Endure.

Real estate man Roger Flory said of the more questionable ventures, "Fortune hunters came from all parts of the country to buy acreage for subdivision purposes. They gave no thought to drainage, utilities, or other improvements. They laid out four lots to the acre and would sell each of these lots for a price originally paid for the acre, and they left the city holding the bag as far as any improvements was concerned."

The Polk directory also offered other yardsticks of Sarasota's growth and progress: Occupational licenses rose from 139 in 1923 to 1,057 in 1925. Electric meters increased from 947 in 1924 to 1,944 through April of 1925. The membership of the ever-busy Chamber of Commerce rose from 125 to 2,430 in fourteen months. All of these increases were reflected in the City Directory, which went from 214 pages in 1924 to 430 pages in the 1926 edition.

With the influx of newcomers, Sarasota's need for a larger hospital became obvious. Until November of 1925, the town's only medical facility was the Halton Hospital on Pineapple Avenue, privately operated by longtime resident Dr. Joseph Halton.

In October of 1924 ladies in the community, including Mrs. George B. Prime and Mrs. E.A. Smith, organized the Sarasota County Welfare Association to carry out the charitable work of the county. They soon set upon the task of building Sarasota a hospital.

The association's first accomplishment was the purchase of a tent in which to care for a tubercular patient. Another tent was bought shortly thereafter. But these were stopgap measures on the road to a bona fide medical facility.

Plans for a hospital building were submitted by the Thomas Reed Martin Studios and a cost of $40,000 for construction and equipment was set.

A countywide building fund campaign was launched and all local businesses were beseeched for money. Participants were given a sign to stick in their window: "This Company and its employees are 100 percent subscribers to the Sarasota Hospital Building Fund."

Individual benefactors were responsible for the largest contributions. Real estate man A.S. Skinner underwrote an operating room; Honore and Potter Palmer Jr. gave $5,000 for an X-ray machine in memory of their mother, Bertha Palmer. Others donated money to furnish individual rooms.

On November 2, 1925, the hospital was open and ready for inspection. The *Sarasota Herald* enthused, "this is the greatest philanthropic undertaking which this county has ever known."

In 1926, a bond issue of $175,000 was approved to provide enough money to add an annex, and the hospital became known as the Sarasota Municipal Hospital, with control turned over to the city.

In a forward to the book *Florida in the Making*, Governor John W. Martin summed up the spectacular achievements taking place throughout his state by writing, "The sun of Florida's destiny has arisen, and only the malicious and short-sighted contend or believe that it will ever set. Marvelous as is the wonder-story of Florida's recent achievements, these are but heralds of the dawn."[51]

Most of Florida was still freewheeling and riding high when Governor Martin penned those words. While the Northern press was predicting, nay, hoping for a bust (a lot of money was pouring out of Northern banks and heading for the South), Stockbridge and Perry scoffed at the idea that there was, indeed, even a boom going on. After offering the sage advice to "inquire and investigate before investing," they went on,

> *The activity in Florida land, viewed as a whole, is not a "boom" in the sense that prices generally have been inflated beyond actual present values. On the contrary, most Florida property has been sold too cheaply! The underlying stability of Florida, based upon its undeveloped resources, is unshakable and immensely greater than even the people of Florida themselves yet realize.*[52]

Promising words, but time was running out.

Before it did, however, the progressive men (and it was mostly men in those days) were considered local heroes, lauded in the press as town builders whose projects showed their faith in Sarasota.

Beginning with J.H. Lord in the April 5, 1926 edition, the *Sarasota Herald* ran a series, "Builders of Sarasota," on its front page along with a brief biography and an etching by Harry Palmer of some of the men who were making "Sarasota Prosper." Praised for their hard work were bankers, lawyers, real estate men, salesmen, civic leaders—a "complete portrait gallery of the men in the front rank in the work of developing this city."

Probably no one received more press coverage during these heady years than John Ringling, circus king, railway man, business tycoon, art collector and, in Sarasota, developer.

Often pairing with Owen Burns, who conducted a lot of business and construction projects for Mister John when he was away on circus business, Ringling first came to Sarasota in 1911 and moved here in 1912.

Although he and his brother Charles sought in Sarasota a retreat, a haven of rest and relaxation away from the circus, they soon saw the potential of development. John set his sights on the Keys with grandiose plans, while Charles concentrated his own efforts east of town with

his Court House Subdivision, which he platted in March of 1925, offering the county the land on which to build a courthouse. Charles also constructed the Sarasota Terrace Hotel, used today as county offices, and the Ringling Office Building on Ringling Boulevard, just west of U.S. 301.

John's legacy remains strong. His vision and hard work on Lido, Longboat and St. Armands Keys ultimately came to fruition.

Both brothers built magnificent mansions on Sarasota Bay and were involved in all facets of Sarasota's growth and development during the boom period. It was John, through the John & Mable Ringling Museum of Art with its vast art collection and the Ringling Art School, who sowed the seeds of Sarasota's present-day cultural reputation.

When Sarasota fell into the doldrums of the real estate bust, John Ringling's announcement in 1927 (Charles died in 1926) that he was moving the circus winter headquarters here from Bridgeport, Connecticut, was an economic boost and remained a top tourist attraction for the city of Sarasota (the Circus City) until the circus moved to Venice in 1960.

AROUND THE COUNTY

T̲HE TERRITORY THAT FORMED THE county of Sarasota had within it several small villages, each striving to be self-sustaining: Bee Ridge, Fruitville, Miakka, Indian Beach, Sarasota Heights, Vamo, Osprey, Englewood, Nokomis, Woodmere, Venice and Hayden among them.

While most of these were absorbed into Sarasota County long ago and are either forgotten altogether or known as roads—Bee Ridge Road, Fruitville Road, Vamo Road—a few of the others were caught up in the boom and rode the crest while it lasted.

Dr. Fred Albee, an internationally renowned bone surgeon, fell in love with the area around Nokomis and Venice after a visit in 1917. The paper reported that he was so impressed with the beauty there that he decided to build his winter home, Palm Point, a seven-acre estate, in Nokomis.

In March of 1917, Albee and his friend Ellis W. Nash platted the Nokomis Subdivision near Dona Bay and Roberts Bay, adjacent to the Seaboard Air Line tracks. His plans for buying more acreage to develop were put on hold when America entered World War I. Albee was commissioned a colonel and treated wounded soldiers in France for the duration of the war.

After he returned, he began buying up large parcels of acreage and soon owned most of the land in Nokomis and Venice. In 1921 he hired architect Thomas Reed Martin to design the Pollyanna Inn at Dona Bay and replatted the subdivision, adding many new lots.

Albee, considered the "Father of Nokomis," advertised his development as the White City or the Pearl City, as his plans called for all of the homes there to be of white stucco.

As the boom took hold, he sold his Venice property to the Brotherhood of Locomotive Engineers, a union based in Cleveland that sought to increase the money in their coffers by investing in Florida's escalating real estate market. At the time, it seemed a sure bet.

At the peak of the boom, Venice and Nokomis were hyphenated, Venice-Nokomis, and advertised by the Roger Rice Company as "The Magic White City on The Gulf." With thirty miles of luscious waterfront property, Rice said he was building a resort city where it belongs, at Venice-Nokomis, and at the same time, "Growing fortunes for those who have planted."[53]

Rice's ads underscored the frenetic nature of '20s-era real estate. "How does your brain work?" it began, and went on to enlighten *who* made money here: "The way you answer that important question will indicate whether you will succeed in Florida or whether you will fail. Is your brain sluggish or snappy? A quick brain cannot help but win. Do you think in split seconds, or do you lose opportunities by clocking your decisions by the day? You've got to think, and quickly in these days in Florida."[54]

As an example of ever-soaring profits made by those with "snappy brains," *This Week In Sarasota* reported on March 4, 1926: "In 1913 Mrs. Elizabeth Schutt purchased the mainland peninsular north of Casey's pass for $1,500. Last year Mr. Roe sold a portion of it to Louis Polakow for the sum of $15,000. He resold it to Mrs. Edith L. Just for a consideration of $80,000 and Mrs. Just held title to it about one week when it was sold to the Brotherhood of Locomotive Engineers for $150,000."

The E. Beeler Realty Company sold Enchanted Isles, "Florida's Most Beautiful Home sites," in Nokomis. A full-page advertisement appeared in the paper, complete with a pen and ink drawing of a winged fairy standing near palm trees, spreading flowers with one hand and waving a wand over Enchanted Isles with the other. The copy explained Nokomis's potential: "The City of Nokomis is at this time the only city on the West Coast that can truthfully advertise the fact that it is located on the Gulf shores and on a beach second to none, with the finest bathing pavilion that has ever been completed on the West Coast." With home sites fronting Roberts Bay and Donna Bay, the Beeler Realty Company offered to pay the transportation costs from anywhere in the United States for those who purchased a lot there.[55]

Into this exciting land of moneymaking opportunity came the Brotherhood of Locomotive Engineers. Organized in 1863, the Brotherhood was a formidable organization that sponsored large corporate undertakings from its home base of Cleveland. They had deep pockets and among their investments they owned the Equitable Building in New York, then the largest office building in the world. They had grandiose plans for Venice.

Florida Governor Martin welcomed the Brotherhood, telling them, "It is particularly pleasing to me to bid the officers and personnel of the Brotherhood of Locomotive Engineers, that stalwart, brave, big-minded group of men welcome to the State of Florida."[56]

The *Times-Union* of Jacksonville reported they purchased twenty-seven thousand acres and called the transaction, "undoubtedly freighted with potentialities as great as have attended any one transaction ever made in the state of Florida."[57]

The purchase price was put at $3,250,000 with $5,000,000 more slated for development.[58]

It was prophesized that fifty thousand rail men with their families would move there.[59]

John Nolen & Associates of Cambridge, Massachusetts, one of the country's most respected city planners, was commissioned to lay out the community. Prentiss French, a noted landscape architect, was hired on to beautify the area. An early promotional booklet promised that as Prentiss, a Harvard School of Landscape Architecture graduate, had just returned from three months' study of landscaping in Mediterranean countries, "The best that Europe offers in the way of attractive settings for homes will thus be available to residents at Venice."[60]

Nolen said of the project, "Your city here marks the beginning of a new day in city planning, not only for Florida, but for all the country."[61]

The project was heavily promoted within the Brotherhood's organization and to the general public with brochures, booklets and newspaper advertisements. In 1926, James E. Alden wrote a booklet entitled *A New Life of Independence*, which extolled the good life that awaited. An illustration shows a young couple, the woman frowning down at the list of bills her husband has

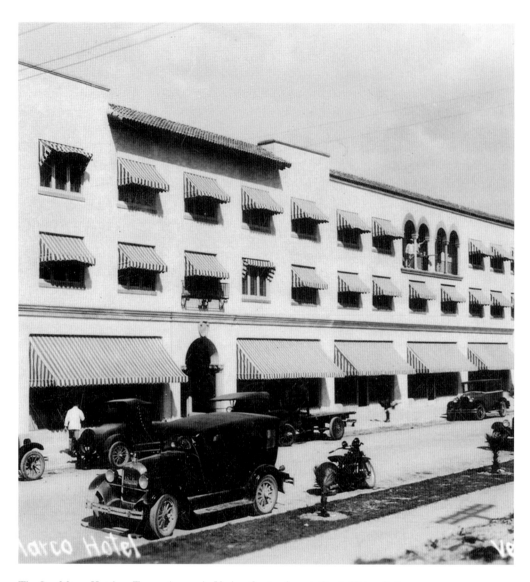

The San Marco Hotel on Tampa Avenue in Venice. *Courtesy Sarasota County History Center.*

to contend with, presumably in their cold Northern home, and notes, "The woman is thrifty but expenses are high where they live. They have to spend money just to keep their places in local social affairs. And this sort of outlay doesn't bring anything at the end of the year. In this book is described a new life of independence for people such as these—people with the energy and keenness to take advantage of the opportunity at Venice."

If any place during this fast-paced era could be said to have had it all, surely it was Venice: beautifully planned and laid out, heavily financed and promoted and desirably located.

As per Nolen's plan, within just two years Venice filled with three grand hotels (Hotel Venice, Hotel Parkview and Hotel San Marco), apartments, a bank, restaurants, parks, lovely northern Italian styled homes and buildings (which had to be approved by the architectural

firm of Walker and Gillette), farms, paved streets, beaches, a golf course, civic center, railway station, the Albee Sanitarium and every other amenity of a successful city. The city was incorporated in 1926.

With the real estate bust, the end came swiftly, leaving in its wake a nearly bankrupt Brotherhood of Locomotive Engineers and what amounted to a ghost town, filled with everything except people.

It was the Brotherhood's sad fate to become involved in Florida real estate at the tail end of the boom. Their hard work and high hopes were all for naught for them, but Nolen's beautifully designed town would be enjoyed by later generations.

Chapter VII.

THE PARTY IS OVER—FOR THE TIME BEING

DESPITE GOVERNOR MARTIN'S ASSERTIONS TO the contrary, indeed there had been a full-blown real estate boom going on in Florida (which would explain the massive influx of new folks and skyrocketing prices) and what better way to measure it than the severity of the bust that killed it?

By the end of 1925 it was becoming apparent throughout Florida that land fever was cooling. The massive hurricane of September 17, 1926, which tore through Miami with destructive and deadly force put the kibosh on any hopes that the lull was not, indeed, the end.

The city of Sarasota did not turn into the ghost town that Venice resembled when most of its citizens just packed up and moved out—some of the houses were left fully furnished. But Sarasota was given an economic body blow from which it would take years to recover.

The slick "binder-boys" left in short order, newcomers slowed to a trickle and advertising for housing developments dried up completely, causing the failure of *This Week in Sarasota* and later the *Sarasota Times*, which Rose Wilson had sold in 1923 to "those who were prepared to enter the field and give the town a better newspaper service than we could." Ultimately the paper would be owned by L.D. Reagin, who located it on today's First Street in the Times Building, currently being rehabilitated by Don Murphy.

The November 22, 1925 Sunday edition of the *Sarasota Herald* had proudly proclaimed on the front page headline, "SARASOTA NOW GREATER CITY," and recounted the "long drive" to extend the borders to sixty-four square miles, the size of "a real city."

After the bust this vast area became too hard for the local economy to handle and in December of 1926 the city belt was tightened to a "more appropriate" seventeen square miles; even that area was difficult to manage for the monetarily strapped government.

A brief flurry of activity occurred when a headline announced that Sarasota might be sitting atop a sea of oil, briefly generating the same hoopla as selling real estate. It proved short-lived, but before smelly sulfur water gushed out of a well on John Ringling's Tract No. 1, twelve miles east of Englewood, the prospect of making money in black gold was hyped as a real possibility.

Once again grandiose ads promising the potential for easy wealth appeared in the Sarasota Herald: "YOU MAY TAKE OUT A BANKROLL," one proclaimed.[62] Although Ringling was leaving the hype to others, Kenneth Hauer, head of the Biscayne Oil Company who was in charge of drilling, offered: "Should oil be found, and we are certain that it will, the first so-called 'boom' will be a gentle zephyr compared to a cyclone." So called?[63]

Baseball great Rogers Hornsby, then in Sarasota for spring training with the New York Giants, was on hand to give out free cigars during the spudding-in ceremony on March 13, 1927. "FIRST OIL WELL TO BE STARTED HERE TODAY," announced the headline of the *Sarasota Herald*.

The *Herald* promised that the roads would be "black with cars" leading to the important ceremony, which was planned to get underway with a signal from Hauer to Hornsby, "ball player deluxe," to release the lever controlling the "big machine."[64]

The attendance for the ceremony was put at five thousand people who cheered wildly as Hornsby broke a bottle of champagne against the drill bit, "after which the mammoth iron bore commenced its journey downward." After promising that work at the well would go on day and night, Hauer closed with, "We believe there is oil here, or we would not be drilling."[65]

The *Sarasota Herald* editorialized, "Florida is not dependent upon the discovery of oil for her future prosperity. Our climate, our seacoast, our soil are our capital. As long as we have these assets, we shall never want for prosperity." It did note, however, "But, if we strike oil, we shall become a world beater for our wealth."[66]

Hauer opened an office at the Mira Mar Hotel and took out a full-page ad in the *Sarasota Herald*. Under a giant headline, "OIL IN FLORIDA," it pictured an Arkansas gusher, "running wild" and offered "3 Ways To Play Oil—Take Your Choice" with a coupon on the bottom of the page to mail in with a check.[67]

Oil fever also spread to Venice. The Community Oil Corporation was formed, composed of locals "having become convinced that there is oil under Florida." They purchased their own equipment and were optimistically cautious: "We do not ask anyone to put their 'meat and bread' money into this proposition but we so feel that the ones who take a chance along with us stand a mighty good chance of becoming rich." They, too, offered a coupon, selling shares for ten dollars.[68]

It was all for naught. Oil never flowed, never even trickled, and soon Hauer was selling the drilling equipment from his office, now in Cincinnati, Ohio, far away from the sulfur water that flowed from Ringling Tract No. 1. Ever the optimist, his for sale flyer noted, "This is a rare opportunity for the right person to start an oil well. All this equipment can be dismantled moved and set up on a new location in a week or ten days—ready for drilling operations."[69]

The lights of Sarasota County dimmed for a while before they went completely out.

As late as 1928 John Ringling prophesized a "prosperous" year, pointing out that "Conditions in Florida are vastly improved and will continue to improve during the new year." He further promised to "carry forward in every way the developments on the islands."[70]

Indeed, after the bust, but before the Great Depression, the community managed to build a brand new Sarasota High School, which was completed in time for classes in 1927.

The school was designed by noted architect M. Leo Elliott in the popular Collegiate Gothic style. Professor J. Claudius Peel from the old high school on Main Street just east of Orange Avenue continued on as principal. The school newspaper, founded by the class of 1923 and published by the class in journalism, was called the *SARA-SO-TAN*. The Sailor's Log, dedicated to Principal Peel, pictured the forty-eight members of the senior class of 1928.

The Sarasota County courthouse is the other memorable building that was constructed after the boom and is still serving us.

The Tamiami Trail Blazers at Everglades City, April 28, 1928. (Standing, from left to right) Ora E. Chapin, Charles Hunt, George Prime, Allen Andrews, Abe Lincoln (Assumhachee), Fred Garmon, seventeen-year-old Milton Thompson, J.P. Gosden, Clark Taylor and Stanley Hanson. (Kneeling) L.J. Duyl, Alfred Christensen, Maurice Beyer, George Dunham, Cycil B. Shawcross and L.A. Aeyr. (Not pictured) C.P. Corrigan, Grover C.V. Hackney, Fred B. Hough, Russel Kay, Frank S. Lewis, George P. Smith, Joe W. Hill, Frank Whitman and Little Billy (Corna Patchee). *Courtesy Sarasota County History Center.*

When Sarasota broke away from Manatee County in 1921, temporary quarters were found for the new county government downtown, where it shared office space in the Hover Arcade, which was then city hall. A facility was built on Oak Street, which soon proved inadequate for the bustling county government.

The Palmer interests had offered free land and seed money if Venice was chosen for the seat of Sarasota County government. They formed the Venice County Seat Committee, headed by T.L. Martin, and promised a free courthouse and a $20,000 bonus if the permanent county seat was located there. However, Charles Ringling's Court House Subdivision, platted in 1925, won out.[71]

The new courthouse was designed in the popular Mediterranean Revival style by prolific architect Dwight James Baum, who came to Sarasota from New York to design the John and Mable Ringling mansion, Ca'd'Zan. Although Baum was hired for the project in 1925, the peak of the boom, the cornerstone was not laid until May 13, 1926, and the building was not completed until the end of that year and accepted by the county in February 1927. It was described as "the most beautiful building south of Washington, D.C."

Another event of major importance to the area was the opening of the Tamiami Trail, the 282-mile route that linked Tampa and Miami. Supporters of the project who helped lay out the route were known as Tamiami Trail Blazers and included George Prime of Sarasota. Work had started on the highway from Miami in 1916, hindered by the woods and the swamplands of the

Everglades with its sharp saw grass, wild animals, alligators, snakes, clouds of mosquitoes and the grueling sun. It was a daunting task and the pace was by necessity slow, averaging two miles a month. After a boost from the support of Baron Collier, it was finally completed and opened on April 25, 1928.

A celebratory journey was made with two hundred cars leaving Tampa to come to Sarasota, where another one hundred cars joined the motorcade for the drive to Fort Myers, where celebrations were held. After spending the night there, "on the following day, the epochal trip across the Trail was made—and the long-dreamed-of route which enabled motorists to 'loop the state' had become an actuality!"[72]

In 1930 motorcycle police patrolling the Trail were told, "Do not molest motorists driving up to fifty miles per hour…warn motorists driving between fifty and sixty miles an hour…arrest ANYONE driving more than sixty miles an hour." The order ended with, "A little politeness goes further in a public officer than any other quality."[73]

A failed venture at another mode of transportation was the desire, during the peak of the boom, for a deep-water port, a la Tampa, Miami and Jacksonville. There was a frenzy of activity to make the dream a reality (given impetus by a railroad embargo), which thereby put Sarasota another step closer to being a "real city." Full-page advertisements were taken out in the *Sarasota Herald* touting the benefits of a harbor for the community's continued growth.

On January 12, 1926, a vote was held regarding the sale of the Sarasota Electric Light and Power Plant, which had been built in 1924. Florida Power and Light had offered $1 million that would be used to finance the harbor project. The proposal passed 471 to 214, and the paper called it "a step forward for the city."

The front page of the *Sarasota Herald* on the day after the balloting showed a huge ship under the caption, "What result of balloting forecasts." Shortly thereafter a deep channel was dredged, the fill of which was used to create the fifty-eight-acre City Island. Only one ship ever came though, and the channel filled back in.

In order to perk up the town, showing signs of post-boom neglect, a group of civic-minded men and women decided they could help brighten up the community and the spirits of its citizens with flowers. On May 6, 1927, they met at the home of Mrs. A.E. Cummer and formed the first circle, known as the Founders Circle. Mable Ringling was elected president and the next meeting was held at the magnificent Ca'd'Zan on November 22, 1927.

Soon other circles were formed—the Bignonia and Tree Circles in 1928, the Indian Beach Circle in 1933. The groups joined together in 1933 and were federated by the Florida Federation of Garden Clubs, becoming the Sarasota Garden Club that continues to beautify Sarasota to this day.

Not long after Sarasota was forced into the doldrums of the dried-up real estate market, it would be faced, with the rest of the nation and the world, with the dire consequences of the Great Depression.

The tone of the Lindsay's *Sarasota Herald* changed dramatically. No more heady claims and bombast so prevalent through most of the Roaring '20s. Optimism was at a minimum as the paper filled with bank foreclosures, property sales on the courthouse steps, suits and countersuits, tax claims, defaults, judgments, receiverships and even suicides. Someone coined the phrase "altruistic suicide": choosing death rather than being a burden on their community or their family.

An early casualty of the bust was the building that had first signaled Sarasota's emergence as a fashionable destination: the Mira Mar property was foreclosed and up for sale to the highest bidder.[74]

Even Ca'd'Zan, the showplace of Sarasota, the site of so many glamorous recitals and evening soirees, the destination of Ringling's rich friends looking to buy property on Ringling Isles, nearly was sold at auction. The sale was prevented only by the death of John Ringling a few days before it was to take place.

One of the most telling notices was an ad taken out by the *Sarasota Herald* itself. Entitled "Let's Keep Him In Sarasota," it featured a wistful looking young man with school books and a cap in his hand and noted, "When you let John or Mary leave the home town—you may have lost a budding Lincoln, Edison, Ford—a 'future great.' Do your part in making Sarasota a better place to live and thrive. Spend your money at home—where your dollar continues to do a hundred cents worth of work for the boys and girls of our own city…"[75]

Regarding the city's financial woes, an editorial on the front page of the *Sarasota Herald* asked "IS IT FAIR?" and railed, "Records of the city show that little more than half of the city taxes assessed for the years of 1926, 1927, 1928, 1929, have been paid." The paper asserted that it was not fair for half of Sarasota's citizens not to have paid their share of taxes, and ended with, "Be fair to your fellow citizen. Be fair to yourself. Be fair to the future of your family and your city."[76]

On July 11, 1930, an editorial demanded, "Let's force them to pay. Let's have that 'day of reckoning' NOW!"

The struggle continued as the infrastructure within the city began to deteriorate, including the Ringling Causeway. When Ringling gifted it to the city it was said, "[There are] no adequate words with which to express our appreciation for this wonderful donation…" Now it was a liability the city could ill afford. Grismer noted that the bridge "was closed to traffic because the wooden planks had rotted—and no money was available to replace them."[77]

Advertisements for housing developments were most conspicuous by their absence and the *Sarasota Herald*, which was begun so auspiciously at the peak of the boom, dramatically shrunk in size. On some days, the entire "Want Ad" section was a single page, and it shared space with "Legal Notices," a Moon Mullins cartoon and "Today's Radio Programs."

Merchants and professional people advertised on a page entitled, "WE BELIEVE IN SARASOTA" and pleaded, "Use Sarasota-made products."[78]

The only respite in the press from a world in a downward spiral were sporting feats, cartoons and advertisements for the movies, which gained in popularity as a ten-cent escape from the day-to-day woe of just trying to survive.

Also big in the news were reports of outlaws such as John Dillinger, Baby Face Nelson, Pretty Boy Floyd and Bonnie and Clyde, and the robberies and shootouts that they were involved in. Not everyone saw them as the terrible felons that they truly were. Their murders notwithstanding, some thought they were robbing from the banks that were foreclosing on "the little guy."

Kidnapping also escalated during these harsh days, the most notable being the Lindbergh baby, with the trial of Richard Bruno Hauptman a regular staple of the nation's front pages.

The local economy was given a minor boost from a building permit issued for the S.H. Kress building on upper Main Street in 1932, the worst year of the Depression. At once nearly fifty men were employed on the project. Illustrating the economic malaise the community struggled with,

the $42,540 cost represented practically all of the building permits issued for the first six months of that year. And that paltry amount was an increase of over 100 percent over the same period for 1931, which totaled only $26,006.[79]

During the opening inspection nearly eight thousand people passed through, taking a look-see. As the store was expected to open before Christmas of 1932 when money for presents was in short supply, the new 5- & 10-cent store fitted the bill for inexpensive gifts.

Also adding to the luster of the downtown area was the Cain Building on Orange Avenue, next to the post office. Designed by Thomas Reed Martin and built for a reported cost of $20,000 by R.S. Cain, it was completed in October 1936 and spaces were leased out by Mrs. Bertha M. Francke, who had organized her own real estate firm. Today, this is the Wilson Building, the law offices of Clyde H. Wilson Jr. (His grandfather, Dr. Cullen Bryant Wilson, practiced medicine in Sarasota from 1907 until he died in 1941 and has the distinction of owning the first car in the town of Sarasota.)

Another boon to the community during the bleak years of the Depression was the arrival of the Tin Can Tourists of America who held their annual conventions here. Organized in 1919 "as tourists who lead their own life," they were welcomed in Sarasota and began setting up their camp around Payne Park.

In 1937, five thousand men, women and children arrived in town, preceded by a parade three miles long with a diverse array of floats that included everything from the landing of Desoto to the "sit down strike" at the General Motors plant in Flint. The caravan was composed of "road yachts to just plain house cars built on outmoded trucks." Their theme song was "Merrily We Roll Along."[80]

Illustrative of the depressed nature of the local real estate, in May of 1937 all fifteen bungalows in Burns Court were sold to twelve residents for a total price of $24,000.[81]

Sarasota residents, though, were luckier than many, especially those suffering up North during the winter months. We had the beaches to enjoy year-round and for those who wanted to (or needed to) there was fishing and hunting to provide recreation and food.

Besides the movies, local diversions included the Winter Headquarters of the Ringling Bros. and Barnum & Bailey Circus and also the annual Sara de Sota Pageant, one of the largest and most colorful festivals in the nation, which drew tens of thousands of spectators.

The pageant was based on a "legend" penned by J.B. Chapline and first enacted in 1916 with J.B. as the "fleet and strong Seminole" Chichi-Okobee, and Genevieve Higel (Harry Higel's daughter) as Sara DeSoto, the beautiful maiden with whom Chichi fell in love.

The story had it that having beheld the lovely Sara, Chichi surrendered himself to DeSoto, her father, "that he might occasionally feast his lustrous eyes upon the orbs of his princess of the house of DeSoto." But the young brave fell ill with Everglades fever—bad stuff. He was at death's door when the eye-popping Sara begged her father to let her nurse the young Indian chief back to health. Lo, "her ministrations wrought a miracle," and soon Chichi was well. But tragically, Sara sickened with the fever, and soon she died. A distraught Chichi gained DeSoto's permission to bury Sara in the most beautiful spot in the world, a bay that would forever be known as Sarasota Bay. Chichi and a hundred braves, in what the politically incorrect legend termed "a wonderful thing," drowned themselves by chopping holes in their canoes so that they could guard her resting place.

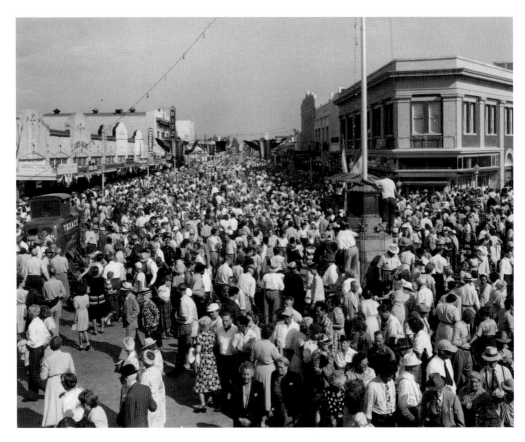

The biggest event of the season for many years was the annual Sara de Sota Pageant. In this shot, the children's parade is about to begin—clear the way! *Courtesy Sarasota County History Center.*

A few thousand people came to Sarasota to witness the first enactment, which was held sporadically until 1935 when the Junior Chamber of Commerce took it over. Through their guidance, the annual event achieved national recognition and rivaled any festival in the South.

The weeklong event varied year by year, but usually included a fashion show, lawn bowling, a shuffle board tournament, social events at the Lido Casino, a frog jumping contest on Main Street and street dancing. A children's parade was a highlight for many area kids and their parents who dressed them in cute costumes and strolled them along Main Street. Included in the celebration was the crowning of the king and queen from the royal court that presided over the activities. Most people, though, came to watch the fantastic parade, which included a vast array of colorfully decorated floats from around the state, marching bands, drill teams, bathing beauties and the Ringling Brothers circus, which showcased its performers, clowns, showgirls and exotic animals—the menagerie moving slowly from the Municipal Auditorium to Ihrig Field at Sarasota High School.

In 1964, the legend of Sara de Sota was replaced by the King Neptune Frolics: the celebration of King Neptune's arrival in Sarasota where he and his "Mystic Crewe" could find respite from the turmoil of Greece. This event ended in 1984.

Venice was given a morale and economic boost in 1932 with the arrival of the three hundred cadets from the Kentucky Military Institute, which brought its academic program to Venice from Lyndon, Kentucky, and returned each winter season. Arriving in Venice onboard their train, the Kentucky Military Institute Special, the dorms and classrooms were set up in two vacant boom-time hotels: the Venice Hotel and the San Marco.

Founded in 1845 and billed as the oldest privately owned military school in the country, their semi-monthly precision drills and colorful parades drew spectators from all over the state. They remained an integral part of Venice for thirty-eight winter seasons until 1970. Declining enrollment forced KMI's closure as a military school in 1971.

A LITTLE HELP FROM OUR FEDERAL FRIENDS

WHILE FOR THE MOST PART Sarasota County had come to a standstill in its growth and development, struggled with keeping teachers paid and schools and bridges operating and the infrastructure repaired, a few bright spots were in the offing.

Traditionally, one of Sarasota's strong suits has been the dynamic leaders who have been attracted here, liked what they found and determined to make the area "grow and prosper."

This was no less true during the dark days of the 1930s as it had been during the formative early 1900s, through the Jazz Age and is still true today.

During the Depression, the guiding forces that managed to obtain some significant projects from the Federal Government's Works Progress Administration program in the mid- to late 1930s included Sarasota's strong, multiterm mayor, E.A. Smith.

Working with an active (as always) Chamber of Commerce and civic leaders and Sarasota boosters such as Roger V. Flory, Karl Bickel, A.B. Edwards, Ralph Caples, Benton W. Powell and Verman Kimbrough, Sarasota landed some construction plums during these hard years, some of which remain today.

At this time Dr. John R. Scully, DVM, was the commissioner of public works, a particularly difficult job during the Depression, and the first project that brought at least some work to Sarasota's unemployed was the repair of the Ringling Bridge. Fifty men worked three days a week for $1.50 a day and were happy to get it.[82]

In 1933, President Franklin Roosevelt's Civilian Conservation Corps (CCC) moved forward, offering a variety of work to the youth of America (ages eighteen to twenty-five).

Eight state parks were established in Florida and A.B. Edwards led the campaign to get a CCC company to establish one along the Myakka River where he had spent many hours hunting and fishing in his youth. Thanks to his persistence, a company of young CCC men, outfitted in olive drab uniforms, known to some as Soil Soldiers or Roosevelt's Tree Army—the CCC members lived in barracks and operated along the lines of the military, rising early each morning to the bugle call—arrived in 1934.[83]

After hot, painstaking and dangerous work, the group, whose members were paid thirty dollars per month (most of the money was sent back home to mom and dad), constructed the visitor center, cabins and picnic pavilions, laid out roads, planted trees, dug ditches and amid mosquitoes, snakes, gators and wild animals under the hot sun completed one of the loveliest parks in the nation. The *Sarasota Sunday Tribune* called the CCC the "Greatest Army In All America," and lauded their effort, which "transformed a tropical jungle into a state park."[84]

The Myakka River State Park, Florida's largest land state park with 28,875 acres, was officially dedicated on February 18, 1941, and opened to the public on June 1, 1942.

Programs of Roosevelt's Works Progress Administration (WPA) were of inestimable value to Sarasota County. For a community starved for good news, the groundbreaking, completion and opening of each WPA project was decidedly a morale as well as economic booster and was followed closely in the press.

On October 23, 1935, an appropriation of $2,974 put forty men to work draining the Bobby Jones Golf Course.[85]

A small beginning, but more money and larger projects were soon to come.

The Municipal Auditorium

Mayor E.A. Smith is given credit for the idea of a bay front park and a Municipal Auditorium and he worked diligently for a grant for that purpose from the federal government.

For $15,000 owed in back taxes, the city purchased a thirty-seven-acre tract on Sarasota Bay, property that had been slated for a hotel during the boom years.

In order to get the backing necessary to apply for the grant, Smith enlisted the financial help of Benton W. Powell, Samuel W. Gumpertz, Karl A. Bickel, John Somerville, J.J. Williams Jr., Felix Jackson, Ralph C. Caples, George L. Thacker, R.P. Hazzard, Prince Michael Cantacuzene, Harley Crane, Frank Logan, Harry Kellim, George D. Lindsay, Ray Richardson, Frank Evans, Clyde H. Wilson and William G. Selby. The men met at the home of Karl Bickel to work out the details. Ultimately the government put $131,000 into the project in two grants, the first for $114,000 and the second for $17,000.

Mayor Smith promised that when the project was completed it would "include every known form of recreational facilities.[86]

The Auditorium is a cavernous 200 by 250 feet offering 50,000 square feet of space. Bragging of its sturdiness, the *Sarasota Herald* reported that "whereas it can withstand winds of 120 miles per hour, it will be able to withstand greater than 300 miles per hour winds."[87]

The Auditorium opened on February 24, 1938, in time to be the staging area for the Sara de Sota Pageant. Three thousand revelers were on hand for the festivities.[88]

The formal dedication was held on January 9, 1940, with a program under the direction of Recreation Director Charles L. Herring.

This was Mayor Smith's dream. He told the *Sarasota Herald*, "A man rarely sees a dream come true, but this building, this plan and this land means to me that a dream has come true."[89]

Smith called the civic center "the finest in Florida" and claimed, "the full use of its splendid facilities should add much to the enjoyment of a stay in Sarasota." He rolled the first ball on the bowling greens, launching a contest between Sarasota and Lakeland.[90]

The grounds were beautified by the Garden Club and the ornate water fountain, designed by Frank Martin (Thomas Reed Martin's son) was donated by shoe manufacturer R.P. Hazzard, a winter visitor from Gardner, Maine. It was said to cost $8,000.[91]

At the rear of the Auditorium, the Chidsey Annex was added, donated by John T. Chidsey. Chidsey also donated funds for the Chidsey Library building, a Junior Chamber of Commerce

project, located just south of the Auditorium. The library committee was made up of A.H. Bayless, chairman; Donald MackIntosh, McCoy Harmon, Lamar Dozier, Frank Lane and J.L. Sanders.

The library was operated by the Woman's Club from 1914 until 1940, when it was taken over by the city. Until 1932 the collection was housed in their clubhouse building and was then transferred to the old Sarasota High School on Main Street.

The new library was designed by the Martin Studio and built by local contractor J.W. Harvey Sr. Billed as "as modern as tomorrow," it was dedicated on November 13, 1941.

By 1955 the *Sarasota Herald-Tribune* noted that the library offered over thirty thousand volumes and reminded that "a library in this city of authors, painters and other artists is a necessity." The chief librarian then was Mrs. Charles A. Service, "energetic and efficient," assisted by Miss Margaret Mudge, Mrs. Dorothy K. Pritchard and Mrs. James Neel.[92]

In 1959 a new addition doubled its space and Marie Selby donated $2,500 to purchase new books that would be of interest to young people.

Today this building houses the Sarasota County History Center but plans are afoot to move the History Center because it lies in a flood zone and could lose its priceless collection of historical photos and artifacts in the event of a hurricane.

For his "benefactions" to the city Chidsey was named Sarasota's most outstanding citizen for 1941. The *Herald-Tribune* called the honor "eminently fitting" and lauded Mr. and Mrs. Chidsey, noting "that he and his estimable wife have won the hearts and esteem of all our people."[93]

In 1948 the Civic Center grounds were enhanced by a replica of a Spanish fort, named after Juan Ortiz, an associate of DeSoto. It was complete with a sentinel, breastworks and cannons, including a five-hundred-year-old Chinese cannon, a Philippine cannon, a cannon used to defend New Orleans and field artillery from World War I. Most of the material was gathered by Karl Bickel and for a time the area also displayed a P-38 fighter plane, a tank and a French railway car.

The auditorium was modified in 1971 with the addition of a new front façade designed by Sarasota School of Architecture architect Jack West. It was renamed the Civic Center Exhibition Hall, dedicated on October 23, 1971, and continued as before, housing various events as it still does to this day.

However, in 1987 there was talk of razing the grand old building and replacing it with a convention center, a proposal renewed in 2005. Fortunately the community rallied against the plan; they would have none of it.

The Auditorium was restored to its previous Art Deco/Moderne grandeur; the first phase was completed in 1993 under the auspices of architects Gary B. Hoyt and Jeff Hole and remains a strong and prominent link to our past, still bringing the "pleasure and happiness," as Mayor Smith prophesized it would in 1940.

The Lido Casino

The Lido Casino was to be the answer to the marked decrease in tourism during the long and slow summer months. On May 18, 1936, the Chamber of Commerce Committee to Create Summer Business voted to take up with the city council the matter of Roger V. Flory's suggestion of securing a municipal bathing beach.

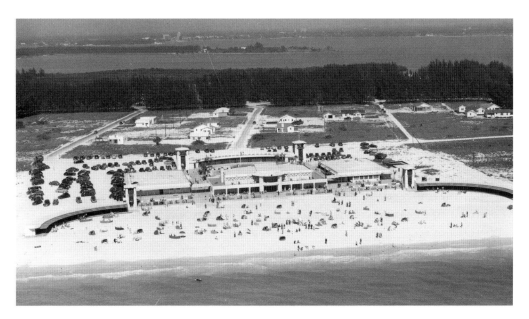

The storied Lido Casino, Sarasota's lost treasure, demolished in 1969. *Courtesy Sarasota County History Center.*

The site chosen was a 1,300-foot stretch on the sugar white sand of Lido owned by the estate of John Ringling, then under the control of Ringling's nephew and co-executor, John Ringling North. North and Mayor Verman Kimbrough, president of the Ringling Art School, worked out a proposal wherein the city would buy the property from the estate for $35,000, which would immediately be paid back to the city for delinquent taxes.

In 1937, the chamber and the city council decided to pursue the construction of a municipal bathing pavilion and thus the seed was sown for what would become the fabled Lido Casino.

This would be another WPA project with many of the same civic leaders involved who had participated in obtaining the Municipal Auditorium, Flory, E.A. Smith and Karl Bickel among them.

The building was the design of the "grandfather" of the Sarasota School of Architecture, Ralph Twitchell, whose drawings of it very much resembled an earlier preliminary sketch by local architect Albert Moore Saxe. These sketches had been presented to the Sarasota Chamber of Commerce and were called "Sarasands." Saxe's version was pictured on the front page of the *Sarasota Herald* on February 6, 1938.

However, it was Twitchell's plan that was chosen and his rendering of the Lido Casino appeared in the *Sarasota Herald* on July 20, 1938. Like Sarasands, it was a memorable structure, very different from anything Sarasota had ever seen.

Wilson Stiles, former director of the Sarasota County Department of Historical Resources, said of it,

> *The construction of the Lido Beach Casino was one of Sarasota's greatest civic achievements....Not only was this dynamic complex an important public amenity, it was a most extraordinary architectural landmark. If it were still standing, it surely would be recognized nationally, if not internationally.*[94]

When the call went out to the community asking for subscriptions of $40,000 to match the WPA grant, the chamber explained the rationale for the project: "By developing summer and winter business alike, the beach project will transform Sarasota into an all-year city, setting up a 12 month standard for business. Then and only then can our young people expect post-graduation jobs in Sarasota."[95]

The Casino was first opened to the public on Thursday, May 23, 1940, and thousands of happy citizens swarmed to what was then being touted as the $250,000 Lido Beach Municipal Casino.

Originally managed by Parks and Recreation director Charlie Herring, the building was soon leased by F.E. Price, who spent thousands of his own dollars decorating and outfitting the entire complex.

The grand opening was a suitably festive affair with dignitaries from throughout the state on hand to offer city officials their congratulations. Rudy Bundy, a nationally known bandleader, was hired to provide the dance music.

The Casino immediately became an oasis of beach fun, a favorite gathering place for locals and tourists. During World War II it became a haven for soldiers training at the nearby bases.

Over the years, countless photographs were taken of its signature second-story sea horses, staring stoically into the distance of the Gulf of Mexico.

There was much to do at the Casino for people of all ages and incomes, as it offered a little bit of everything: hamburgers and hot dogs to steak dinners; cokes and French fries to martinis with olives; dancing the evening away to sitting on the second-floor terrace watching the crowd; swimming meets, gymnastic events, karate lessons, bridge parties, political rallies, prom dances, etc.

Post Office

In June of 2003, the Federal Building at Orange Avenue and Ringling Boulevard reopened after a reported $3.5 million was spent on purchasing and restoring it by the City of Sarasota. In a city that had lost much of its identity, it was money well spent.

Mayor Mollie Cardamone said that the building would provide space for city workers and "help restore [commissioners'] reputation for saving historic buildings."[96]

After suffering numerous problems with the renovation of the Van Wezel Performing Arts Hall, City Manager Michael McNees assured the city commission, "I promise this will be the most closely scrutinized $3 million renovation in the history of Sarasota."[97]

The architectural firm of Barger & Dean Architects along with Kraft Construction handled the project using the original drawings.

The Classical Revival building was designed by nationally known architects George Albree Freeman and Harold H. Hall, cost $175,000 and was opened in November of 1934.

The *Sarasota Tribune* called the new building with its columns and intricate design work, "Another Milestone On Road To City's Civic Improvement." At the dedication, Postmaster General James A. Farley stood on a platform, surrounded by flags, bunting and state and local dignitaries, as well as hundreds of local citizens. Introduced as "the right hand man of the president," he gave a

rousing speech, declaring that "he was delighted to be in Sarasota," and as he had seen so many people from his home state of New York, "he felt right at home."[98]

Farley had been given a hero's reception when he arrived at the Seaboard Air Line Railway station at Main Street and Lemon Avenue. He was met by a welcoming delegation, including L.D. Reagin, Sarasota's postmaster and former owner of the *Sarasota Times* newspaper, and taken to the Sarasota Terrace Hotel. Soon cadets from the Kentucky Military Institute, stationed in Venice during the winter, paraded in front of him for his review. Then a Ringling circus elephant, the symbol of the Republican Party, named Mae West was led past, bearing a large sign, "I'm all alone—come up and see me sometime." The joke, it was said, "created no end of merriment for the postmaster general."

Today the building, reflecting a bygone era, houses city offices and stands as a testament to the wisdom of preserving the past for future generations.

The Sarasota and Venice Airfields During World War II

As we have seen, there was not much to cheer about in the late 1920s and into the 1930s, but some excitement and optimism were offered when Sarasota opened its first Municipal Airport. Just as the opening of the first railway station in 1903 had signaled a rung up the ladder of progress, so too did our first airport.

Located across from the entrance to the circus winter quarters on Oriente Avenue (today's North Beneva Road), the sixteen-acre tract was given to the city by Ralph C. Caples and A.E. Cummer.[99]

Airplanes, and the feats and derring-do of the men and women who flew them, were front-page material in those days and air records were being broken in speed, distance and altitude; wing-walker daredevils made crowds gasp and, as today, plane crashes were page one news.

On January 12, 1929, planes from around the country were invited to test Sarasota's new landing field and excite the expected crowds with "the zooming of motors, the swishing of wings and gyrations of planes high in the air."

A show of stunt flying and airplane races was part of the program, which the *Sarasota Herald* assured would be an important event in the history of Sarasota. The celebration would announce to the world that the "city has taken its proper place in the category of cities that stand for progress."[100]

Always hoping that such an affair would bring newcomers to Sarasota, the Chamber of Commerce prophesized that after the two days of celebration, the pilots would "carry the news of Sarasota's beauties, advantages and resources…to different parts of the nation."[101]

Ultimately National Airlines brought air service to Sarasota, but during the rainy season the landing strip became too muddy to use safely and for a while Sarasota was cancelled out. National wanted a modern runway.

Officials from Manatee and Sarasota Counties joined to find a suitable tract of land and formed the Sarasota-Manatee Airport Authority. The new airport on 160 acres of property was started in 1938, another WPA project, employing 225 Manatee County workers and 74 Sarasota County workers.

At the outbreak of World War II, the U.S. Army took over the project and finished its construction for use as an Army–Air Force training facility.

Florida became the home for numerous air-training bases. The climate allowed year-round training and, compared to many other states, the population in many areas was sparse.

At the beginning of World War II, two bombing sites and a gunnery range were established in Sarasota County. Pilots practiced with bombs containing black and white powder, dropped in concentric circles that produced large clouds on impact.

The Ninety-seventh Bombardment Group was the first to use the Sarasota Army Air Base, but the field soon proved inadequate for the large B-17 Flying Fortress, and in the summer of 1942 the field was turned into a fighter base.

In Venice, with a population of approximately five hundred citizens at the beginning of the war, the Venice Army Air Base eventually swelled to six thousand trainees, which had a dramatic economic impact on the community. Add to the newcomers four hundred Chinese soldiers of the Fourteenth Chinese Service Group, there to train for logistic and maintenance support of combat units in South China.

In February of 1945, two hundred German prisoners of war were sent to the base, used in construction, cleaning, renovation and kitchen duties. They followed a policy of "no work, no eat."[102]

As there was no military hospital within the vicinity, Dr. Fred Albee authorized the use of his private Florida Medical Center for the military.

The troops had their work cut out for them. In preparing the field, they lived in "hutments," half-wooden buildings half-tent, and had to pull stumps, weed and do general cleanup.

The first group to arrive was the Thirty-seventh Service Squadron, Twenty-seventh Service Group on July 7, 1942.[103]

In June of 1943, the base became a finishing school for fighter pilots. Trainees were introduced to P-39s, P-47s, P-40s and the P-51 North American Mustang, the plane that accompanied the B-17s on their raids over Germany later in the war, greatly enhancing the safety of the bomber crews by warding off German fighter planes.

The Venice Base continued in full service until August 1945. By November, its population had been reduced from six thousand personnel to four hundred. The base closed in early 1946.

The servicemen in Sarasota and Venice were warmly received and cared for by the locals, many of whose own sons and daughters were in far-off parts of the nation, sick for home and hopefully being cared for, wherever they were, until they were shipped overseas.

While the ratio of servicemen to locals was not as significant in Sarasota as in Venice, they were still an appreciable presence in the community, and their numbers swelled when soldiers from the surrounding bases took their leaves here.

A Service Men's Club opened in a building at the end of Sarasota's city pier and offered the boys light refreshments, card games, ping-pong, music and fishing equipment, and found for them free meals and lodging when necessary. (During the summer, a "master size" electric fan cooled them down—in one way at least.)

The Municipal Auditorium was pressed into service as the Sarasota Army and Navy Club. The spacious, nay cavernous, interior of the Quonset-shaped building allowed for a boxing ring, dances, areas to write home and a library.

The real action for soldiers on leave was either at the Lido Casino, practically brand-new, or downtown where the watering holes filled with uniformed men looking for un-uniformed women.

Particularly popular was D.C. Ashton's The Manhattan on lower Main Street, which catered to soldiers at the Bar of Defense, "Where Fun Begins," featuring fifty-cent cocktails with wartime names: Victory V, Air Raid and Depth Bomb.

Buses ran from Five Points back and forth to the air base and the happenings in town were advertised in Rex Kerr's *Air Field Eagle*.

Not all leave-taking was focused on fifty-cent cocktails. The Ritz and Florida Theatres featured first-run movies. Hollywood turned out a massive number of propaganda films to keep reminding why we were fighting; even cartoons caricatured the enemy as evil-doers and buck-toothed buffoons.

Also downtown, the Sarasota Bowladrome was popular and bowlers could "bowl for Vim, Vigor, Vitality and Victory and cool off with a 10 oz. Draft Schlitz for 10 cents."

When the Ringling Brothers Circus was in town, the Winter Headquarters drew many soldiers on leave, as did Texas Jim Mitchell's Reptile Farm and the Sarasota Jungle Gardens.

Unfortunately, but not unexpectedly in the segregated South, black soldiers were not welcome at either the Army-Navy Club, the Service Men's Club or at any of the places their white counterparts headed for rest and relaxation. The African American community pulled together and provided their own club at the Newtown Community Center, staffed by volunteers who offered some respite and a place to get away from the daily grind of training. Of course there was no "master-size" fan to cool them, nor access to fifty-cent Depth Bomb cocktails.

It's impossible to say how many young servicemen who were stationed in this Gulf Coast paradise during the war years returned, but many did; the memories of their short stay here was the stuff of retirement dreams.

LOST TREASURES

A LONG WITH REAL ESTATE BOOMS, indeed, chiefly because of them, the loss of landmark buildings is another thread that runs throughout Sarasota's history.

In its premier edition, the *Sarasota Herald* ran a photo of Sarasota's first hotel, the one built by John Hamilton Gillespie as the DeSoto Hotel. Once the pride of the community, it had set Sara Sota apart from the other villages within Manatee County, giving the fledgling community a destination for its first snowbirds.

Adjacent to Sarasota Bay and the pier, the thirty-room, three-story hotel, with its observation room, was painted Flagler Yellow in hand-tinted postcards and was perfectly situated for the many fishermen who came to Sarasota in the early years; often their large catches were strung in front to photograph for bragging rights.

The hotel was renamed the Belle Haven Inn in 1899 and was enlarged in 1911 to sixty bedrooms and a forty- by fifty-foot dining room that could accommodate 150 people. Its walls were painted "a very light pink while the ceiling is done in light green."[104]

The *Sarasota Times* also noted that "the halls and rooms are protected with numerous fire hoses and buckets, while in the rear is a large fire escape." One of its two parlors had an upright piano for entertaining guests and a smoking room on the east side of the hotel was "arranged with an eye to comfort those that like the soothing effects of tobacco."

Twelve of the rooms offered a fireplace "which adds greatly to the coziness of them," and were furnished in black walnut with large closets offering hooks and shelves for hats. Other rooms were outfitted with brass beds and white chairs and dressers, with either wallpaper or were "tinted, in some harmonizing color."

Twenty rooms had private baths and a telephone was available in the manager's office, "which connects with all the lines in the south." The elevator was for freight, "but as the stairways are wide this causes no inconveniences to the hotel guests."[105]

As would be true for many years in the local hotel business, the names of guests, their home towns and, often, their occupations were published in the paper, as were accounts of the hotel's festivities and parties: "The Musicale given by Mrs. George L. Whipple at the Belle Haven Inn Friday evening was most enjoyable." Additionally, "Mrs. Smith later in the evening gave the piano solo, 'Sweet Genevieve,' a gem of her own composition." The guests were also treated to a vocal solo of "Calvary" by Reverend W.F. Allen of the Methodist Church, "and in response to encore [sang] 'Rocked in the Cradle of the Deep.'" The night ended with a piano solo by Mrs. Hebler and F.A. DeCanizares's rendition of "The Lost Chord" and "Anchored."[106]

Simple times and simple pleasures. By the Roaring '20s, tastes had changed dramatically both in entertainment and accommodations. Modern and more comfortable hostelries were

required during the Jazz Age, leaving the antiquated hotel vulnerable. With the '20s land boom, the property on which it stood was more valuable than the building, a fact of life we often hear in 2005.

When the *Herald* ran its story under the headline "OLD LANDMARK DOOMED" along with an article about the history of the community, there was no hue and cry to save the building. Simply, it was a victim of progress and in its stead the site would be the home of Sarasota's third, and for a time, last downtown skyscraper, the American National Bank Building, another symbol of the city's newly found prosperity.

The nine-story replacement of the Belle Haven Inn would, years after the bank folded with the Depression, become the Orange Blossom Hotel, a Sarasota landmark that was saved from destruction by local developer Jay Foley, who said of it, "I see this building becoming a classic part of Sarasota history." Foley had the foresight to see it as a bridge between Sarasota's past, its present and future.[107]

Unfortunately, Foley's vision of saving yesterday's Sarasota for future generations—he also had a hand in saving the Hotel Sarasota building and the Gator Club—has been the exception as the old has often been razed to make way for the new.

The Lido Casino

One of Sarasota's most heartfelt and significant losses was the Lido Casino on Lido Beach. Although it stood for only twenty-nine years, the Casino has become the focal point of memories of the good old days in yesterday's Sarasota; its loss universally felt by those who enjoyed it, as well as newcomers who admire photographs of it and wonder why such a dramatically beautiful building that offered so much to so many locals and tourists was razed.

By the late 1950s it was becoming obvious that the Casino was losing some of its luster. Revenue was dropping, and improvements needed to be made. In an article for *The News*, A.J. Ruttenber reported, "…the Casino is not quite up to the plush atmosphere which is beginning to penetrate Lido." Further, it was giving the city a headache. *The News* later editorialized, "Evident everywhere are signs of deterioration of this once famous Sarasota landmark. Cracked walls, flaking paint, sidewalks and roof areas badly in need of repair." It called the Casino "…a second rate advertisement for any city, let alone a proud one like ours."

Help seemed to be in the offing on December 8, 1964, when the citizens voted a $250,000 bond issue to "remodel, modernize, and improve the Lido Beach Casino and provide facilities suitable for conventions."

But time dragged on and despite press reports that it was going to come back bigger and better than ever, the Casino, the voters of Sarasota notwithstanding, was razed on February 13, 1969.

Jack Betz, who had been a lifeguard at the Casino pool and was a former city commissioner and mayor, told me in an interview in 1992, "The people voted to remodel it. We didn't do that and I think it was wrong—I still think it was." He was the only commissioner who voted against the destruction of the Lido Beach Casino.

The Mira Mar Hotel

I have previously noted the importance of the Mira Mar Hotel to the success of Sarasota as a destination for wealthy snowbirds during the Roaring '20s.

Located on South Palm Avenue, by the 1970s the hotel, once called "the Gem of the West Coast," was showing signs of neglect with the *Sarasota Herald-Tribune* warning, "Mira Mar Hotel In State of Decay."[108]

After its glory days, the hotel was in litigation for nearly twenty years, changed hands several times (it sold for $115,000 in 1949 and $250,000 in 1955) and closed in April of 1957 as tourists sought out beachfront accommodations.

Enter Charles S. Lavin. Known as the "Hilton of the retirement hotel industry," Lavin had a string of retirement hotels that were described as "the answer to the prayers of thousands of low-income retired people caught in the upward spiral of living costs."[109]

At the time he bought the Mira Mar, Lavin owned the Manatee River Hotel in Bradenton and the MacArthur Beach Hotel in Venice, plus twelve other hotels around the country. His plan, which was featured in the *Reader's Digest*, offered inexpensive rates in a hotel setting free of the restrictions encountered in institutions—"excellent housing at low rates for low-income groups."

The only requirement to be a guest in a Lavin hotel was a doctor's certificate of good health. Otherwise it was operated just as any other hotel, with the guests volunteering to do some of the chores. "Belonging was the key word in Lavin's philosophy."[110]

After Lavin retired in the 1970s, the hotel began to deteriorate. Philip Koch, administrator of the Building and Zoning Department for the City of Sarasota, notified the owners of the hotel, the Manor Hotel Corporation of Florida, that because of "substandard conditions," fifty-five vacant rooms "shall not be occupied," and that as rooms became vacant, could not be re-occupied.

The letter noted, "We believe after much discussion, phone calls, and even waiting for a new prospective buyer that supposedly was interested, that sufficient time has expired to correct the deficiencies." The company was given ninety days to comply or the "Certificate of Occupancy for the entire structure will be withdrawn."[111]

A group headed by James A. Richardson was formed to "recapture [the] splendor" of the old hotel; the "Return To Splendor" theme was adopted by the John Ringling Center Foundation twenty-five years later in the fight to save the John Ringling Towers.

Richardson and his group sought protection for the hotel, still an apartment complex for the elderly, by having it listed in the National Register for Historic Preservation. This would allow them to apply for federal grants to defray the estimated $250,000 to $400,000 it was expected to cost to bring the hotel back to its original luster.

A petition generated support for the hotel and Mayor Ron Norman was all for the hotel's rehabilitation, saying, "I don't think it's wise for a community to be stripped of its heritage."[112] Downtown merchant Jay B. Starker said there was "overwhelming support" to save the building.[113]

The hotel was sold to Melvin Weintraub of Yonkers, New York, and Lewis Conti of Mira Mar Associates for $840,000. Their plan called for a "mixed-use" complex of residential, office and retail.[114]

Unfortunately, the "overwhelming support" noted by Starker is not necessarily a requisite for saving landmark buildings in Sarasota. On December 30, 1982, a photo spread by Glenn Trout in the *Sarasota Herald-Tribune* entitled, "From Radiance To Rubble," showed the backhoes busy at work razing the "50 year old decrepit building to make way for a $25 million complex that will include twin 17-story towers."

The twin towers plan was never realized. An 85,000 square foot, multilevel parking garage was constructed where the hotel had been and the Mira Mar Apartments were incorporated into an office/retail complex called the Mira Mar Palm Centre.

The complex went into foreclosure in 1987 and was bought by Thomas E. Lewis of Lewis Property in August of 1987 for a reported $6 million.

In 2005 it remains a popular and unique stretch of restaurants, art galleries and chic shops.

The Hover Arcade

Until U.S. 41 was rerouted along the bay front, city hall and city pier could be accessed by following Lower Main Street through the archway of the Hover Arcade and onto the pier, which provided car parking and slips for boats to dock. Charles and John Ringling often anchored their yachts there.

Neo-Classical in design, it was a lovely tan brick building with a red tile roof. It had once been the site of Dave Broadway's Restaurant, a popular gathering place during Sarasota's formative years. On one side of the building flicks from Universal films were shown in the Lyric Theatre, and in 1921 the city fire department was headquartered there, as was, temporarily, the newly formed Sarasota County government.

It was built in 1913 by the Hover Brothers: Dr. William E., J.O. and Frank B., who wintered with their families in Sarasota from Lima, Ohio. The group was known locally as the Hover Colony. They had purchased the dock from Harry Higel in 1911 and began making improvements on it. (Much to his credit, Dr. Hover had once said that he would not present a bill for his services if it would render the patient or his family a hardship.)

The city acquired the building and dock in 1917 for $39,581.34. In 1905, Higel had offered the property to the city for $1,500, but they demurred. Five years later, he offered it again for $5,000. Once again the city declined. Finally he sold it to the Hover brothers for $12,500.[115]

The building with its signature towers and inviting archway became a symbol of Sarasota: it was the logo on city government stationary and for many years was a bridge between generations, a tie to yesterday.

For a time the Chamber of Commerce had an office there and another tenant, J.C. Cash, whose son Joe was the World Champion Water Skier in the 1950s, offered skiing lessons. Sadly, Joe Cash was killed in a car and train collision in July of 1967.

During World War II, the Enlisted Men's Service Club was in one of the buildings at the end of the pier. Later a diving board was installed, offering quick entry into the water.

Some city staffers recalled lazy summer days when they could drop a fishing line into the water from their office windows.

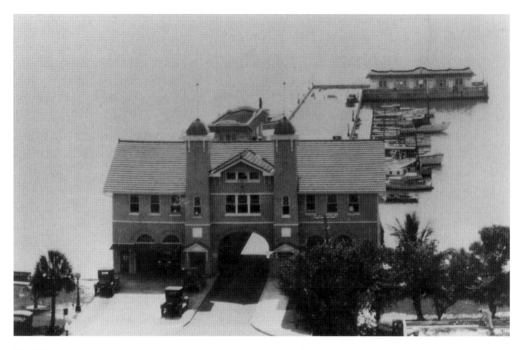

The Hover Arcade, for many years the location of city hall. *Courtesy Sarasota County History Center.*

By the end of the 1950s, it was apparent that the quaint building could no longer serve the governmental needs of a burgeoning city.

In the bond referendum of 1964, the one that requested $250,000 to renovate the Lido Casino, the city printed a pamphlet explaining the amounts of money requested and uses for the various bond issues it was putting before the voters. The Hover Arcade, looking its worst, was stamped "OBSOLETE." It had outlived its usefulness and had no future in modern Sarasota. There was no call to save it, no petitions were passed around. OBSOLETE, an anachronism in a downtown Sarasota "going modern." The Hover Arcade was demolished in September of 1967.

The War Memorials

One would hope that a memorial to the men and women who fought and died for their country would, by definition, be permanent. In fact, paying homage to the honor of our soldiers, sailors and marines has always been a strong suit for grateful Sarasotans who never failed to answer the call to arms and rally around their flag.

But the well-meaning intentions of one generation have not always been taken up by the next.

Probably the most noteworthy example of the failure to maintain the good intentions of grateful citizens were the Memorial Oak trees that lined both sides of Main Street, east from Orange Avenue.

After World War I, when Sarasota's boys came home, a sign was painted in the center of upper Main Street near Five Points, "Welcome Buddies," and the stretch of Main Street

east of Orange Avenue was renamed Victory Avenue. To further honor the young men of Sarasota who had fought in the "war to end all wars," a grateful community, headed by the Woman's Club, decided to pay tribute by planting an oak tree, one for each of the 181 men who had fought the good fight. Their gesture was done for love of country and to demonstrate their appreciation for the services of the gallant young men who helped make the victory possible.

At the dedication of the trees in 1922, Woman's Club President Mrs. Frederick H. Guenther promised that the memorial was "an avenue of living trees, whose beauty and grateful shade would delight and bless generations long after you had passed on."

By 1954 the trees, indeed, had grown full and lush, and for some that was a problem.

Leaders of Sarasota, always pushing the city forward, determined that the trees were standing in the way of progress. Ken Thompson, the city manager, told a reporter, "The presence of trees along Main Street has undoubtedly curtailed development of the city's main street as a business street." A city commissioner was more blunt: "It's either the oaks or progress."

Not all agreed, and the battle was enjoined. Did shade trees impede progress? Some members of the community thought not. Civic leaders Karl Bickel and his wife, Madira, international travelers, he being the founder of United Press, reminded that such grand cities as Rome and Paris had trees along their boulevards and were proud of them. Madira, former president of the Sarasota Garden Club, said that city beautification was as important to civic progress as new street lights and swimming pools.

The battle turned into a full-fledged war. Friends of Friendly Oaks was formed and waged a campaign to save the trees. Petitions were signed, money collected, commissioners were lobbied. *The News* editorialized strongly in favor of their salvation.

An expert from the University of Florida was called in and pronounced the trees healthy. He said that removing them would be foolish.

The president of Maas Brothers Department Store, Jerome Waterman, promised that ten oaks bordering the site of a new Maas Brothers would be spared. *The News* thanked him by saying he had "earned the gratitude of the entire community."

On January 7, 1955, the first oak was felled to "the unfeeling axe of progress" and the Friends of Friendly Oaks asked, "Can the will of a few rob Sarasota of its heritage, its lovely avenue of shade trees? Will the center of Sarasota be left to broil in the blazing sun like a factory town?"

But in the end, one by one, the trees fell, and the memory and sacrifice of 181 of Sarasota's brave soldiers was forever dimmed by their loss.

In 1954 one of Sarasota's most treasured and visible landmarks, the American Legion Bay Post 30 War Memorial at the center of Five Points, was moved away.

Originally, the memorial had been a simple flagpole with a Stars and Stripes fluttering in the very heart of downtown Sarasota. In 1928, the tenth anniversary of the armistice that ended World War I, an eight-sided monument of cut stone designed by architect Clare C. Hosmer was unveiled. Standing approximately ten feet tall and weighing fifteen tons, it was bedecked with carved stone fish and eagles. Attached to it was a flagpole and a traffic signal that directed cars around Five Points.

The Sarasota Bay Post No. 30, American Legion Memorial Monument was designed by architect Clare C. Hosmer and dedicated at Five Points "with appropriate exercises" on November 12, 1928, the day after Armistice Day. It was moved to Gulf Stream Avenue in 1954. *Courtesy Sarasota County History Center.*

The countywide celebration was a two-day affair with a rousing parade before thousands of spectators. Proudly marching down Main Street in separate divisions were veterans from the Civil War, Spanish-American War and World War I. They were joined by the Daughters of the American Revolution, United Daughters of the Confederacy, numerous fraternal and social organizations, local dignitaries, bands and Boy Scouts.

After the "Star Spangled Banner" and "Onward Christian Soldiers" were sung, the poignant poem by Lieutenant Colonel John McCrae of the Canadian army, killed in 1918, was read: "In Flanders field the poppies blow between the crosses row on row…"

No Sarasota servicemen were killed in battle during World War I. Horace Mink, who did not return, had died in a stateside hospital.

In 1937 after a suggestion that the memorial be moved out of the way, Dr. Jack Halton, longtime civic leader, intoned to the *Sarasota Herald*, "If it [the last war] ever does [come], when the smoke of the last battle is cleared away…shining out in God's dear sunlight, I pray that the citizens of Sarasota will see the Stars and Stripes waving at the top of this flag pole, right where we put it."

We were, sadly, far from our last war.

After World War II plaques honoring Sarasota's fallen men and women were added, giving the memorial more significance. Since it was located for all to see, it served as a constant reminder of their sacrifice.

In 1954, the state road department declared it a traffic hazard, and it was rolled down lower Main Street to Bayfront Park at Gulf Stream Avenue, where, out of sight, out of mind—except on Memorial Day—it has remained, with the addition of names of the fallen from the Korean War and the Vietnam War and most recently the war in Iraq.

Later the memorial was modified. The flagpole was removed and in its stead, the statue of a doughboy was attached. The park upon which it sits was renamed to honor the Reverend J.D. Hamel, town chaplain who had been a combat soldier during World War II and who had participated in many memorial services, playing taps and giving invocations for those Sarasotans who had fallen in battle.

In 1943 the Founders Circle of the Sarasota Garden Club appointed a committee to determine a suitable memorial to honor the men and women of Sarasota County who were overseas fighting in World War II.

Mrs. Edward W. Pinkham, who chaired the committee, came up with the idea of Honor Parkway; a living memorial of lovely Cocos Plumosas trees on Bayfront Park, south of the Municipal Auditorium to honor both those who would be lost in battle as well as those who would be lucky enough to return home.

On a bright January day in 1947, the community came together, joined by the American Legion, the AMVETS color guard and the Sarasota High School marching band, to listen to speeches recalling the difficult war years, offer prayers and most importantly to thank and pay their respects to their hometown heroes. Each of the trees was decorated with a green and white wreath.

Master of Ceremonies Frank Evans, a World War II naval officer, introduced the speakers. Founders Circle President Mrs. Walter G. Frauenheim told the audience that the parkway would be "a place of sanctity…in our busy little city and that the city and the public [would] assist in maintaining it as such." Civic leader Karl Bickel reminded, "We must as a community, never forget that a living memorial involves a keen and sensitive sense of community responsibility."

Mayor J. Douglas Arnest then came forward to accept the parkway for the city and City Manager Ross Windom promised that the city would maintain the parkway and the trees.

Perhaps the most poignant part of the ceremony was when Sarasota High School principal Carl C. Strode presented a plaque with the names of graduated students who were killed during the war.

The ceremony ended with a twenty-one-gun salute followed by "Taps."

Sadly, the flush of patriotism and sentiment waned for Honor Parkway just as it had for the Memorial Oaks. The "community sense of responsibility" that Bickel had spoken of dissolved with time. He had warned that, "We cannot enthusiastically accept this gift today and walk away and forget it tomorrow." But that seems to be precisely what happened.

Two of the trees and a plaque remain. You can see them at the headquarters of the Sarasota Garden Club, reminders for only a very few who remember that sentimental January day so many years ago.

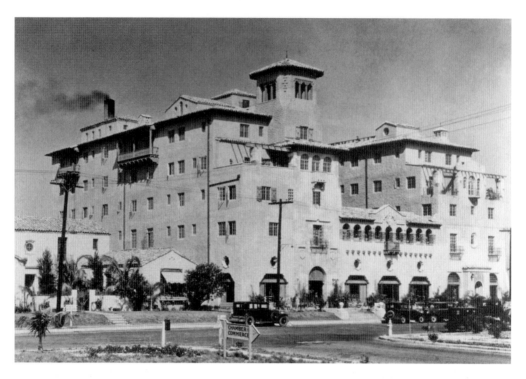

Designed by Dwight James Baum and built by Owen Burns, who named it to honor his wife, the El Vernona was acquired by John Ringling during the Great Depression. The name was later changed to the John Ringling Hotel and finally it was the John Ringling Towers, a retirement apartment. *Courtesy Sarasota County History Center.*

The El Vernona Hotel/John Ringling Hotel/John Ringling Towers

Owen Burns fell in love with the beautiful Vernona Freeman at first sight when she came to Sarasota for a visit. After a whirlwind courtship they married in 1912, honeymooned in Europe and returned to Sarasota to raise a family. Burns, of course, continued to involve himself with all aspects of Sarasota's growth and development. As the largest landowner in the city, he was vitally interested in the community's success.

The 150-room El Vernona Hotel, the largest and most opulent of the '20s-era hostelries, was designed by Dwight James Baum, who worked in Burns's office building, later known as the Bickel House. The two had previously worked together on Ca'd'Zan, John Ringling's grand mansion that was built by the Burns Construction Company, and they would collaborate on other projects during the '20s. Their efforts won praise in the *Sarasota Herald* in a full-page spread, "Dwight Baum and Burns in Boon to City."

Burns spared no expense on his wife's namesake hotel, outfitting it to the nines and hiring a professional and experienced staff and a world-class chef. Guests were promised, "The courtesy one expected in the wayside inns of Andalusia was an eternal command of every El Vernona employee."

Designed to look like a Moorish castle, it stood boldly on what was called Broadway Avenue, a section of Sarasota for which there were grand plans. The *Sarasota Herald* said of the hotel, "Almost startling in its magnificence, brilliant in its glory and fairly taking one's breath with the simple grandeur of its appointments."[116]

But the timing of its construction and date of its auspicious opening could not have been worse. It was December 31, 1926, New Year's Eve, and the boom was over.

By all outward appearances everything was still fine in Sarasota; the celebration at the hotel and the parties throughout the city that night could not have been merrier.

A look at the front page of the *Sarasota Herald* on January 1, 1927, illustrates that the realization of the real estate crash had not registered.

New Year's Day headlines and stories read like everything was still moving forward: "Hotel El Vernona Makes Formal Debut In Burst Of Gaiety." "Gay Throngs Pay Their Tribute To Builder's Vision." "City Observes New Year Eve In Gay Manner." "Many Tourists Are Coming To Sarasota Now." "'U' Club Has Gala Evening At The Mira Mar Casino."

It would be the era's last hurrah. Within three years the hotel was foreclosed on by the Prudence Bond Company, the furnishings were sold to the John Wanamaker Company of New York and the hotel was soon to be acquired by John Ringling.

At first the hotel's name was changed to the El Verano and operated as before, as a staid luxury hotel for seasonal guests.

After Mister John died in 1936 the hotel came under the control of his nephew, John Ringling North, who, although disinherited by Uncle John, remained as executor of his estate.

Now it was the John Ringling Hotel and North added the colorful trappings of the circus, with circus acts performing in the ballroom, and his M'ToTo Room cocktail lounge became *the* place to go for nightlife in Sarasota.

The hotel was managed for many years by Charles H. Carr Sr. who with his wife hosted one of the big events of the year, the annual St. Patrick's Day Ball for St. Martha Church.

Like the Mira Mar Hotel and the Orange Blossom, the hotel changed hands several times and was eventually converted into the John Ringling Towers retirement apartments.

After the Towers closed, the building slowly sank into disrepair, wasting away—"demolition by neglect," as it evolved into an eyesore for some, and a tarnished jewel awaiting a savior for others.

The battle to save what was once Sarasota's premier hotel was enjoined at first by the Sarasota Alliance for Historic Preservation. Their John Ringling Towers Task Force was led by architect Don Chapell and for a time kept the bulldozers at bay. Then another group was formed, the John Ringling Centre Foundation headed by Don Smally, who had participated in the saving of the Florida Theatre building, and Deborah Dart. Over the years of battle, they were joined by some tireless civic-minded citizens who had seen enough of Sarasota's past frittered away. The original Board of Directors consisted of Don Smally, Debbie Dart, Stewart Stearns, Kay Glasser, Jim Clark, Rod Macon, Jimmy Dean, Bob Johnson, Ron Royal and Barry Todd. Later board members would include: Joyce Waterbury, Bill Merrill, Don Chapell, Kathy Ziarno, Kathleen Toale, Sandy Slaminko, Bill Preissner, Kate Korp, Jim Brown, Peter Yates, John English, John Nicholas, Bob Rettig, Bobbi Hicks, Jay Berman, Martin Treu, Joann Wolverton, Richard Capes, Fred Starling, Ted Bogusz, Jeff LaHurd, Ruth Richmond, Wilson Stiles. Hardworking volunteers included Pat and Judy Ball, Manny Rodriguez, Chris Fitzgibbons, Janet Robbins, Mary Ruffin, Rose Marie

Grupp, Bill Hansberger, Bill Dooley, Ryan and Kyle Preissner, Bob Town, Brian Sterling, Millard Yoder, Devin Rutkowski, Lillian Burns, Barbara Strauss, Ron Royal, Jack Hoffman (the Pretzel King), Judy Graham, Dr. Jim and Tonya Fogelman, Marty Petlock, Bob Ardren, Marjorie North, Kimberly Brown, Donald and Lotijean Mize and Jessica Higel. These people and many others worked diligently. It would be, sadly, a losing battle and a great loss to Sarasota.

Succeeding city commissioners seemed to be ambivalent, never getting full-bore behind the project, and one city staffer was singled out in a *Sarasota Herald-Tribune* editorial, reminding her that she worked not for the developer but for the city of Sarasota.

The pitch of the foundation was "Return to Splendor" and numerous rallies, vigils and fundraising activities were held. In the end, however, it was all for naught, and after a losing court battle undertaken by the Alliance, the hotel was condemned as being unsafe and razed.

At the end of it, Rich Ferrell who had represented the Crowne Plaza Hotel chain, which had hoped to rehab it and turn it into a boutique hotel, said that his group could not believe that the city would allow a building of such historical significance to be demolished.

Chapter X.

AGRICULTURE

Not so many years ago, Sarasota was characterized by citrus and berry groves, celery and pepper fields and cattle and dairy farms. Tens of thousands of acres were devoted to one type of farming or another, as much a part of the local economy as tourism is today.

As late as 1957 aerial maps of the South Gate area show row after row of lush orange trees—the development's slogan of "Where you live among the Orange blossoms" was not hype—and the sweet scent of orange blossoms was very strong around the groves.

Sarasota's temperate climate and rich soil made it a natural for farming and raising cattle. Long before we came to rely on the tourist trade as our economic mainstay, and even afterward, agriculture was the lure that brought many here.

The Scots had been falsely promised that with very little difficulty they could become gentlemen farmers, harvesting gold from citrus trees, and the theme of farming opportunities as a draw would later run concurrent with Chamber of Commerce hype of wooing tourists.

Early settlers like the Whitakers, Crowleys, Rawls, Redds, Wilsons, Albrittons and Blackburns struggled daily to be self-sufficient, growing their own food, always waging a battle against the vagaries of Mother Nature—storms, mosquitoes, wild animals, snakes and alligators. Wildcats were so common that sometimes the dogs didn't even bother to bark at them. According to *A History of Agriculture of Sarasota County*, where much of the information in this chapter comes from, Jasper Crowley recalled, "Every child was afraid of a wildcat and sooner or later expected to be caught by one."[117]

These were hardworking folk, at the task seven days a week from sunup to sundown providing food for themselves, their community and, later, the nation.

While attending to the farms that would be their livelihood, the early settler families tended a garden, raised chickens, stocked a few cows for milk for the family and hogs to butcher, which they did usually in the cold of the winter months so that the meat would not spoil while it was being cured and smoked.

During the summer months when a cow was slaughtered for beef, a piece of the butchered animal would be sold to each of the nearby families so that it could be immediately cooked and not spoil.

"There was always the danger of food spoiling, or of weevils getting into the flour, or worms into the brown sugar. The housewife had to be very careful in her care of the food in order not to have the family supply ruined."[118]

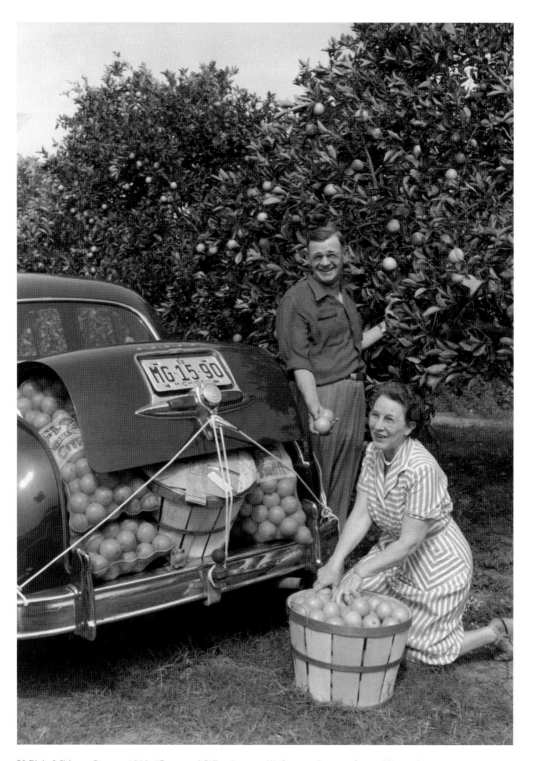

U-Pick, Midway Groves, 1952. "Luggage? What luggage?" *Courtesy Sarasota County History Center.*

When Sarasota was still a part of Manatee County, the Sarasota-Venice Company issued a sixty-four-page booklet giving a comprehensive overview of the farming scene. The brochure assured that any person willing to work (and hard work it was) could make a go of it in the Sarasota Bay region by farming. It would take approximately five years for citrus trees to be fruit-bearing and "with proper attention" a grapefruit grove could net between "$200 to $350 or more annually."

Until the trees matured, it was suggested that chickens could be raised for enough money to get by. "Chickens do well. There is a steady local demand for eggs and broilers for consumption by the many tourists who spend their winters here."[119]

Chicken farming required one or two acres. Each acre would support five or six hundred chickens and on "account of the exceptional conditions, earn a cash return sufficient for the needs of the ordinary family."

Newcomer Mrs. J.J. Cates shared that even though she had no previous experience, it was easy to raise four hundred hens and noted, "I have made enough from these chickens to feed and clothe my family, my husband and myself."[120]

Other testimonials underscored the wisdom of raising chickens. Margaret C. Davis said her Rhode Island reds made her between $1.50 and $1.80 per bird per year, earning her $33^{1}/_3$ cents for a dozen eggs.[121]

Fishing and hunting were other options for earning a living while awaiting the groves to bear fruit and produce income. In those days the woods were filled with all manner of game and fowl, and the waters offered bountiful fishing, oysters and clams.

C.M. Robinson, who had lived in Sarasota for forty years as of 1914, said, "If a man can't make a living here, he can't make it anywhere." He told of coming to the area with one suit of clothes and making good. "It's the easiest country to make a living and the easiest to get ahead."[122]

Whitaker brought the first cattle into Sarasota in 1847 and grazed them in Myakka near today's main entrance to the state park. He is also credited with planting the first orange groves in the area.

In the same area of Myakka, Mrs. Palmer raised cattle at her ranch, called the Meadow Sweet Pastures, and was the first in the state to begin dipping her cattle to eradicate ticks. At that time it was generally believed by local ranchers whose cattle roamed free that dipping cattle would kill them.[123]

The Palmer interests were also responsible for significant drainage, and they farmed approximately five thousand acres off Fruitville Road. They hired former County Agent Ed Ayres in 1926. He was in charge of experimenting to see what crop would be best suited to the muck land. It was decided that celery would be best for both economic and horticultural reasons.[124]

The Bell brothers, John and Tom, are also closely linked with farming in the Fruitville area. They came to work for the Palmers from Sanford, where they made their reputation in celery farming. They built and operated the Palmer Farms Growers Cooperative Packing House. Tom Bell became president of the Sarasota Growers Cooperative, a position he would serve in for many years. He also invented machinery to wash the celery and received a patent for a celery-cutting device that helped increase production.[125]

In 1946 or 1947, the Bells sold their Sarasota interests to Pat Ferlise. Tom Bell became involved in a number of civic projects in Sarasota, organized the Citizens Bank and was its president for ten years. When Cardinal Mooney High School was established, he let them use the Bell Plaza for temporary quarters until the high school was built.[126]

East of Sarasota off of State Road 780, the Hi Hat Ranch was one of the best known in Florida. Originally the property was acquired by Ross Beason in 1937. He had planned to turn it over to his son, but sadly, Ross Beason Jr. was killed in action April 15, 1944 in World War II and Beason decided to sell his holdings, which were bought by Herman E. Turner in three separate transactions, ending in March 1945. Managed by Latimer Turner, Herman's son, the ranch was said to be "one of the most remarkable pieces of property in the state," and contained twenty-seven artificial lakes, a landing strip, thirty-four hundred acres of sodded pasture, dipping vats, ninety-four miles of improved roads, a palatial ranch house and six hundred miles of four-strand barb wire fences."[127]

In April of 1954, Herman Turner, who had been past president of the Sarasota County Livestock Association, was named Farmer of the Month.

Another important local rancher was Dallas Dort, a practicing attorney who operated the three thousand-acre Double D Ranch and was also one of the founders of New College, serving as its president in 1972–73. In his storied career he had served in both the Roosevelt and Truman administrations and played a role in the development of the Marshall Plan, which helped with the reconstruction of Europe after World War II.[128]

L.H. "Buck" Hawkins raised approximately 1,200 head of cattle on his ranch. In a 1975 interview explaining why the price of beef had risen so much, Hawkins recalled that a cow hand could be hired for $1.50 a day in the teens and early twenties, but by 1975 the salary had jumped up to $35 per day.

Most of this type of farming property has been sold off to developers, but one longtime rancher who still stands firm, saving his property for his "great-great-grandchildren," is Berryman T. "Buster" Longino. In 1998 the Longino Ranch included eight thousand acres in Sarasota County east of the Myakka River off State Road 72 that his family has owned since 1934, and another nine thousand acres he leases. On it he raises cattle, timber and citrus. In 1998, Longino won the Commissioner's Agricultural–Environmental Leadership Award.

Longino's father had been in the turpentine business in the 1930s and 1940s, but the business folded around 1950 and Longino, who had a bachelor's degree in forestry from the University of Florida, decided to use the property for forestry. While waiting for the pine trees to grow he decided to run cattle. He recalled buying one hundred head for one hundred dollars. Later he and his family—father and three sisters—incorporated, with Longino being the manager.[129]

In July of 1989 he was appointed by Governor Martinez to the Sarasota County Commission to fill out the term of Mabry Carlton, who was killed in an airplane crash.

In a *Sarasota Herald-Tribune* interview in 2005, Longino said he received one or two letters a week from developers inquiring about purchasing his land and, "I throw the letters right in the trash where they belong."[130]

Another cattle rancher who held the line was the feisty Fleta Carlton, who maintained the traditions of a way of life that was dying out. An unlikely cattle rancher, at a diminutive five feet two inches, Miz Carlton's tough outward appearance belied a charitable and sensitive woman who was well loved and respected in her community. She had taken over the operation of the Carlton Triangle Ranch when her father died in 1967 and ran it until she died of a stroke on March 11, 2006, at age eighty-two, a sad loss for the Old Myakka community.

T. Mabry Carlton Jr. is a name synonymous not only with Sarasota ranching, but also as a positive force in Sarasota County government; a well-thought-of county commissioner who spearheaded the effort to buy the thirty-three thousand-acre MacArthur Tract in east Sarasota County on which to develop the county's own drinking water supply. He had once called it Sarasota's version of the "Louisiana Purchase."[131]

He was elected to the county commission in 1980, 1984 and 1988. He had used his airplane to help herd cattle and was in the pursuit of that when he crashed and was killed. The public outpouring included folks from all walks of life.

Dairy farming was another part of Sarasota's agriculture heritage. In 1922, Jackson F. Bispham started the Bayside Dairy (named for its proximity to Sarasota Bay). Like the Schmidt Brothers Dairy in Tallevast, this was a family operation.

In the 1930s there were eight mom and pop type dairies in Sarasota and two in Venice, bottling their own milk and delivering it to their customers, sometimes twice in the same day. One of the Venice dairies, owned by the Brotherhood of Locomotive Engineers, even brought in an experienced dairyman from Wisconsin.

Cows were milked by hand in those days, a very labor-intensive job. The hired help lived on the grounds, were cooked for by the woman of the house and were paid a dollar a day.

When Bispham's sons, Cy and Jack, finished high school, each was given a quarter interest in the dairy and ultimately they built a new dairy in Gulf Gate circa 1950 on property that had been the experimental farm for the Palmers' Sarasota-Venice development. There they had 125 cows, and in 1955 sold their milk routes to Hood's Dairy. The Gulf Gate property was sold in 1957.

The Schmidt brothers, Walter and Charles, and partner Welch Whitesell, began their dairy in 1925. After World War II, Charles moved to where Kensington Park is now located and ultimately sold his property to the developers.

As improvements were made in processing and handling milk, the small dairies that could not afford the new equipment went out of business. As Cy Bispham recalled, "When Pasteurizing came into effect one or two of the small dairies dropped out. When the metal caps with the new type bottler came in it took another toll on small dairies."[132]

Sarasota was once flush with citrus groves. Mr. Karl B. Albritton, who came to the community of Bee Ridge with his father circa 1900, recalled that the Palmers established most of the first groves in the Bee Ridge area (the South Gate Development was on the Hyde Park Palmer Grove).

Albritton recalled that his father, T.A. Albritton, bought land from both J.H. Lord and the Palmers, developed groves and sold off ten-, twenty- and forty-acre parcels to people

from the north. He cleared the land, planted trees on it and when the buyer came down, the grove was already established. The purchaser could take over the grove or the Palmers would take care of it.

Another son of T.A. Albritton, Paul C. Albritton, would distinguish himself in the legal profession, becoming the youngest circuit judge in Florida history when he was appointed by the governor in 1927 at thirty-one years of age.

SEPARATE BUT NOT EQUAL

IT HAS NEVER BEEN EASY being an African American in Sarasota. Florida had been, after all, a slave state and prejudice flourished long after the Civil War and even after civil rights legislation.

The first black members of our community to settle here—"negro" or "colored" were the nicer names by which they were known at the time—were, according to A.B. Edwards, Aaron and Jeannette Bryant "brought in as, respectively, a household servant for one family…and a maid servant of another." They were "taught how to work and to know their place. They later married and established their own home, and attended the white Methodist church and all community affairs."[133]

Two early settlers here were runaway slaves, George Washington, who lived near today's Sarasota Jungle Gardens, and Lewis Colson, who became a well-respected citizen, known as Reverend Colson. He had been with the group of land surveyors who had platted Sarasota in 1885 for the Florida Mortgage and Investment Company.

In 1897, for the consideration of one dollar, he sold to the trustees of the Bethlehem Baptist Church the property on Central Avenue and Seventh Street on which the Bethlehem Baptist Church was built. He was the first minister of the church, serving from 1899 until 1918. He and his wife Irene are the only African Americans to be buried in Rosemary Cemetery.[134]

While Edwards remembers these people and others in the black community fondly, his recollections are sprinkled with descriptions that leave no doubt that while the early black settlers were respected and pulled their own weight, they were, for the most part, treated as second-class citizens.

John Hamilton Gillespie employed Leonard Reid, who came to Sarasota in 1900 as a manservant for many years, and while Gillespie was said to have sought out his advice and council and treated him humanely and with respect, he was not considered socially equal, and not just because of their different economic situations. Reid was black.

Reid worked with Gillespie in laying out Sarasota's first golf course, one of the first in the state. Writer Richard Glendinning wrote of him, "he carried himself with the dignity of a Scottish chieftain."[135]

When Reid died in 1952, his passing was noted in the local papers, "Pioneer Negro Citizen Dies," with his photograph, stories of his employment with Gillespie and his involvement in the community.

The Roaring '20s were among the hardest times for Sarasota's African American community. The Ku Klux Klan was often a visible presence here, with cross burnings and other forms of intimidation, both physical and psychological. Sarasota's branch of the Knights of the Ku Klux Klan, the Invisible Empire, was Klan Number 72.

Always looking for ways to legitimize itself—"NO HONEST RIGHT THINKING, WHITE American can CONSCIENTIOUSLY oppose the Knights"—they brought a Klan circus to Sarasota for the week of October 18–23, 1926, with "the best acts obtainable."

In conjunction with the circus (actually the Bob Morton Circus under the auspices of the Klan) a Miss Sarasota was to be chosen from whichever of the contestants sold the most circus tickets. The winner and runners up would receive "gifts of an expensive nature…beautiful to behold."[136]

The fact that the Klan circus was so well received underscored the sentiment of the times. In conjunction with the circus, 354 men and 82 women, local Klan members, marched down Main Street in their white Klan outfits, watched by thousands who "greeted them with a cheery hail from friends who lined the way."[137]

The parade was preceded by two fiery crosses that "stood out in the tropical sky clearly and distinctly," with the flag carried by the women members of the Klan auxiliary.[138]

It is not difficult to surmise the chilling effect on the African American community. The circus had been staged to raise funds to build a Klavern (Klan headquarters), which would "exceed anything of its kind south of Atlanta."

On October 23, 1926, a deputy sheriff, perhaps emboldened by the recent Klan activity, assaulted Robert Walthau, "a Negro," with his gun and black jack and kicked him after he went to the ground.

Charges were filed for assault and when the deputy was arrested he justified his actions by saying that he had asked Walthau if he was working and offered Walthau a job unloading some trucks. Walthau replied it was none of the deputy's business.

Said the deputy, "I warned him not to talk to me in that manner…that he should remember to speak to a white man with respect the next time he was spoken to or he would get more of the same."

The attack was witnessed by a Mrs. Walters, who made the complaint and took Mr. Walthau to her husband's pharmacy, the Orange Pharmacy, to have his wounds dressed.

Mayor Bacon had no comment about the beating for a *Sarasota Herald* reporter, and Sheriff Leon Hodges said he would "undertake a thorough investigation" and if it was warranted, would suspend the deputy.

These were the days when it was not unusual for authorities to "round up" African American men, charge them with "idleness" and order them to pay a fine. Since they often could not pay, they would be placed on the chain gang. One story in the *Sarasota Herald* was headlined, "Doing Nothing But It Costs. Sarasota Negroes Find They are Not Lilies of the Field." The story related how twenty-nine black men were rounded up in a poolroom, charged with "idleness" and fined twenty-five dollars each, plus court costs. The arrests were made because the sheriff had received numerous complaints that it was impossible to find labor.

Another story, "Judge Hard on Negro Idlers" noted that "every Negro seen loafing on the street was questioned."

And on it went.

As the black population increased from the early settler years, their section of town became Overtown, north of downtown Sarasota, an area previously called Black Bottom.

Overtown's proximity to Rosemary Cemetery became a concern for white Sarasotans, who considered moving the cemetery as "the location, having to pass through the colored

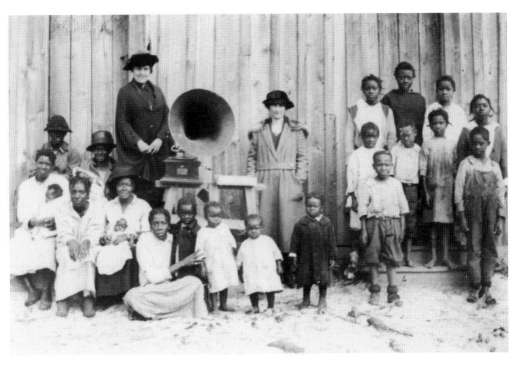

Mothers and their babies at the Laurel "Colored" School circa 1921. The names that accompanied this photo: Lela Franklin, Rosevelt Tyson, Rosewell Bradford, Ruth Harris, Katie Jackson, George Bodiford, Malissa Thomas, John Harris, Robert Bodiford, Doretha Nichols, Leola Hall, Ella White, Ella Stafford, Ike Tyson. *Courtesy Sarasota County History Center, Sherry Borza Collection.*

quarters to reach the cemetery is not desirable." The blacks were encouraged to move further north.[139]

Developer C.N. Thompson and his son, Russell, tried to facilitate the move by opening a subdivision of "forty acres for colored quarters" with 240 lots that could be bought "on easy payments." The subdivision was called Newtown and was "exclusive for colored people."[140]

Schooling for black children at this time was substandard. Certainly they were not welcome in the white schools; in fact, many whites didn't believe they needed any education at all, or no more than the fourth grade. They were taught with shoddy, hand-me-down materials.

Black children attended classes at Phythians Hall until Sarasota Grammar School was built in 1925. Later this became Booker Grammar School, named for Emma E. Booker, its first principal and major educational leader. Later Booker High School was added. Under the leadership of Professor James Robert Dixon, the first graduating class in 1935 had four students.[141]

The struggle for equal education would go on for generations and was only grudgingly allowed when federal tax dollars were tied to integration.

In the 1920s Newtown Heights was added to Newtown to accommodate the increase in the African American community.

In Overtown, E.O. Burns, brother of Owen Burns, constructed the Colson Hotel for black visitors. The *Sarasota Herald* noted, "Colson Hotel Is Novel One," and applauded Burns, saying that "he had laid claim to greatness because he has just opened the Colson hotel, to the Negroes of the city."[142]

Educator Emma E. Booker (right). *Courtesy Sarasota County History Center, Sherry Borza Collection.*

Named after Lewis Colson, the twenty-eight-room hotel had four bathrooms "to be conveniently located over the second floor, to be within easy reach from any part of the house."[143]

The Mediterranean Revival hostelry was said to cost $35,000 and its ground floor offered shops, a soda drink parlor and a "sanitary barber shop."

The spiritual needs of the black community were met by several churches in the Newtown and Overtown area: Payne Chapel AME Church was established in 1907 on property given by Gillespie and named to honor Daniel Payne; the Mount Moriah Christian Church established in 1913 also served as a community school, led by the Reverend E.W. Range; the Truevine Missionary Baptist Church, organized in 1918, elected the Reverend O.J. Johnson as their first pastor; the House of God Church, founded in 1922 by Mother Mary Magdalena Tate along with her two sons, Walter Curtis Lewis and Felix Early Lewis; the New Bethel Missionary Baptist Church, 1924, previously known as the House of God, with the Reverend C. Preston as the first official pastor, 1925–1927; the Church of God in Christ, 1925; the Hurst Chapel African Episcopal Church, Incorporated, 1928, first named Bryant Chapel for its first pastor; the Shiloh P.B. Church, 1930; Church of Christ, 1932; and the Reverend Henry L. Porter's Evangelistic Association, Incorporated, 1971.[144]

Overtown and Newtown were closed, self-contained communities with their own mom and pop businesses to serve their needs. Among those singled out for mention in McElroy's book are the wood yards that supplied firewood, owned by Richard Humphrey, Willie Green, Charlie Green, Malie "Pop" Richardson, "Doc" Bethea and Lonnie Briggs. James "Jim" Hindsman was a cobbler who had a shop on today's Dr. Martin Luther King Jr. Way.

McElroy recalled that many barber shops and beauty salons started in kitchens before moving into storefronts. Well known in the community were Nathaniel Frazier, Robert "Bud" Thomas and Jetson "Jet" Grimes. The black community also had their own cab companies, grocery stores, service stations, funeral homes and cemeteries.

For the most part, African Americans only mixed with whites when doing their housework, caring for their lawns and performing other domestic duties—waiting tables, shining shoes.

The separation extended to African American servicemen who trained here during World War II. A Colored Service Men's Club building, designed by Albert Moore Saxe, was started in 1942. At the groundbreaking Mayor Smith addressed the "need for a colored recreation center." Three hundred people turned out for the ceremony, listened to speeches and patriotic songs by the "colored chorus."[145]

When Sarasota's new bus depot opened on Main Street and Orange Avenue in July of 1943, much ado was made of the fact that "the arrangement of the station is unique in that it has separate accommodations for white and negro patrons from ticket windows to lunch rooms."[146]

There was never a lynching reported in Sarasota, but accounts of them in other parts of the South were reported, as were floggings, cross burnings and questionable jury verdicts regarding white men killing black men.

This was the status quo for Sarasota's black citizens until 1955.

In October of 1955, the blacks continued to push for the right to swim at previously whites-only beaches. Neil Humphrey, president of the local branch of the NAACP, issued a statement to the paper calling the NAACP

> *an organization built upon Christian principles and human rights and its purpose is as follows: 1. To educate America to accord full rights and opportunities to Negroes. 2. To fight injustice in courts when based on race prejudice. 3. To pass protective legislation in state and nation and defeat discriminatory bills. 4. To secure the vote for Negroes and teach its proper use. 5. To stimulate the cultural life of Negroes. 6. To stop lynching.*

Hardly a radical agenda.

It was front-page news when blacks went to Lido Beach to swim. A hundred showed up on October 3, 1955, with Police Chief Robert Wilson saying that "everything was peaceful and quiet and there was no law forbidding them to use the beach."[147]

The city responded by closing Coolidge Park, the portion of the beach the blacks had visited, emphasizing "the safety factor." You can't be too careful.

A Negro Beach Study Committee had been named to try to find a solution to the problem and had recommended black sites at Manasota Key, Siesta Key, Casey Key and Englewood. Longboat Key had also been considered and was on the table for a while, but was shelved.

The News editorialized that something should be done about the problem "NOW!" They reminded readers that as this was a tourist town, "this [the integration of beaches] will play havoc with our economic life—for Sarasota depends on tourists."[148]

Woolworth lunch counter at the Ringling Shopping Center. On March 2, 1960, a group of eleven African Americans sat down here and were refused service. The leader of the group, Gene Carnegie, told *The News*, "We could have easily brought 40 people in here and another 200 outside picketing, but that would incite trouble and would not be in the best interests of the community." *Courtesy Sarasota County History Center.*

As early as 1953, the Chamber of Commerce had backed a plan to locate a "Negro Beach" near the Civic Center complex, to which the city invited them to mind their own business. Said Mayor-Commissioner Leroy T. Fenne, "My advice to you is to let the county and city work out their problems...I can't see where the Chamber of Commerce can justify coming here asking us to support [this location.]"[149]

By September of 1956 a twelve-man citizens committee headed by George Higgins had recommended a strip of beach on the southern tip of Siesta Key at Midnight Pass. There was also a promise by the city to build a swimming pool in Newtown. The Siesta site was vigorously protested and the idea rejected by the county commission.

Internationally known author and Siesta Key resident MacKinley Kantor, a Pulitzer Prize winner, called the action of the county commission "political cowardice" and threatened to write an article for national publication entitled, "Sarasota Cheats Its Black Children" unless a solution was found.[150]

Kantor's promise brought him the threat of a cross burning in his yard to which he assured that, "If they try, they'll get a hole in them." Kantor was not for integration of the beaches; he wanted the blacks of Sarasota to have their own beach, as, indeed, did some members of the black community. Longtime black community leader Abe Jones said he spoke for many local blacks when he said, "Why, its just plain crazy thinking to want to go swimming with the white folks. We are different, regardless of what anyone may say, and we should keep in our own place while seeking the advantages which have not been possible in the past."[151]

Jones's statement was not embraced by the majority of the black community and was denounced by the black leadership.

Hoping to defuse the situation, the city said that work on a $75,000 swimming pool and facility would begin immediately.

During this time period Venice was also considered a site for a black beach—quite a drive for the residents of Newtown. However, Venice Mayor James P. Kiernan strenuously objected and the Venice city council unanimously decided that if this was forced on them by the county they would move to block an easement through the Venice Airport for the intracoastal canal.

This hot potato, tossed about from one municipality to another, from one section of the county to the other, from one politician to the other, was cooled somewhat when the Newtown Pool was dedicated at the Newtown Recreation Center on November 27, 1957. The beach question went on everyone's back burner.

But other battles lay ahead.

Key among them was school integration. Into the '50s and early '60s, black students had few textbooks; most of their assignments had to be copied from the chalkboard. When they did manage to get textbooks and supplies they were hand-me-downs from the white schools. Former Mayor Jerome Dupree recalled, "Every piece of equipment sent to Booker schools was second hand."[152]

It was only after the federal government tied federal dollars to compliance with the 1964 Civil Rights Act that a little educational progress ensued, but the battle was not over. Ahead were the busing issue and a black boycott of white schools in 1969, during which black educators and leaders set up Freedom Schools to educate their children in an effort to get equality in Sarasota's public schools. (The Sarasota-Bradenton Airport Authority, in 1956, agreed not to provide segregated facilities at the new air terminal so that federal funds would not be cut off.)[153]

The black leaders fighting for equality and respect at this time were John Rivers, Jerome Dupree, James Logan, a Riverview High School honor student who was one of the boycott leaders and of course many others, both white and black.

From the perspective of 2005 this seems like ancient history. African Americans in Sarasota have been fully integrated into the Sarasota scene. Fredd Atkins was elected the

first African American mayor in 1987, followed by Jerome Dupree and Carolyn Mason. Atkins serves in 2005 on the city commission.

But have they truly been accepted in our predominantly white society? In 1998, nationally syndicated columnist Bill Maxwell, an African American, wrote in a column titled, "Supper with a serving of racism," that in a local restaurant he felt "outrage" at his treatment. As late as 2002, Sarasota Mayor Carolyn Mason said that race played a role in the rude treatment she received at a charity event on Longboat Key.[154]

Sarasota and the rest of the nation have surely come a long way from the days of the Klan lynchings and cross burnings, Jim Crow laws and segregation in general—but we have a ways to go. It is still unusual to see African Americans either downtown or at the beach black leaders fought so hard to access.

POST–WORLD WAR II GROWTH AND DEVELOPMENT

N EAR THE END OF GRISMER'S *The Story of Sarasota*, he wrote of the new city charter that had been approved in the special election of November 5, 1945. It provided for the establishment of our current city manager–city commission form of government.

On December 4, the first five city commissioners were chosen, serving at no salary. They were Francis Walpole, J. Douglas Arnest, Arthur E. Esthus, Ernest Sears and Clarence J. Stokes. This group of men appointed as our first city manager Colonel Ross E. Windom, formerly city manager of Westerville and Portsmouth, Ohio. An engineer by training, "He assumed his new duties here February 1, 1946 and soon began making widespread changes in governmental procedure. His success or failure can be reported by the next person who attempts to record the history of Sarasota."[155]

Windom promised a flexible government that could respond quickly to the needs of the people. His three-point program called for the appointment of a planning board and rezoning of the city, adoption of a pay-as-you-go plan of city government and equalization of property assessments, preferably by an independent firm of trained appraisers.[156]

He ran a tight ship, with city hall gaining the name of Fort Windom from his "militaristic-style" of management.

He served as Sarasota's city manager for only two years before moving on to St. Petersburg, where he served for eleven years. He had been a firm proponent of cleaning up Sarasota Bay, leading the city commission to begin "the development of a modern sewage treatment plant and a network of sewer lines which greatly improved the quality of effluent going into the bay."

Windom died on March 7, 1998; he was ninety-five years old. His son, Dr. Robert E. Windom, became the assistant secretary of the Department of Health during the Reagan administration.[157]

Carl H. Bischoff from Washington, D.C., took over the helm of city government on July 1, 1948. As Windom, he was a recent army veteran, having served as a military governor. Previous to his military experience, he was the city manager of Rumford, Maine, and then Asbury Park, New Jersey. Bischoff said upon his arrival that he had "never received a more sincere welcome in any city than I am receiving in Sarasota."[158] His wife was described as "charming."

But the Bischoff tenure was short-lived. He was ousted in a move that to him "came as a complete surprise." In a special meeting at which the press was barred, the commission unanimously requested Bischoff's resignation before his second probationary period was over. According to press reports, Bischoff came under fire from the Sarasota County legislative

City managers of Sarasota pose in front of city hall. (From left) David Sollenberger, Ross E. Windom and Ken Thompson. *Courtesy Sarasota County History Center.*

delegation, which had sought to have the police department removed from his control and limit other areas of his authority.

Bischoff's duties were officially ended at noon, May 31, 1949, and city treasurer and tax collector Charles Pickett was named the acting manager.

Pickett had arrived in Sarasota in 1913 as a sixteen-year-old from New York with his mother and lived in the Worcester Mansion on Bird Key, left to Mrs. Pickett by her brother Thomas W. Worcester. Pickett, who served as the city treasurer for thirty-five years, began his tenure during the Great Depression, and when he died in 1979, was remembered in a *Sarasota Herald-Tribune* editorial as the man "who restored the city to financial respectability and solvency."[159]

In 1950, Sarasota's city manager door would stop revolving for quite some time to come. Enter Ken Thompson, who would be at the helm of city government, leading it, in the real sense of the word, for thirty-eight years as Sarasota experienced some of its most profound changes.

He came to Sarasota having served as assistant city manager of Miami Beach. A graduate of the University of Florida, Thompson was trained as an electrical engineer and during his first several years helped Sarasota alleviate its problems in water, sewers, drainage and other infrastructure issues as he sought to modernize Sarasota and keep it abreast of the influx of new tourists and residents. He too had been in the military.

When Thompson came to Sarasota in 1950 there were fewer than twenty thousand residents in the city (the county population was only 28,827) to which the term "sleepy" was often and aptly applied.

These were the days that many still remember with such nostalgic fondness; relaxed and casual times when everyone seemed to know everyone else; when shops and stores closed at noon on Wednesdays and were not open at all on Sunday. These were the days when the Ringling Bridge was lined with fishermen, the out-islands were tropical retreats and artists and writers came for quiet inspiration. It was the era before the outward spread, when downtown Sarasota was still the heart and soul of the community.

Post–World War II Growth and Development

A look at a map of Sarasota in 1925 and 1950 (and even later), would reveal very few differences; but the Sarasota that had basically stopped growing after the 1920s land boom was about to crank up again, and Ken Thompson would be the navigator who guided it for thirty-eight years.

People may not have agreed with some of Thompson's decisions, but he made them in what he thought was the best interests of the city of Sarasota. When he was nearing retirement, former *Sarasota Herald-Tribune* editor Waldo Proffitt said of him, "No hint of scandal ever touched him in all of his years in the spotlight. He strongly believed in the commission-manager form of government and considered himself a servant of the people and their elected representatives."

Summing up his impact on the community, former State Senator Bob Johnson said, "Just look about Sarasota. He built the thing from scratch. Sarasota went from a one-stoplight-town to the city it is today."[160]

The changes in Sarasota during the 1950s were fast in coming. In 1951, Broadway Avenue was extended to Gulf Stream Avenue "to display the city's bay front beauty to tourists."

In 1953, the year the city celebrated its fiftieth anniversary, the hospital was turned over to the County Hospital Board, the Municipal Auditorium was air conditioned, many streets in Sarasota were renamed and renumbered, a million-dollar municipal Improvement Bond Issue was approved, improvements were continued on the city water and sewage, nine holes were added to the Bobby Jones Golf Course and the water supply to the Lido Beach Pool was improved.

Changes and improvements continued. In June of 1954 the City bought the necessary rights of way to four-lane 2.21 miles on the South Trail for $164,242; the American Legion War Memorial was moved to Gulf Stream Avenue (a move many longtime residents did not approve of); a new fluorescent lighting system was installed downtown, giving it the appearance of "a Great White Way" with a suitably grand celebration to coincide with the Diamond Jubilee of the invention of the incandescent light bulb. Festivities for the occasion included live music, a street dance, televisions for prizes and a Miss Queen of Light contest. (The first section of eighty-five mercury vapor lights on the South Tamiami Trail, which had been widened to seven lanes, was installed in October of 1955.)

In April of 1954 a repaving plan encompassed approximately 80 percent of the city, the largest item in the $1 million budget. Thompson planned to ask for $100,000 more to complete the repaving of all the streets.

In May of 1954, a contract of $31,802 was awarded for the building of a Community House behind the municipal auditorium that would be used by many teens over the years as a Youth Center, memorable for Friday night dances and ten-cent admissions, unless you did not have a dime, in which case Bill Blackburn, its director, would let you in free. This marked a shift in the Parks Department to include recreation programs, not just park facilities. It was a "new" concept brought by Ken Thompson from Miami.

In January of 1955, a parcel of property on Main Street and Highway 301 was rezoned to allow the construction of a Maas Brothers Department Store. Opened on October 1, 1956, with speeches by city officials including former Mayor A.B. Edwards, it initially sold everything from boats and outboard motors to clothing and prescription drugs. Managed for many years by John Schaub Jr., Maas Brothers was a mainstay for Sarasota shoppers until it closed in 1991. It was also a favorite for lunches for staffers from the courthouse. The building was turned into a lower-end mall for a while before it was demolished in September of 1996 to make way for the Cobb Hollywood 20 Cinema Theatre (today the Regal 20 Cinema).

A plan in 1955 to move city hall from the Hover Arcade to a site to be built at Payne Park was met by stiff resistance from Christy Payne, son of Calvin Payne, who had donated the property for "park purposes." The idea went no further.

In May of 1955, the City approved a plan for construction of a building to house the Florida West Coast Symphony, Inc, adjacent to the Community House. A drive for funds was started with a committee headed by Mrs. Harry Mundy, David Cohen, Erwin Gremli II, Sam Idelson and Mrs. E.L. Santana. Construction was slated to begin June 1.

Through the mid-'50s, downtown Sarasota remained much as it had always been. Five Points had lost the War Memorial in 1954 but Badgers Drugs was still there, celebrating its fiftieth anniversary in 1955; the Sport Shop, Palmer Bank, Madison's Drugs and an Amoco gas station still surrounded the heart of downtown. As always the Plaza Restaurant was the eatery of choice for special occasions and was *the* place for local movers and shakers to meet for lunch to work out deals. Badgers Drugs had the favorite coffee and lunchtime counter; it was still "the Store of the Town." Longtime *Sarasota Herald-Tribune* columnist Helen Griffith was a regular there, gathering information for her "Around the Town" column.

The downtown hotels—Mira-Mar, Orange Blossom, Colonial Hotel (formerly the Watrous), Hotel Sarasota, Sarasota Terrace Hotel and John Ringling Hotel—were still registering guests, but soon the desire for beachfront accommodations would put them out of business.

Sears-Roebuck, J.C. Penney, Montgomery-Roberts and Tucker's Sporting Goods were still drawing customers, although they would soon feel the pinch of the shopping centers where parking was easy.

Besides Montgomery-Roberts and the Sport Shop (for sportswear and everywhere), locally owned stores included Sarasota Hardware and Paint Company (still in operation), J.C. Cash Jewelers, Delson's, Warren's Exclusive Shoe Store (which remained open until 2005), Shrode Jewelers (still in operation), Glenwit's, Nello's (closed for good in 2006 when Nello Marconi's son, Joe, sold the property and retired from the clothing business), Harmon's and Angers' Men's Store.

Downtown lounges included the Aztec Room in the Orange Blossom, the Cypress Lounge, Sara-Bar (later the Hurricane Room in the Hotel Sarasota), Rick's Circus Lounge Tavern, Baccus Liquor store for package goods, Bullard's Bar, the Gator Bar & Grill and the Oasis.

Theatregoers still watched movies at the Ritz (formerly the Virginian and Sarasota Theatre) and the Florida (formerly the Edwards and now the Sarasota Opera House).

As today, parking was a problem. Even as early as 1926 a newcomer told of having to circle the area four times before he could find a place to slip his Model-T into, proof to him that Sarasota was a "happening place."

Sites were sought for public parking downtown and parking meters were ordered, 110 in 1956 to augment the 600 plus meters already in the city limits. Even with the spread outward, parking issues trouble city merchants and shoppers, theatregoers, nightclubbers and diners to this day. When the new lot opened in March of 1957, available parking had increased, but there never seemed to be enough spaces.

By the end of 1957, the widening of the highway on the North Trail had been completed and dramatic changes were about to take place along the downtown bay front with the addition of Bayfront Drive created from bay dredge and fill.

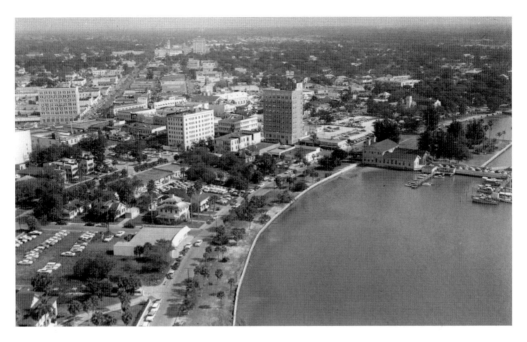

Gulf Stream Avenue when downtown Sarasota was linked to its crown jewel, Sarasota Bay. *Courtesy Sarasota County History Center*.

In summing up 1957, Mayor Leroy Fenne lauded City Manager Thompson, citing "His knowledge of the many phases of municipal government and his ability to analyze and interpret them to us…"[161]

The rerouting of U.S. 41 through Luke Wood Park and in front of Sarasota Bay on Bayfront Drive was one of the two most controversial decisions ever made, one that its critics assail to this day. The other was the razing of the Lido Casino in 1969, equally derided.

Dredging for Bayfront Drive, which was to link the North and South Tamiami Trail, was scheduled to begin in April of 1957. The hope was that a drive along the downtown bay front, traditionally recognized as the crown jewel of Sarasota, would impress newcomers.

However, property owners along the route filed suit saying their riparian rights were in jeopardy and sought an injunction, which was denied by Sarasota Judge John D. Justice. An appeal was heard by the Florida Supreme Court in July of 1957, which also denied the injunction.

While the case continued in litigation, work got underway. A portion of city pier behind city hall was cut out, dredge work begun in the bay for fill and finally, in May of 1958, the bid for the Bayfront Drive road was awarded to the Cone Bros. Construction Co. of Tampa which bid $681,141 for the job that was expected to take fifty weeks to complete. Dredging was completed in June of 1958.

By 1964 a jack rabbit leg-shaped peninsula had been dredged and filled just south of the City Pier and would become Island Park. For years it would be the site to watch the Ski-A-Rees water shows and it became the home of Bill and Lillian O'Leary's O'Leary's Sarasota Sailing School with its popular snack bar. The snack bar morphed into O'Leary's Tiki Bar and Grill and serves breakfast, lunch and dinner.

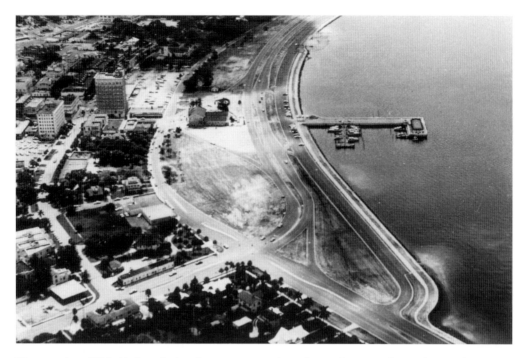

The rerouting of U.S. 41 along the bay front was not a universally popular move. *Courtesy Sarasota County History Center.*

The need for a first-class marina was high on the list of must-have items for Sarasota. In 1963 the city approved plans for a $300,000 project with 143 boat slips, called Marina Mar, with an upscale restaurant, shops, snack bar and amenities for the boaters. The Marina Mar complex was designed by architect Robert L. Shaw and built by E.E. "Gene" Simmons and was the perfect complement to a modern Sarasota.

Marina Mar soon failed and was taken over by Jack Graham, who transformed it into Marina Jack and guided it as it grew with the community. He called the area "Sarasota's front porch," and ran it for over thirty-three years.[162]

Ninety-two slips were added in 2005, bringing its total to 316. The Marina Jack restaurant continues as a popular first-class dining establishment and lounge. Today the Marina Jack complex is owned by Bob Soran, who also took over O'Leary's.

With the completion of Bayfront Drive, the venerable city hall building (Hover Arcade) was empty but not yet in harm's way. A proposal was made to turn it into a "Spanish-type Oasis" with plans drawn up for it by local architect William Zimmerman. It would augment a plan to turn Lower Main Street into a plaza.

Critics of the new bayfront plan were scathing in their remarks. A group of architects of the American Institute of Architects, in town for a regional conference, blasted the project that had effectively isolated downtown from Sarasota Bay. "Douglas Haskell, editor of the Architectural Forum said, 'It's Murder.' Haskell went on, 'It's a filthy, dirty crime…It's unforgivable and idiotic, cutting off the community from where five years ago people could go to the pier and enjoy the fishing and the bay.'" And in case his point was lost, added, "'I declare that

gorillas, chimpanzees, dogs, monkeys and jackasses could not do worse than they have done in Sarasota.'"

Paul Rudolph, formerly of Sarasota and a leading light in the Sarasota School of Architecture who was chairman of the Department of Architecture at Yale decried that the plan separated the center of the city 'from its greatest asset; the water.[163]

On February 1, 1959, on the front page of the Sunday morning edition of the *Sarasota Herald-Tribune*, an aerial photo appeared of Sarasota's Bayfront Drive, completed but not landscaped, with a caption noting the "vexing" problem of whether extensive parking should be allowed.

Landscape architect Roy Hull of the City Planning Board who designed the "Hull Bayfront Plan" said, "I cringe at using our only open areas on the bayfront for parking." He said people were not going to park there to do downtown shopping. He proved to be right.[164]

As early as the beginning of 1960 it was obvious that the plan for residents and visitors to "enjoy the bay in the panorama of light and shadow and sunset and dawn" would not be realized. "Now very few can enjoy it in that respect, since the whish of traffic is far from conducive to repose and contemplation of beauty. It is enough to get across, if across you must go, all in one piece."[165]

For old-timers who remember when downtown and Sarasota Bay were connected, that has been the lament ever since.

Concurrent with the Bayfront Drive, a new John Ringling Causeway and Bridge was in the offing. It too was fraught with controversy.

The first bridge, the one built by the great Ringling himself to open his developments on Lido Key, St. Armands Key and Longboat Key to the public, which he later turned over to the city, was opened with typical '20s fanfare. The colorful Czecho-Slovakian National Band was on hand for the occasion and a procession of cars was led by Ringling in one of his Rolls-Royces.

According to its designer and engineer, James A. Mortland, still active in the 1950s, the original bridge had been designed at Ringling's request to last only twenty years. Mortland, on hand for the new bridge opening, said he was proud that it lasted fourteen years longer than it was intended.

In 1952, the State submitted a $7 million Bayfront Road/bridge proposal, a package deal offering a four-lane bridge to replace the original Ringling Causeway and a two-lane bridge over Big Pass that would link Lido and Siesta Keys. Each bridge would charge a ten-cent toll. (Karl Bickel had been quoted about the Big Pass Bridge: "The Big Pass scheme which replaces the Twelfth Street location is the mystery. Apparently it was created in the dark, fostered in silence and handed to the State Road Board and through it to the people of Sarasota like a bright new bomb.")[166]

State Road Board Member Al Rogero was the point man for the state. He came to Sarasota in July to meet with locals and pitch the proposal. Interested citizens filled the Municipal Auditorium to listen to the plan, which included the Bayfront Road project.

Ultimately the Big Pass Bridge was taken off the table, as was the ten-cent toll, which was met with strident disapproval from the public. Ten cents was, after all, a dime.

After test pilings had been hammered into the bay bottom in April of 1957, construction on the bridge began on June 18, 1957, carried out by the Harding Contracting Company, which said their equipment could drive fourteen pilings a day. The $2 million causeway and bridge was approached from Bayfront Drive, not Golden Gate Point, which had been dredged and filled for the first causeway in the early '20s by Owen Burns.

On April 15, 1958, without flourish or fanfare, one of the spans of the new bridge was ready. A simple sawhorse with a "Road Closed" sign was removed, and the first car, a red 1958 Chevrolet, crossed.[167]

Work continued on the project through 1958 until, with suitable celebration, what was called the "City's Key Dream" became a reality. On hand for the great event were legislators, senators, local officials and hundreds of citizens who had watched the progress as they crossed over the old bridge.

It was a chilly January morning that greeted the crowds who gathered to hear the speeches and watch the ribbon cutting. A fleet of cars from Horn's Cars of Yesterday led a procession across, preceded by the Sarasota High School Marching Band. Sarasota Mayor-Commissioner Frederic Dennis served as the master of ceremonies and some of the speeches were (thankfully) abbreviated because of the chilly weather.

Al Rogero, the key to making the project a reality, was on hand to present the bridge to local officials in the name of Governor LeRoy Collins. He congratulated the contractors and called the bridge a symbol of cooperation.[168]

The next day, a full page in Kent McKinley's ever-feisty newspaper, *The News*, took credit for the fact that the bridge was toll free, calling it "the first major editorial campaign carried on by *The News*."[169]

Another hallmark event in 1959 was the construction of the new airport terminal at the Sarasota Bradenton Airport. Designed by Paul Rudolph, but scaled down because of cost constraints, it was dedicated on October 25, 1959.[170]

Unfortunately the terminal was considered too small for the needs of the growing community after it first opened. Thirty years later, on October 29, 1989, the new terminal was completed. At a cost of over $56 million it was built with the future growth of Sarasota and Manatee Counties in mind, and fifteen thousand curiosity seekers were on hand for the open house. Considered a "big city" airport, SRQ's (Sarasota-Bradenton International Airport) interior was designed to showcase many of the area's singular attributes, including a 2,400-gallon saltwater shark tank maintained by Mote Marine Laboratory, exotic tropical plants from the Marie Selby Botanical Gardens, a waterfall and numerous paintings, drawings and photographs of the area.

The airport is under the auspices of the Sarasota Manatee Airport Authority, whose executive director, Fredrick J. Piccolo, was hired on December 1, 1995. Piccolo faces the daunting task of attracting and keeping new carriers. He believes that the airport is "an economic engine" that attracts not only tourists, but also succeeds in getting businesses here.

Sarasota ended 1959 with the largest construction year in its history up to that time, with $12,331,366 in new construction, according to the Building Department. Projects included a new Sears on the South Trail at Bahia Vista accounting for $1,016,00; the new housing project in Newtown was $810,000; followed by a new YMCA for $240,000; a $215,000 addition to Sarasota Memorial Hospital; $223,500 for the Arvida Yacht Club on the site of the old Worcester Mansion on Bird Key; $315,000 for the Triton Apartments; and lesser amounts for a Galloway Furniture Store (a Sarasota School of Architecture building designed by Victor Lundy), Donald-Roberts Furniture and some offices and other businesses. Four hundred and twenty houses had been built that year.[171]

Post–World War II Growth and Development

Surpassing the importance of the new Ringling Causeway and Bayfront Drive for the community was the announcement that Arthur Vining Davis was coming to Sarasota with big plans. His Arvida Corporations development proposals for Bird Key and Longboat Key were to today's Sarasota what Andrew McAnsh's construction of the Mira Mar Apartments and Hotel had been to yesterday's.

Over one thousand real estate people gathered in the Municipal Auditorium to listen to Arvida's vision of the future. The immediate plan called for Bird Key to be expanded to make room for 511 home sites, 291 of which were to be on the waterfront and priced at $17,000 to $32,000. Interior lots sold for $9,000 to $15,000. To stoke the sales fire, Arvida offered the top three salespeople a twenty-seven-foot Chris Craft cabin cruiser or a new Lincoln Continental, an RCA console TV and a week trip to an exclusive hotel in Boca Raton.

In a full-page ad, Arvida declared, "It's a rare city here or abroad that has an iota of the charm of Sarasota. You'll find us good neighbors."

A new day had dawned in Sarasota and once again it would never be the same.

In 1967 Arvida unveiled grand plans for development on Otter Key, and the north and south end of Lido Beach. Otter Key was to be used for single- and multifamily homes with a park on the east end of the island.

They planned an eighteen-hole golf course with a clubhouse on South Lido Key, with a waterfront resort hotel and high-rise apartments. On North Lido Key they designed single-family residences.

The plan, however, was quashed.

The Save Our Bays Association, Inc., with John Bergen as the president, was formed on December 4, 1967, with thirty-two concerned citizens out to fight Arvida's bulkhead plan proposed to the city commission. They took a full-page ad in the *Sarasota Journal* prophesizing that in two years citizens would be asking, "WHAT HAPPENED TO SARASOTA?" if the Arvida request was granted by the city. At a contentious city hall meeting, most of the 250 in attendance spoke out against the plan. Over the objections of Arvida's attorney, Mayor Jack Betz allowed the Save Our Bays group to present a petition with one thousand signatures.[172]

To underscore their displeasure with the Arvida plan, on January 13, 1968, Save Our Bays held a "boatacade" with watercraft of all sizes, which spread along Lido and Otter Keys, honking their horns, blowing whistles and ringing bells. Bergen announced that the group would continue to police the waters of Sarasota Bay.[173]

Ted Sperling, a charter member and past president of the Save Our Bays and a city commissioner for six years, later led several campaigns for public acquisition of beach properties. He was one of those who pushed for a $7.75 million countywide bond to purchase land at South Lido Key, Otter Key and Casperson Beach and he also helped secure the land on North Lido Beach.[174]

Roger Flory, real estate man, publisher of the annual *Sarasota Visitors' Guide*, civic leader and perennial Sarasota booster, played key roles in two major Sarasota growth spurts. He had recalled that during the freewheeling 1920s when he first arrived in Sarasota from Chicago, "cash registers were singing" but noted that many developers' projects were not bona fide. Subdivisions were often laid out with no thought to drainage, utilities or other improvements. Fortune hunters bought on speculation and when all the shouting was over, they left Sarasota holding the bag.

By comparison, he noted that in the 1950s newcomers, some of whom trained here at the Sarasota and Venice airbases during World War II, bought property not for a quick resell, but to build their homes on and raise their families. Sarasota was drawing newcomers who planned to spend their lives here and were vitally concerned about their newly adopted community.

Summer tourism was on the rise. The number of rooms available for tourists tripled between 1946 and 1956; the number of restaurants doubled and offered three times the seating capacity; in 1955 the number of telephones increased to 18,087. Trailers soared from 5,388 registered in Florida in 1947 to 41,807 by 1954. Trailers in Sarasota increased from 94 to 3,283. In explaining the marked increase, it was noted, "They realize that their $10 a year license tag is all the taxes they pay." A mobile home show at the Municipal Auditorium drew 40,000 "trailer conscious" gawkers who walked through the latest offerings in mobile home life and were on hand to watch as Miss Jane Snyder of the Gulfshore Trailer City was crowned Mobile Home Park Queen.[175]

Advertisements for new housing subdivisions, new businesses including small strip centers and major shopping centers (the bane of downtown merchants) were filling the papers as the local real estate sales force increased, sans the fast-talking "binder-boys" of the previous generation.

Interestingly, A.B. Edwards, Sarasota's first real estate man, was still at the task in the late '50s, as was Roger Flory. They were joined in the 1950s by names that would become locally familiar: Don Boomhower, Inc., Art Clark, Derr & Associates, Walter Gruhler, R.H. Lopshire, Lucille M. Howe, Stuart-Embry Realtors, Jo Gill and Associates, Ed Younker, Irene W. Wooden, Jack Heritage, R.H. Fye ("See Fye Before You Sell or Buy") and numerous others.

After World War II, Martin Paver and his sons, Paul and Stanley Paver, formed Paver Construction Company and became a leader in local housing developments. In 1954 they offered $10,000 homes in the first addition of Paver Park Estates. Veterans were offered terms of no down payment and only $65 per month for a two-bedroom, one-bath house with screened porch, vinyl plastic floors, natural Birchwood kitchen cabinets and an in-the-wall heater. Non-vets had to pony up a $1,250 down payment.

Sarasota Springs billed itself as "Designed By Nature For Year Around Living" and called itself Sarasota's most beautifully planned development.[176]

Melody Heights off Lockwood Ridge Road promised, "Suburban Life In The City," offering 70- by 110-foot lots for $1,150, "Where Your Life Will Always Be a Song."[177]

The parade of new housing developments continued throughout the '50s with DeSoto Lakes offering home sites for $695 at 25 percent down and up to three years to pay. As one of their ads put it, "8,250 square feet of Florida Happiness for less than 10 cents a square foot," which included free title insurance, free deed recording, no closing costs, no fees and no city taxes—tough to pass up.

Advertised as Sarasota's first moderately priced split-level homes, Greenbriar Estates off Tuttle Avenue—"Florida Homes Designed for You"—sold twenty-three houses during their first week. At only $13,750 they were still nearly twice as much as the $6,995 homes in Sarasota Springs, where "Nature was Smiling."

Lake Sarasota Estates, a Tanner enterprise—"Your Way to Better Living"—offered lots from $695 and Philip Hiss, noted member of the Sarasota School of Architecture, advertised that some of his designs could be available. His model home drew national attention as *House and Garden* magazine planned a feature story on it.

In 1956 the first residents of Paver's new development, Kensington Park, were ready to move in. Sixty houses had been sold by July of 1956 and many more would be in the offing. By 1961 there were nearly seven hundred homes (with seven hundred more planned) and an adjacent shopping center was in the works. Prices for these homes ranged from $11,950 to $19,950 and Stanley Paver, president of Paver Construction Company, said, "It is our intention in these new models to show Mr. And Mrs. Public that Kensington Park Homes are designed for every family."[178]

Searcy Koen platted Oak Shores along Phillippi Creek off Bahia Vista in April of 1952. A longtime resident, Koen was active in community affairs and donated the property for the Lions Club, the Boys Club and the Salvation Army. When he died in 1992 he bequeathed a large sum of money for Pines of Sarasota Nursing Home on Orange Avenue.

Southgate, "The Beautiful King & Smith Development Where You Live Among the Orange Blossoms," opened with much flourish with homes going for $15,000. By November of 1957, the Roland S. King–Frank Smith project was offering 350 more home sites to the 1,550 lots that had already been sold, making it Sarasota's biggest community development.[179]

Richmond Construction Company was very active during this period and Laurence Richmond and his wife, Ruth, were recipients of the *McCall's* magazine Citation of Excellence for their designs in 1960, the first builders in Sarasota history to receive the prestigious award. They advertised their homes, which Ruth designed, with the slogan, "Live Better in the Best." In 1970 Ruth Richmond received the Woman of Achievement Award in Construction for her many years of quality, affordable houses.

If you were looking for less expensive quarters but did not want a trailer, the Jim Walter Corp. offered a shell of a home on your lot for as low as $995, with $25 down. This was their Lake Shore model, "the greatest home value ever offered the perfect size for the newly married or retired couple." For a home, it was diminutive but "easy to clean and economical to heat or cool."

A downtown Sarasota landmark, the Mira Mar Auditorium, which hosted many of the great performers of the previous generation, fell to progress in January of 1955. As it was razed, A.B. Edwards recalled that its upstairs had offered gambling for snowbirds during the boom years, operated by the Chicago concern of Conrad and Locke, who also ran the Golden Horseshoe. Edwards said the place was off-limits to locals.[180]

On Siesta Key, *The News* reported, "SIESTA KEY BOOMS IN SEVEN YEARS," offering as proof that its population went from a few hundred in 1948 to five hundred permanent residents by the end of 1954.[181]

In the mid-'50s two factors increased the comfort level in Sarasota and also the number of tourists who came during the summer months: air conditioning and the war on mosquitoes waged by Sarasota County and led by Mel Williams.

The upturn in in-home air conditioners was due to "housewives shopping in air conditioned stores and bread winners [remember this was the mid-'50s] working in air conditioned offices." They began demanding the same cool surroundings in their homes and cars, and manufacturers responded by developing low cost air conditioning systems.[182]

As for the mosquitoes, they were more than pesky irritants. They had always prevented pleasant summertime outdoor evenings. And while they had been "put up with" as part of life in Sarasota, they were preventing progress and they would have to go. Mel Williams was appointed director

of mosquito control in December 1945 and fought them, much like Churchill's World War II admonition, on the land, in the air and on the beaches. He waged an unrelenting campaign, and it could be argued that as much as any individual he turned Sarasota into a year-round resort.

Using fogger jeeps and airplanes, they sprayed the little swarming devils with DDT, Chlordane and malathion. Local flights, one manned by Sarasota High School teacher and former World War II PBY pilot Ed Swope, who would later become the assistant principal of Riverview High School, were called Operation Mosquito and the Dawn Patrol. While setbacks and adjustments in chemicals had to be made, Mel Williams won the war. (While the spraying was going on, neighborhood children often ran behind the foggers, which were belching out clouds of chemicals.)

A more urgent concern during the 1950s, a living nightmare for mothers, fathers and their children, was the polio scourge that put all in fear of a crippling life in an iron lung (often likened to an iron coffin), leg braces and crutches and possibly an early death. No one knew when, where or who the disease would strike, and parents kept their children out of swimming pools and theatres and away from communal drinking fountains. On October 22, 1954, *The News* noted that the disease struck a young Alta Vista schoolboy, the twenty-first local polio victim of the year. It wasn't until April of 1955 that local mass immunization with the Salk vaccine was begun on first- and second-grade schoolchildren. In 1960 the more popular Sabin oral vaccine became available. It provided lifelong immunity without the need for booster shots.

Another perennial problem in paradise, red tide, still stymies scientists to this day. 2005 was a particularly difficult year with month after month of dead fish being washed up on the shores of the gulf and bays with their accompanying stench. Finding a way to eradicate the toxic algae is elusive and some have conjectured that perhaps one of the causes is the runoff from homes and businesses. Sarasota's Mote Marine Laboratory requested $2 million a year from the state legislature to study ways to mitigate the problem.[183]

At the end of the 1950s, Sarasota shoppers had two major shopping centers to take their business to, and commerce shifted away from downtown, which went into a downward spiral.

Ringling Shopping Center, "where your every need can be filled in a one-stop shopping trip," with Publix Supermarket as its anchor, opened for business on what had been Bert Montressor's Golf Driving Range. The first stores in the center were Beauteria Beauty Shop, Belk-Lindsey Company, Coach Butterfield Toys, Center Shoe Repair, Jimmy Crews Barber Shop, Crowder Bros. Hardware, Darby Cleaners, Diana Shops, Grants Sweet Shop, Publix and the S&H Stamp Redemption Center, Touchton Rexall Drugs Store and F.W. Woolworth Co. The grand opening was November 15, 1955.

Ground was broken for the larger South Gate "$2,000,000 shopping center" in March of 1956 and was ready to open for business in January 1957, with both a Publix and a Winn Dixie grocery store. It was dubbed, "a glittering emporium of merchandising and a new era in shopping." Along with its two grocery store anchors it offered Coach Butterfield Toys, Cameras, Inc., Cinderella Bootery, Darby Cleaners, The Garden Spot, W.T. Grant Company, Glamour Shop, House of Gadgets, Lad & Lassie, Liggett Rexall Drugs, The Little Shop, Mae's Beauty Salon, Thom McCann Shoe Store, Sellers Barber Shop, South Gate Hardware, Woodrow Stores and F.W. Woolworth.

South Gate Shopping Center was transformed into the South Gate Plaza, and is today called the Westfield Shoppingtown Southgate, owned by Westfield America Trust of Texas, filled with a wide array of upscale stores.

The Sarasota Square Mall was purchased by Westfield America Trust in 2003 and, with its anchors of J.C. Penney and Sears and its multiscreen movie theatre, is pitched as a "family-oriented mall."[184]

Except for some cosmetic upgrades and changes in retail establishments, the Ringling Shopping Center has remained as it had always been.

Downtown Sarasota definitely felt the pinch, exacerbated when both J.C. Penney and Sears left Main Street. Many storefronts went vacant, and in 1964 the buildings along the south side of lower Main Street to Palm Avenue were razed to make way for the 150-space Central Parking Plaza. Amid the rubble were Badger's Drugs (the quintessential downtown gathering place), the Downey Building and Ellie's Book Shop, among others. In 1972 this area would be the site of the twelve-story First Federal Savings and Loan building, later known as the RISCORP Headquarters, and today the Zenith Building.

In 1962 the old Colonial Hotel (formerly the Watrous) at the northwest corner of Main Street and Palm Avenue was demolished. It had served as a hostelry since 1916 and was a victim of changing tastes in lodging and closed, becoming a rundown firetrap.

The Orange Blossom Hotel was another victim of the desire for beachfront accommodations. It closed in 1965 to be reopened in 1968 as retirement apartments. Sarasota developer Jay Foley bought the building in 1994 for a reported $600,000 and renovated it into condominiums in 1999, saving two upper floors for his personal residence.

The Ritz Theatre on upper Main Street quit showing movies at the end of 1965. Its final films, *Roustabout* and *How To Stuff A Wild Bikini*, were shown on December 20. Built in 1916 as the Virginian, it had, along with the Florida Theatre (formerly the Edwards Theatre), which would close in March of 1973 with *Black Gun*, been a major downtown drawing card for generations.

The new city hall building on First Street was ready for occupancy in 1967. Designed by the prolific Jack West of the Sarasota School of Architecture, the original budget of $1 million was whittled down to $600,000 and West was told that the budget could not be increased nor could size of the building be reduced. West wrote that the low bidder was local contractor Gene Simmons at $840,000 and noted of the difference, "The architect could not eat or sleep."[185]

West wrote that the plans were revised, and concrete block was substituted for the brick. "Aspects of the City Hall project were heartbreaking; but not the major sculpture...I chose my friend Jack Cartlidge, an extremely talented and less than fully appreciated local sculptor, who produced a $100,000 monumental sculpture in copper for $4,000. The sculpture depicted the five city commissioners and was entitled 'Nobody's Listening.' No one understood the delicious humor except the sculptor, the architect and Ken Thompson, the city manager."[186]

In 1968 West's design of city hall won an award from the Florida Association of the American Institute of Architects, which cited it as "a place to carry on municipal business without pomposity."[187]

With Mayor Jack Betz, Vice Mayor David Cohen, Commissioner Gil Waters and numerous other local dignitaries looking on, A.B. Edwards cut the ribbon to open the new building to the public on December 11, 1967. All former city councilmen were invited to attend the ceremony.

The spread outward continued unabated and the county grew. In 1970 the county population had increased from the 1960 number of 76,083 to 120,413. During the same period the city population went from 34,083 to 40,237.

In 1971, the boom-time Hotel Sarasota was closed, being seen as a fire hazard. Sarasota's first skyscraper, it was the first downtown property to sell for over $1,000 a front foot. It would be remodeled into offices. Today the first floor of the building is the popular site of Andrew and Meghan Foley's Sarasota News and Books.

While the Ritz Theatre would be razed to make way for a series of Main Street retail shops, the Florida Theatre was renovated and continues to draw downtowners as the Sarasota Opera House, a major cultural attraction.

Other long-standing buildings on Main Street to be demolished were the Hotel DeSoto (not Gillespie's earlier hotel), which had been built by Stanley A. Weida circa 1913 as the Weida Hotel. A few doors west of the Seaboard Air Line Railway Station, it was popular until the 1950s, fell into disrepair and closed as a hotel in 1956. Downtown merchant and property owner James Hanna, who had been a merchant in Sarasota since 1932, bought it and for a time its first floor was used for retail businesses. It was demolished in 1973.

Perhaps nothing better illustrates the decline of the downtown during this era than the fact that one of the vacant buildings at 1437 Main Street was opened as an adult bookstore in 1971.

Another building on upper Main Street to be leveled was the J.C. Penney building that went down in 1976. It, too, was owned by Hanna.

Lemon Avenue and Main Street had been the point of entry into the community since 1903, when the West India Railroad and Steamship Company, which would become the Seaboard Air Line, began service. A brick building was erected there in 1912, which was replaced in 1937 with a modern-looking depot designed by Frank C. Martin (son of Thomas Reed Martin) of the Martin Studio of Architecture. At the dedication ceremony, Mayor E.A. Smith intoned, "The Seaboard doesn't build stations like this in towns that aren't going anywhere." Among the trains were the Orange Blossom Special, Suwannee River Special, 'Cross Florida Limited and the Coast to Coast Limited.

At the east terminus of Main Street, where the Kane Building is today, was the Atlantic Coastline Railway station. Built in 1925 of Spanish Mission design, it was said to be a tribute to the certainty of Sarasota's future.

The two train companies merged in 1967, becoming the Seaboard Coast Line Railroad Company, and used the passenger station of the Atlantic Coast Line Railroad. The Seaboard station was demolished in 1973 and the Atlantic Coast Line Station was torn down in January of 1986, having served a few years as a Brewmasters Restaurant.[188]

In 1940 Venice had only 507 permanent residents. The influx of servicemen during World War II jumped the number considerably, but in 1950 only 727 souls called Venice their home.

Although progress was slow, the community was inching along and by 1953 required new educational facilities. Venice Elementary School was dedicated on October 27 of that year, with the school's architects, Werner Kannenberg and Arthur Hanebuth, on hand to present a set of keys to the building to acting Principal Joseph Camp.

In 1955, construction was underway for the new Venice-Nokomis High School. Their original high school graduated its first class of four boys and four girls in 1930 and was woefully inadequate

by the '50s. The new school was dedicated in December of 1955 and so was Sarasota's Brookside Junior High School.

Venice Gardens, a large development in Venice begun in 1956 by Murray Morin, contained approximately 2,600 building lots. Morin strived for "an architectural balance stressing individuality which will not permit any possibility of sameness of design."[189] Home sites sold for $25 down and $25 per month and by 1960, when Venice had a population of 3,444, Venice Gardens was home to three hundred families. The "Jewel" by Integrity Homes sold there for $12,750 in 1961.

The big news for Venice in 1960 concerned the Ringling Bros. and Barnum & Bailey Circus, which moved their new winter headquarters there. As the show prepared in Sarasota for its ninetieth edition, circus clown Pat Valdo remarked of this last stint in the Circus City, "It's kind of a sad thing."[190]

When that year's season ended, the circus headed to its new home in Venice, arriving on November 29, 1960. Greeted by Venice Mayor Smyth Brohard, a reported ten thousand people lined the two-mile parade route and cheered as the trains were unloaded of their animals and marched to their headquarters. The parade was led by VFW Vice Commander Frank Korinek driving a ¾ replica of a 1901 Oldsmobile with a sign, "Venice Welcomes the Greatest Show on Earth."[191]

Their new circus headquarters would be inside a five thousand-seat arena at the Venice airstrip, a new "little Madison Square Garden."

In 1961, for the first time in Sarasota County history, the ninety-first edition of the Ringling Brothers and Barnum & Bailey Circus premiered in Venice.

General Development Corporation, a subsidiary of the Mackle Company, had purchased approximately one hundred thousand acres and incorporated it into North Port Charlotte in 1959. The twenty-one residents there voted to annex forty-seven square miles more, thus becoming one of the largest municipalities (and least populated) in Florida. The residents, employees for General Development, were allowed to live there free for one year.[192]

By 1960 North Port Charlotte still had a population of only 178, which jumped to 2,684 in 1970.

Home sites, twenty-five thousand of them, were advertised for $10 down and $10 per month for ten years and the Mackle brothers, Frank, Elliott and Robert, offered completed homes for $8,970 for a two-bedroom model, or a three-bedroom, two-bath home for $16,260 with easy terms of $860 down and $110 per month.[193]

The Mackles, who had built many homes on Key Biscayne, Coquina Key and Port Malabar subdivision, were out of North Port Charlotte by 1961 but in 1962 had begun construction on Marco Islands and in 1963 started Deltona Lakes, leaving a lasting mark on Florida.

The development was dormant for years; people from the North quit sending their money down and lost what they had invested. Except for miles of roads, there was no infrastructure in place.

At the other end of the county, in November of 1955 Longboat Key residents met at the Longboat Key Firehouse and 199 of the 252 qualified electors, spurred on by "the Negro beach question," voted on November 14 to incorporate. The Town of Longboat's first mayor, Wilfred LePage, was sworn in by County Judge John Justice.[194]

In the early years the Key was a haven for Indian and Cuban fisherman who camped there. The first permanent white settler was Thomas Mann, a Civil War veteran from Indiana who had

settled in Bradenton but left for the Key with his family to escape the yellow fever epidemic, and farmed on the north end of the island.[195]

Farming and fishing were the mainstays of the island for many years, with John Savarese providing the means, through his fleet of boats, to get the goods to market and keep supplies coming in.

The north end of the island was called Longbeach with the filing of a plat in 1911. A postmaster was appointed in 1914 and the name was maintained until Longboat Key was incorporated in 1955.[196]

The south end of the island was homesteaded by Byron Corey, who was appointed postmaster in 1907, serving twenty-five people. They raised avocados, guava, papaya, tomato and hogs and in order to get the crops and meat to market, Corey built a dock into the bay for pickup. But the hurricane of 1921 flooded the island, taking out the dock with his house and post office and ruining the crops. Most of the residents left and the post office was closed.[197]

Just prior to the land boom of the 1920s, Owen Burns began buying up property on the south end of the Key from individual landowners for John Ringling, who had big plans for Longboat Key. In a three-page letter dated March 30, 1923, Burns wrote Ringling of his progress: seventy-one acres of the Woods property was purchased for $3,000; for the Edmondson property, the exact acreage was difficult to pinpoint but the price was $4,500; the thirty-four acres of the Rodriguez property was going to be difficult to negotiate as he wouldn't sell for less than $200; the Rorer property would go for $100 per acre for thirty-two acres. He told Ringling that the Palmers were also going to sell their holdings.[198]

Soon the south end of Longboat Key would be the setting for Ringling's grand Ritz-Carlton Hotel and golf course.

Longboat Key came to a standstill with the 1920s real estate bust. It was used for a practice bombing range during World War II, and there were still relatively few homes on it in the mid-'50s. Lodging for out-of-towners was provided by unobtrusive mom-and-pop type cottages and a few motels. On the southern tip stood John Ringling's ill-fated Ritz-Carlton Hotel, a forlorn reminder of the 1920s real estate bust. Nearly completed, it became an adventurous site to explore and several people were killed falling down the elevator shaft. Arvida razed it in 1964.

In the late 1940s, Herbert Field arrived and began developing on the Key. He established the Colony Beach Club Resort in 1954, the Far Horizons in 1956, the Buccaneer Inn in 1957, the Sea Horse and Field's Yacht and Tennis Club in 1968 and the Sea Horse beach resort.

Field had helped found the town of Longboat Key and was active in both Sarasota and Longboat Key. He served on the Sarasota County School Board for eight years and was its chairman for six years. He also served on the Sarasota County commission for eighteen months, having been appointed by the governor, and was vice-mayor and a commissioner of Longboat Key.

Field's vision for the Key was in marked contrast to how the area was later developed by Arvida. According to longtime Longboat Key restaurateur Edith Barr Dunn, owner of Schenkel's, Field didn't want anything higher than the tallest palm tree on Longboat Key.[199]

The Colony Beach Club was bought in 1969 by Dr. Murray "Murph" Klauber, an orthodontist from Buffalo, New York. He changed the name to the Colony Beach and Tennis Resort and it is perennially one of the top-rated resorts in the country.

Post–World War II Growth and Development

The '50s building spree throughout Sarasota was not without its detractors who felt, even then, that the community was losing some of the sleepy time charm and ambiance that had drawn so many, writers and artists included, for inspiration and a casual, slow-paced lifestyle.

Lido was beginning to fill with beachfront accommodations. By 1958 lodging there included the Lido Biltmore Club, the Emerald Shore, Gulf Cove Motel, Sand Castle, Three Crowns, Azure Tides ("It's Gracious, It's Continental"), Gulf Beach, Surf View, Sun Tide, Surf and Sand, Coquina Hotel Court, White Sands Cottages and the Li-Sota.

Mrs. Mary Freeman, a local, nationally known author, said that she hoped Sarasota would "sober up" from its "progress intoxication." She warned that "her city might turn into an imitation Miami, populated by 'pasty, paunched men with big cigars.'" She offered that it was still not too late to take matters in hand; "the citizens must make a more intelligent and louder noise than the speculator." She had made her views known in *The Nation* magazine with the story "American Myth—You Can't Stop Progress."[200]

Less alarming was a warning issued by the City in a 1960 brochure concerning land use. Among the anticipated problems, "Today/Tomorrow in Sarasota" noted: "A change in the image of Sarasota; Destruction of distinctive charm of residential areas; mis-location of public facilities and private developments; inefficient land use patterns; worsening traffic congestion; central commercial blight, and unanticipated high public costs."[201]

In 1961 construction was underway for Gulf Stream Towers, a downtown condominium on Gulf Stream Avenue. It would be the forerunner of a new style of downtown living that has swept that section of Sarasota, continuing through 2005 with no signs of abating.

Irving Z. Mann is often credited with being the father of condominiums in Sarasota. He had come here from Miami and, according to well-known real estate man and civic leader Parker Banzhaf, "He phonetically spelled condominium on the sign so people would know how to pronounce it. He was a very, very likeable guy." Banzhaf recalled that Mann set a building pace that awakened the sleepy fishing village. "He was the first condominium developer in the city. He was innovative and he did things this city is proud of," said former Mayor Jack Betz.[202]

During the 1950s and 1960s the "look" of Sarasota was changing away from the predominant old-fashioned Mediterranean Revival/Spanish Mission style of architecture. A group of talented architects who collectively became known as members of the Sarasota School of Architecture found in Sarasota the perfect spot to showcase their modern designs.

Mentored by Board of Public Instruction Chairman Phil Hiss, they were responsible for a number of innovative school designs including the Alta-Vista butterfly wing (Victor Lundy), the new addition to Sarasota High School (Paul Rudolph) and Riverview High School (Paul Rudolph), Brookside Junior High School (the first modern school, which came in "on time and under budget" and laid the groundwork for the others, Ralph and William Zimmerman). They also built numerous condominiums, businesses, churches and public buildings, including St. Paul's Lutheran Church on Bahia Vista Street (Victor Lundy), the Summerhouse Restaurant (Carl Abbott), the Siesta Key Beach pavilion (Tim Seibert), Nokomis Beach pavilion (Jack West) and the Sarasota city hall building (Jack West). Their innovative designs, which brought "the outside, in," put Sarasota on the international map and included Ralph Twitchell (considered the grandfather of the school), Paul Rudolph, Edward "Tim" Seibert, Mark Hampton, Bert Brosmith, Gene Leedy, Jack West, Victor Lundy, Carl Abbott, Ralph and William Zimmerman,

Some of the members of the Sarasota School of Architecture. *Courtesy Sarasota County History Center, from Sarasota School of Architecture by John Howey.*

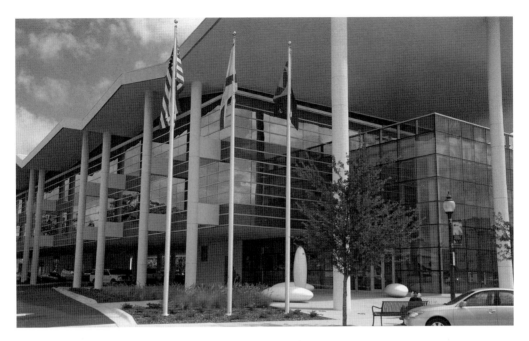

The new *Sarasota Herald-Tribune* building. *Photo by Ed Lederman.*

Frank Folsom Smith, John M. Crowell, Albert Moore Saxe, Jack Beatty, Arthur Hanenbuth, Werner Kannenberg and Roland W. Sellew.

Of this group, Frank Folsom Smith designed Plymouth Harbor on Coon Key. At twenty-four stories, this hallmark building is still the tallest in Sarasota. It opened its doors on January 15, 1966, and continues to provide superlative service and accommodations for its residents.

Seibert, one of the most prolific of the group, was responsible for a number of projects on Longboat Key for Arvida and the Bay Plaza condominium downtown. His design of the Cooney House won the AIA Florida Test of Time Award.

The designs of these men were featured in such publications as *Life*, *Look*, *Time* and the *Saturday Evening Post* and although much of their work, particularly their signature beach homes on Lido, Siesta and Casey Key, have been razed to make way for the newly popular "mega-homes," there has been a resurgence in their popularity and people from all over the country and the world come to Sarasota for a look-see of their work.

As Sarasota inspired such men as those of the Sarasota School of Architecture, renowned writers and artists who moved here to be creative were similarly stimulated. The unblemished beauty of the area was truly inspiring, and the casual and relaxed lifestyle combined with the friendly, unaffected locals made for a unique setting.

Drawn here were such talented artists as Helen Sawyer, William Hartman, Wells Sawyer, Syd Solomon, Ben Stahl, Jon Corbino, Jerry Farnsworth, Julio de Diego, Thornton Utz, Hilton Leech, Lois Bartlett Tracy and so many others.

The Ringling School of Art and Design opened with the auspicious name of The School of Fine and Applied Arts of the John and Mable Ringling Museum of Art on October 2, 1931. It was led for many years by Verman Kimbrough, whose administrative skills kept it afloat during

and through the Great Depression. During the early 1940s Kimbrough and his family moved into the dorms and operated the institution as a large family. Eula Castle, who was seeking a position with the school, was told by Kimbrough, "We cannot do better than room and board in the dormitory and $25.00 per month for someone to teach Interior Decoration..."[203]

While the Ringling School of Art and Design is the most famous of Sarasota's art schools, others sprang up to take advantage of skills of resident artists. Among these are the Amagansett Art School of Hilton Leech, Irene M. Jensen's Art School and the Longboat Key Art Center.

And of course to round out the artist scene, numerous galleries have opened over the years to showcase artists' works and their colony and neophyte artists have been served since 1926 by the Sarasota Art Association, known today as Art Center Sarasota.

In 1953, a group of noted local women artists formed the Petticoat Painters. Their total is capped at twenty and the original group was composed of Marty Hartman, Judy Shepard Axe, Elsinore Budd, Stella Coler, Genevieve Hamel, Betty Warren, Eve Root and Helen Sawyer, who is referred to as the "heart of the Sarasota art world" in *A History of Visual Art in Sarasota*. Later the painters took in Mildred Adams, Shirley Clement, Sally Boyd Dillard, Dorothy Sherman Leech, Helen Frank Protas, Elsa Selian and Rose H. Spitzer.[204]

The writers' colony was equally well represented and included Pulitzer Prize winner MacKinlay Kantor; mystery writer John D. MacDonald; Joseph Hayes, author of *The Desperate Hours*; Duane Decker; Richard Glendinning; novelist and short story writer Wyatt Blassingame; Walter Farley, who authored *The Black Stallion*; and numerous others. This group and some of their artist friends met for many years at the Plaza Restaurant, the quintessential Sarasota eatery and bar, and ate, drank and played Liars Poker. (That women were not allowed was a hard and fast rule.)

Returning to local government, Ken Thompson was an impossible act to follow. After one attempt to oust him in 1959 failed (the motion to fire him died for want of a second), he was entrenched, the perennial power in Sarasota city government. As succeeding city commissioners came and went, City Manager Ken Thompson was always there to greet them and then to bid them goodbye when their term was up or when they lost an election. He guided Sarasota from 1950 to 1988, the longest tenure of any city manager in the country.

Thompson always had an eye on protecting and enhancing the community's cultural heritage and potential. Among his many accomplishments was convincing the state to buy the south end of Lido Key from Arvida, which was planning a golf course there. Today it is South Lido Park, owned by Sarasota County.[205]

The city named Ken Thompson Park and Ken Thompson Parkway on City Island in his honor.

Thompson was succeeded by David Sollenberger, an affable, soft-spoken former teacher whose fourteen-year tenure as city manager was likened to a roller coaster ride. A real gentleman, he seemed to be frequently only one vote away from being ousted by his bosses, the city commissioners.

Keeping five bosses pleased, each with their own agenda and constituency to assuage, was no easy task in an ever-changing always growing city. Bruce Franklin, president of the ADP Group, an active planning and architectural firm in Sarasota, said, "It's hard to be effective when you always have to have your finger in the air, trying to see how the wind is blowing and trying not to offend five different bosses going in five different directions."

SARASOTA FORECAST:
Outlook Bright —
Future Promising

Sarasota Herald-Tribune

OCTOBER 16, 1959

ARVIDA ANNOUNCES BIRD KEY PLANS

Bird Key to Have 291 Waterfront Lots!

New Development Will Also Have 220 Off-Water Sites

Present at last night's meeting was Milton N. Weir, President of Arvida Corporation. Mr. Weir's experience as Senior Partner of M. N. Weir & Sons, Inc., has given him a keen insight on the Florida Real Estate market. He predicts that Bird Key will rank high among Florida's finest residential developments.

Brokers Pack Auditorium for Presentation Meeting!!

Crowd in Festive Mood as Arvida Unveils Plans

Ringling Estate Becomes Site of Bird Key Yacht Club

Bird Key Yacht Club

Elaborate Gates to Mark Bird Key Entrance

Arvida's announcement, "You will find us good neighbors." *Courtesy Sarasota County History Center.*

The John Ringling Causeway; for many it was "A Bridge Too High." *Photo by Ed Lederman.*

Sollenberger came to Sarasota in 1987 and recalled in an interview with *Sarasota Herald-Tribune* columnist Charlie Huisking that "he was most proud of his efforts to make downtown more vibrant and attractive." With the notable assistance of his development director, Don Jakeway, he helped to establish small downtown parks and called the completion of Selby Five Points Park "a major statement in where we were going."[206]

From the mid-'70s until 2002, Paul Thorpe, tagged "Mister Downtown" for all of his years of service there, was active with the Downtown Association, a group he co-founded and was executive director of for twelve years. Through his leadership the group sponsored numerous downtown activities to draw people, including an annual Fourth of July Fireworks celebration on Island Park, parades, festivals and the hugely popular Saturday morning Farmers' Market.

Thorpe had also pushed for a new downtown bus station and lobbied for a downtown grocery store, which was realized when Whole Foods Market Centre opened at 1451 First Street on December 8, 2004, having garnered some controversial concessions from the city, reportedly $6.5 million mostly in land and tax breaks.[207]

Downtown Sarasota was given direction during a three-day charrette sponsored by the American Institute of Architects, who met here in 1984. The Regional Urban Design Associate Team mapped out a downtown that had an anchor at each end of Main Street, much like a mall, which would facilitate foot traffic from one end of town to the other, feeding into the smaller businesses along the way. Their proposals also called for a "necklace of green parks."

Ernie Ritz and Bruce Franklin, both very active in downtown development, felt that the design team left an important guide for the beautification and resurgence of Sarasota in the 2000s; they saw the RUDAT plan as the spark that started the transformation of

Controversy surrounded the design and placement of the Selby Library. *Photo by Ed Lederman.*

downtown. The plan was followed by Sollenberger and the hardworking development director Don Jakeway.[208]

Sollenberger also oversaw the construction of the $8.5 million Ed Smith Stadium and negotiated contracts with the Chicago White Sox and then the Cincinnati Red Sox. Among his most pressing responsibilities were the implementation of $19 million in parks, roads and draining projects provided by a bond issue, and overseeing the redevelopment of downtown Sarasota.

Although the John Ringling Towers, a significant landmark listed on the National Register of Historic Places, was razed along with the Karl Bickel House during his time in office, he pushed to purchase and save the Federal Building on Orange Avenue.

In the end, Sollenberger was brought down by the cost overruns and other problems associated with the renovation of the Van Wezel Performing Arts Hall, a project he called his "Titanic."[209]

Even his critics on the commission had nothing but kind words for him after he was forced to retire in March of 2001. Multiterm commissioner and supporter Gene Pillot said he was "a strong administrator with absolute integrity." Commissioner Carolyn Mason, who voted for his ouster, said, "He is a fine person, a kind person."[210]

The east end of Main Street was rejuvenated through the efforts of a retired orthopedic surgeon, Dr. Mark Kauffman, and his partner, attorney David Band. Their construction of the Main Plaza and then linking to it the Hollywood 20, which opened in May of 1997, has brought millions of people to that end of Main Street.

Still active at seventy-three, Kauffman also developed the ten-story Courthouse Center at Main Street and U.S. 301, a combination of office, retail, condo and parking.

Kauffman, who has other major projects in the works, was quoted in a Kevin McQuaid article: "I guess I flunked retirement."[211]

After Sollenberger, next in the city manager's position, a veritable hot seat, was Michael McNees, up from Collier County where he had been the assistant county administrator. McNees, an amateur actor, came on board in September 2001 as real estate became frenetic with construction cranes dotting downtown, raising numerous high-rise condominiums. He too has been beset by controversy, which has become an integral part of that job.

One of the most contentious and controversial issues in Sarasota's history whirled around the construction of the newest John Ringling Causeway Bridge. Many in the community, and the city commission, at least initially, thought that the bridge was too imposing (as tall as an eight-story building), that the view of the bay was hidden behind its cement rail and from the land it was also, to them, obtrusive.

After a fierce struggle pitting the city commission and its anti-bridge allies against the Department of Transportation, the DOT won. The reportedly $67.7 million cost of construction was over twice the original cost estimate.[212]

Designed and constructed by PCL Civil Constructors Inc., work got underway in the fall of 2001. The bridge is 3,097 feet long, 107 feet wide (said to be the widest bridge of its type) and made of a series of pre-cast cantilevers that were barged to the site from where they were constructed in Palmetto and fit into place. Although it came with only a five-year warranty, it was said that the bridge would last at least seventy-five years.[213]

This, the third John Ringling Bridge, was dedicated on August 30, 2003. Festivities included a morning run across the span sponsored by the Manasota Track Club, speeches by public officials, a flotilla of boats, a procession of antique cars led by the Sarasota High School marching band (like the dedication of the second Ringling Causeway) and an evening fireworks display.

The acrimonious fight to stop the bridge was by then long over and the citizens joined together to celebrate and to move forward.

Another major construction project filled with controversy and contention was the design and placement of the new 73,000-square-foot Selby Public Library. Opponents of the downtown site at Five Points, led by, among others, Harriet Oxman, president of the Friends of Selby Library, wanted the library moved from its location at Boulevard of the Arts to the Mission Harbor property north of Boulevard of the Arts, which was larger, more centrally located and offered more parking spaces.

The original Selby Library had been housed in a 31,000-square-foot building designed by the Chicago architectural firm Skidmore, Owings, & Merrill and situated on 4.7 acres of land on Sarasota Bay. It had been dedicated on August 26, 1976. Today this is the site of the G.WIZ-The Hands-On Science Museum.

By the 1990s the library was too small and new quarters were sought, setting up the divisive battle of where to place it. It became a hotly contested issue between interested citizens, county commissioners, city commissioners and the aforementioned Friends of Selby Library. Ultimately the downtown proponents won out and the library was ready for its grand opening on August 1, 1998.

Designed by Eugene Aubry, lead designer for Hoyt Architects, by the time it was opened the rancor had subsided and its Friends group is an integral part of its success. Liz Beatrice, the head

librarian, included among her original staff Trudy Clemence, with forty years of experience as the reference librarian, having been a part of the staff when the library was located in the Chidsey Building many years before.

One of the popular features of the library is the arched 3,700-gallon aquarium, made possible thanks to a donation from businessman Charles Stottlemyer and his wife, Dee.

The Sarasota County library system has expanded to meet the needs of the ever-growing county and today includes the Frances T. Bourne Jacaranda Public Library (Bourne had labored and lobbied tirelessly for the area libraries); the Venice Library; the Fruitville Library, dedicated on December 8, 2001; the Elsie Quirk Pubic Library in Englewood (Elsie Quirk and her husband Wellington saw the need for a library in Englewood and donated the money for it); the North Port Library, which opened in 1975; the Gulf Gate Library, which opened on December 5, 1983; the Longboat Key Library (not a part of the Sarasota County system); and in Newtown, the newest library, the North Sarasota Public Library, which was formally opened with a ribbon-cutting ceremony on October 30, 2004.

Daily Diversions

E QUAL IN IMPORTANCE AS EASE of transport and suitable accommodation to bring flocks of snowbirds to sunny Sarasota was providing them with the means to occupy their time during their stay and, hopefully, bring them back.

This was recognized early on by the progressive element in the small community, even before Sarasota broke away from Manatee County in 1921.

Initially, the draw was for the sporting opportunities and our "salubrious climate." Fishing here was unequalled anywhere and game for hunting was abundant. Displays of the catches of the day were often showcased on racks in front of the hotels where the fisherman was staying. Photographs of the proud anglers and hunters with their rod or rifle in hand invariably made it into promotional material that was sent throughout the country. The number of fish caught and their size was regularly reported in the local press.

Indeed, fishing became a mainstay in Sarasota's early popularity and gave rise to an abundance of cottage industries: commercial fisheries, fish camps, fishing guides and charter fishing boats (the *Captain Anderson* was perennially popular). Bait and tackle stores like Tucker's Sporting Goods ("Tucker's Tackle Takes 'Em"), the Tackle Box on upper Main Street (run by Gordon Brye), Dan Byrd's New Pass Bait Shop and Hart's Landing were among the more popular fishing-oriented establishments in town.

The original John Ringling Bridge became a haven for fishermen who had no difficulty reeling in as many fish as they had the strength to get over the railing. Adjacent to the old causeway, Deamus Hart opened Hart's Landing in 1934, moving to his present site in 1964, which is currently operated by his son, Dennis.

The popular Tarpon Tournament started here in 1930 and continues to draw fishermen from around the country to this day. Even the "Spirit of Sarasota" was depicted in an Asa Cassidy painting as a winsome beauty, waving from astride a tarpon in Sarasota waters.

Fish are not as bountiful today, but it remains a popular pastime and today's popular fisherman and telecaster Captain Johnny Walker's signoff, "Take your kid fishing, because someday he may take you," are good words to live by.

Fishing could not stand alone as a drawing card, nor could the gentlemanly pastime of golf, a sport brought to Sarasota (and Florida) by Scotsman Gillespie, who almost immediately laid out a two-hole practice course, followed in 1905 by a nine-hole course east of town, beginning at today's Links Avenue.

In 1916, the course, then under the ownership of Owen Burns, was put in first-class condition; its 120 acres said to be in "an ideal location in an ideal city for an ideal people that like this ideal sport." Burns's brother, Edward O. Burns, was in charge of the upgrade, and with the help of

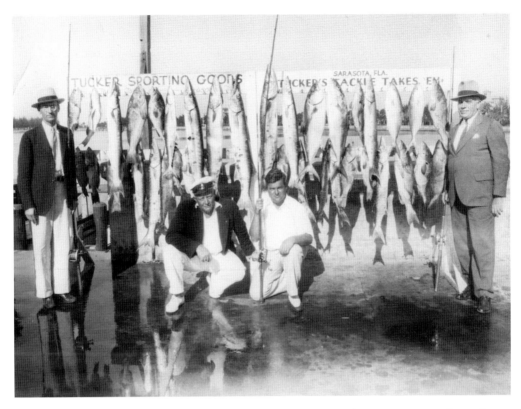

Sarasota Bay once teemed with all manner of fish, and you could take 'em with Tucker's Tackle. *Courtesy Sarasota County History Center, George I. "Pete" Esthus Collection.*

Leonard Reid, who had worked for Gillespie for many years, was put in such great condition that "when Northern people learn what a fine course Sarasota has, they will flock here in great numbers." The distance between holes varied from 150 to 550 yards.[214]

The course was used until May of 1926, when it made way for the growth that was taking place in the area: the Sarasota County Courthouse, the Atlantic Coastline Depot and the Sarasota Terrace Hotel.

The first eighteen-hole course in the area was the Whitfield Estates Country Club (today the Sara Bay Country Club), opened in conjunction with Whitfield Estates. On hand for the opening was Bobby Jones, who played a seventy-two-hole match with fellow golfing great Walter Hagen. Jones was employed by Whitfield Estates developer George Adair of Atlanta as a sales vice-president.

The Bobby Jones Municipal Golf Course in Sarasota (some thought it should have been named to honor J. Hamilton Gillespie) was opened on Sunday, February 13, 1927, with Bobby Jones the star attraction. He played a match against Watts Gunn and was given a Pierce-Arrow automobile for his efforts. (The *Sarasota Herald* called him "Sarasota's Own.")

Both of these courses were designed by Donald Ross, the most famous golf course architect of the day, as was the Longboat Key Course, adjacent to John Ringling's ill-fated Ritz-Carlton Hotel.

In 1910, the *Sarasota Times* had lobbied for a local brass band, noting that "There is nothing that gives so much snap and go to a town as a brass band." The band was soon formed and played at many local functions and welcoming receptions.

The Sarasota Minstrels also performed regularly for locals and out-of-towners, as did the City of Sarasota Band, under the direction of Merle Evans. A sampling of what Evans offered from the winter season 1927–28 program: "The Conqueror" by Tieke, "Maxmillian Robespierre" by Litloff, "Hungarian Fantasia" by Tobani, "Blue Danube Waltz" by Strauss and for some of the less highbrow members of the audience: "Plantation Songs of the Sunny South" by Lampe and a novelty tune, "The Whistling Farmer Boy" by Fillmore; quite an eclectic variety of music. Evans distinguished himself as the bandmaster for the Ringling Bros. Circus Band for fifty years, never missing a single show in thirty thousand performances. The American Federation of Musicians credited Evans with playing to more persons than any musician in history.[215]

The municipal band was also led for a time by Voltaire Sturgis, who would form and lead the Sarasota High School band from 1930 until 1956.

Another local winter season favorite was the Czecho-Slovakian National Band, brought to Sarasota by John Ringling to add color and excitement to the opening of the John Ringling Causeway and his Ringling Isles development. The group played free concerts downtown at a band shell at the Mira Mar Park and also at St. Armands Circle. Attired in the colorful costumes of their homeland, they were invariably on hand to spice up the numerous grand opening celebrations taking place throughout Sarasota during the land boom. Their rousing performances were often preceded by a march down Main Street to their bandstand. During the off-season they performed in New York City at Coney Island.

As early as the 1910s, hotels offered their guests entertainment. The Belle Haven provided music by the Belle Haven Inn Quartet. Dances were always popular, whether at in-home gatherings with family and friends or at a hotel to mark a special occasion.

In 1912, the Sarasota House celebrated the yuletide with a dance and banquet, "the most brilliant social affair of the season." The long porch was decked out with colorful Japanese lanterns, draperies in "holiday colors" and potted palms. Thanks to the beneficence of the Sarasota Ice & Electric Company, the lights were left on all night. After dancing, locals and snowbirds were treated to a "feast of good things": oysters on the half shell, stone crab salad, celery, sliced tomatoes, olives, cold chicken, cold ham, potato salad, ice cream, cake, coffee, candies and salted nuts. "Patriotic" punch, probably not spiked (at least in the bowl), was served.

King's Orchestra from St. Petersburg, musicians "adept in their line," provided the music. After many toasts by Dr. Jack Halton, physician and civic leader, to "good will and peace," the festivities ended.

Such genteel and homespun gatherings did not die off with the Roaring '20s. But the wants and needs of the era's "flaming youth" were served up with new dances, new rhythms, racy movies and new personalities, all to the chagrin of their elders, who thought that America's youngsters were surely headed to fire and brimstone. Patriotic punch may have still been available, but the party (and backseat) drink of choice was often produced in a tub and poured from a hip flask.

Bobbed hair girls aped Clara Bow, the "It" girl, while their suitors, with slick-backed hair, turned to the likes of Rudolph Valentino for their cues. Cigarettes were heavily advertised for young ladies

whose former admonishment, "Lips that touch tobacco, will not touch mine," went by the wayside. One manufacturer taught women how to handle a cigarette so "as not to look affected."

A host of talent from various entertainment mediums, both local and national, went through Sarasota during the Roaring '20s, including Tom Mix, Will Rogers, Pfeiffers's Melody Kings and Van Orden's Sarasotans. Radio station WJBB, "The Voice of the Semi-Tropics," sponsored by the local Chamber of Commerce, transmitted shows from the Sarasota Terrace Hotel, the El Vernona Hotel and the Ringling Bros. winter headquarters. For the children they offered story telling by FOO FOO, a Ringling Bros. clown.

Shows, dances, recitals and entertainment of all types were put on at the Mira Mar Auditorium, adjacent to the Mira Mar Hotel.

Arthur Britton Edwards, the local boy who helped push Sarasota forward, opened the Edwards Theatre on Pineapple Avenue in April of 1926. It joined the Sarasota Theatre (formerly the Virginian and later the Ritz on upper Main Street) and the Airdome in screening movies, putting on stage productions and vaudeville.

The theatre continues to serve today as the Sarasota Opera House. It was purchased for $50,000 in 1979 by the Sarasota Opera Association and under the leadership of Deane Allyn it was completely renovated by the architectural firm of Barger and Dean Architects, Inc. Looking absolutely marvelous, it opened on February 6, 1993, with the performance of Verdi's *Il Trovatore*.[216]

The city of Sarasota's premier attraction from 1927 until 1960 was the winter headquarters of the Ringling Bros. and Barnum & Bailey Circus. Located on what had been known as the Fairgrounds off Oriente Road (today's North Beneva Road), the circus quarters was, until Walt Disney opened Disney World in Orlando, the most popular tourist attraction in Florida.

John Ringling made the decision to move the circus quarters here in 1927. Sarasota was falling into the doldrums on the real estate bust and his announcement was banner headline news on March 27, 1927: "CIRCUS COMING TO SARASOTA." This move gave the community an economic boost as well as being a morale builder.

The gift of the circus opened, appropriately enough, on Christmas Day 1927 with the ever-present and always popular Czecho-Slovakian Band on hand. Merle Evans, the perennial circus band leader, and his Concert Band also performed.

Admission was twenty-five cents for adults and ten cents for children. "Great throngs" were on hand and the money taken in that day was given to the John Ringling Community Chest fund for distribution to "deserving cases of charity."[217]

According to A.B. Edwards, approximately $50,000 worth of mortgages on the property on which the circus set up its headquarters had been waived by Edwards, Ralph C. Caples and E.A. Cummer, which made it economically feasible for the circus to move from Bridgeport, Connecticut.

When the circus left Sarasota for Venice, it was hoped by Edwards and others in the community that the grounds would revert to public use. Ultimately though, the property was sold to the Arvida Corporation, which purchased all of the Ringling holdings. The parcel was later resold to the Paver Brothers and used for their Glen Oaks subdivision.[218]

During those thirty-three years there were bits and pieces of the circus scattered throughout the city: backyard riggings for the aerialists, Circus Day Sales, circus themes and performances in restaurants like Casa Canastrelli's, circus benefits for St. Martha Church, circus parades

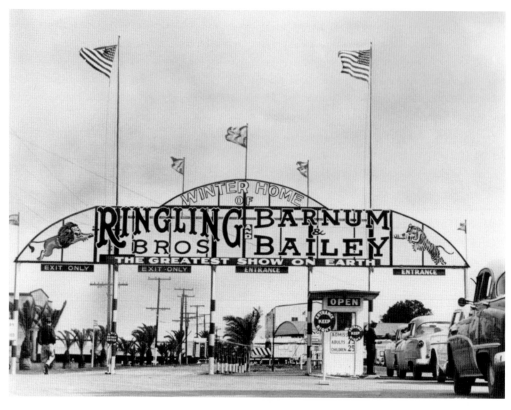

Entrance to the winter quarters of "The Greatest Show on Earth," the Ringling Bros. and Barnum & Bailey combined shows. *Courtesy Sarasota County History Center.*

associated with the Sara de Sota Pageant, the Circus Hall of Fame, circus acts at the John Ringling Hotel, circus performers as classmates and neighbors, the annual blessing of the circus trains by Father Elslander and his altar boys and news accounts of the circus as it traveled around the country. (The 1940 tour of the Big Top completely ringed around the United States, 17,898 miles to 35 states and the District of Columbia, putting on 430 performances, including 127 day stands and 9 day stands in Chicago, 10 days in Boston and 24.5 days in New York. The circus that year was made up of 1,517 employees of 34 different nationalities.)[219]

But the focal point was the approximate 155-acre winter headquarters, a mini-city where the performers rehearsed for the next year's tour at "little Madison Square Garden." Nearly one hundred thousand "children of all ages" visited the quarters annually, pumping money into Sarasota's economy.

The attraction included, besides the rehearsing performers, a large zoo filled with the animals that accompanied the big top.

When the circus left for Venice in 1960 the *Sarasota Herald* printed a comprehensive editorial about Sarasota's relationship with the circus, noting:

> *The world of the Greatest Show on Earth under the Big Top was an exciting one in its day and it provided for Sarasota much free publicity…*

> *The Ringling management of recent years has operated in a far different vein than did the late John Ringling. They have been all out to get everything possible for the circus. They didn't generate kind feelings in many instances, including the sale of the Winter Quarters land which had been obtained without cost from the county. After realizing about $350,000 profit on the sale, the circus officials asked for more free land for the new operation. But the time for the free ride had ended.*
>
> *It is hoped that the new partnership of Venice and the circus will be a highly successful one.*
>
> *Sarasota will miss the circus. There always will be in Sarasota the nostalgic recollections of the circus in its more colorful days.*
>
> *But Sarasota has also made its own place in the tourists' sun and many, many fine attractions and a wonderful climate combine to attract tourists from all over the world.*

And the circus was gone, at least from the Circus City.

On November 11, 1967, John Ringling North sold the circus to the Feld family, Irvin and his brother, Israel. The contract was signed at the Coliseum in Rome. Today the circus is run by Kenneth Feld, Irvin's son, and Nicole Feld, Kenneth's daughter.[220]

For the baseball fans, in 1924, Sarasota induced John J. McGraw to bring the New York Giants to Sarasota for spring training. Ringling is given the credit for luring what was then the premier team in baseball. They played at Payne Park through 1927, bringing the best players of their day and also generating publicity for the community as sports scribes sent back reports to the large cities of the Northeast: New York, Boston, Philadelphia et al, touting the charms of Sarasota.

Unfortunately McGraw became involved in Sarasota real estate and his Pennant Park subdivision on Sarasota Bay, just north of Whitfield Estates, was heavily promoted; but it sank with the crash, taking its investors with it. McGraw felt it prudent to pitch his tent in another town for spring training 1928.

The baseball void was taken up from 1929 until 1932 by the Indianapolis Indians, an American Association team who could not return during the Great Depression because of the cost of travel.

The Boston Red Sox came in 1933 and played here for twenty-five years, leaving quite unexpectedly for Arizona, much to the chagrin of local officials.

In 1959 the Brooklyn Dodgers played some of their spring training games in Sarasota and in 1960 the "GoGo" Chicago White Sox, under the leadership of the colorful personality Bill Veeck, signed a five-year contract, which stretched to twenty-eight. They had been induced to come to Sarasota by John Schaub Jr. and Willie Robarts of the Sarasota Sports Committee. Arthur Allyn, who took over the team, was very involved in the affairs of Sarasota.

The last Major League game played at Payne Park was in 1988. The field was an antiquated throwback, not up to the standards of the day. For the modern era, the 7,500-seat Ed Smith Stadium, named for the hardworking, multiyear president of the Sarasota Sports Committee, was built and ready in time for spring training in 1989.

Another long-lived sport in Sarasota is lawn bowling, aka bowling on the green, with the Sarasota Lawn Bowling Club active here since 1927. It is one of the community's oldest clubs and its members represent a wide array of nationalities. It moved to its current site adjacent to the Municipal Auditorium from McAnsh Recreation Park in 1939. Unfortunately, each time there is talk of building in the area, it seems the greens are in harm's way. According to club historian and two-time club president Paul Ward, "the trickiest sport ever devised by the mind of man" is due to host the International Open Lawn Bowling Competition in 2006.

Two dining establishments deserve mention because they are as much a part of yesterday's Sarasota as any landmark building: the Plaza Restaurant formerly on First Street and the SMACK formerly on Main Street and Osprey Avenue.

The Plaza was founded by Benny Alvarez and C.G. "Raymond" Fernandez in 1928. Randy Hagerman became a partner in the 1930s and the business prospered through thirty-five years in five different decades and became the hallmark of fine dining and power lunches in downtown Sarasota.

SMACK's was the quintessential family drive-in and teenage cruising mecca. It could have been used as the setting for the coming-of-age movie *American Graffiti*. It was founded by W.L. "Mack" McDonald in 1934, who moved it to Main and Osprey in November of 1938, where it became noted for its great food and beautiful carhops. McDonald sold out at the end of the 1950s and the restaurant lasted a couple more years. As he recalled it, "In the old days, everybody went to the SMACK."

While John Ringling is generally and correctly credited with bringing culture to Sarasota with the John & Mable Ringling Museum of Art and the Ringling School of Art, it was David Cohen who bolstered Sarasota's claim of being the cultural hub of the Gulf Coast. Cohen, a child prodigy violinist, co-founded the Florida West Coast Symphony and led it for twenty-one years. He also spearheaded the effort to build the Van Wezel Performing Arts Hall. When Cohen died in 1999, former Mayor Lou Ann Palmer said, "He's responsible for everything good about Sarasota, especially its cultural significance."

Credit for founding the Florida West Coast Symphony was also given to Mrs. Thomas W. Butler, J. Lorton Francis, Dr. W.D. Sugg and George F. Gibbs of Venice in 1949. Mrs. Butler said the aims of the symphony were "to give the many fine musicians who reside in Sarasota and Manatee Counties an opportunity to play together, and to make great music available to visitors and residents alike."[221]

Its conductor was Alexander Bloch, who had been the conductor of the National Symphony in Washington and the NBC Symphony in New York and headed up the symphony in the 1950–51 season. The Symphony Hall was designed by architect and symphony member Erwin Gremli Jr., "a hometown boy," and his partner, Colonel Roland A. Sellew. It was dedicated in front of a large crowd on November 5, 1955, and was credited with being the first community rehearsal hall in the United States.[222]

Paul Wolfe led the Symphony from 1961 until 1996, when he turned over the baton to Leif Bjaland in 1996; Bjaland remains the conductor and artistic director to this day. The talented and affable Wolfe also helped establish the Florida String Quartet in 1967 and led it for thirty-five years.

Looking west along Main Street from Orange Avenue. *Photo by Ed Lederman.*

A valuable component of the symphony is its youth program, which has several youth orchestras made up of students from Sarasota and Manatee Counties.

The youths of Sarasota are also served well through the Booker High School Visual and Performing Arts program. In 2005 the school won the top production prize and accolades for its actors for *Seussical, the Musical* at the Southeastern Theatre Conference festival.[223]

The Venice Symphony, which holds its concerts at the Church of the Nazarene, is currently conducted by Maestro Wesley John Schumacher in his seventeenth year of leadership. The Venice Symphony was called a Cultural Gem of Venice and South Sarasota County by Venice Mayor Dean Calamaras.

Music lovers and theatergoers living in today's Sarasota have a wealth of choices available to them. One of the most popular, successful and longest-lived little theatre in America, Sarasota's The Players, began the 1930 season just as the Great Depression was getting underway. Among its founding members were Out-of-Door School owners Miss Fanneal Harrison, a decorated nurse during World War I, and Miss Katherine Gavin. The first plays were held in the abandoned Siesta Key Golf Clubhouse; soon they moved to the Archibald Building on east Main Street, where Main Bookstore is today, then to the American Legion Coliseum on North Washington Boulevard, on to the Golf Street auditorium and finally, in 1936, to their own Players Theatre, a pecky cypress building designed by Ralph S. Twitchell.[224]

Continually growing with its popularity, a new, larger theatre was built next to the old one in 1973 and offers all the necessary sets and backstage wherewithal to put on the finest and most sophisticated Broadway productions available anywhere.

On January 5, 1970, the Van Wezel Performing Arts Hall opened with the stage production *Fiddler on the Roof* to great applause and has remained the mainstay for many of Sarasota's world-class performers. Van Wezel, often called the Purple Cow, was designed by William Wesley Peters of Frank Lloyd Wright's famous Taliesin Associated Design Firm. The idea for a city-owned hall was put forward by Allied Arts Council President Rita Kip, who interested Mayor David Cohen. In 1964, a $1.35 million bond issue was voter approved for the hall's construction. However, more money was needed, which was provided by the Lewis and Eugenia Van Wezel Foundation, which agreed to donate $400,000 if the hall was named in honor of the Van Wezels.

Beginning in April of 1999 and completed in October of 2001, the 1,736-seat Van Wezel underwent a reported $20 million renovation, which added 25,000 square feet, plus upgrades throughout the hall.[225]

In today's Sarasota, the Van Wezel is only one cultural entertainment venue of many. The mission of the Sarasota County Arts Council, headed for many years by Patricia Caswell, is to create an environment where the arts flourish; and flourish they do, to a remarkable degree. A sampling of what is available composes a long and diversified list of cultural and various and sundry other attractions that are available year-round and includes: Sarasota Opera, The Sarasota Music Festival, La Musica, International Chamber Music festival; the Sarasota Ballet for dance; two film festivals (the Sarasota Film Festival, attended by Hollywood luminaries, and the Sarasota Film Society's Cine-World Film Festival at Burns Court Cinema); an array of different music styles: The Florida Voices Ensemble, the Florida West Coast Symphony, Gloria Musicae, Key Chorale, North Port Performing Arts Association, Sarasota Big Band Jazz Ensemble, The Venice Symphony, Sarasota Pops Orchestra, Sarasota Jewish Chorale, Sarasota Concert Association, The Sarasota Chorale and the Sarasota Folk Club.

Interests in nature, science, history and lifestyles are served up at venues including the Marie Selby Botanical Gardens, an 8.5-acre oasis of flowered beauty and tranquility on Sarasota Bay, near the very heart of downtown. Over the years the Selby name, through the William G. Selby and the Marie Selby Foundation, has become synonymous with local philanthropy. The Selbys, who had made a fortune in the oil business, had first come to Sarasota in 1909 and lived in a houseboat in Sarasota Bay. The unpretentious couple loved the area and built their home here. They established a three thousand-acre ranch southeast of Myakka City where Bill oversaw a herd of Angus cattle and Marie rode the horses she kept there.[226] Bill liked to meet with the locals for coffee at Badgers Drug Store while Marie loved to attend to her garden. Between 1955 and 2005, their foundation has provided more than $76 million for 359 agencies and more than 3,500 scholarship recipients.[227]

Other museums include: the Crowley Museum and Nature Center; the G. WIZ—A Hands-On Science Museum at the former site of the Selby Library on Boulevard of the Arts; Historic Spanish Point; and the Sarasota Jungle Gardens.

Mote Marine Laboratory & Aquarium is a popular attraction as well as an internationally renowned research facility. Formerly the Cape Haze Marine Lab, that facility was taken under the wing of William Mote, who became its "guardian angel," donating millions of dollars to

it. In 1967 the name was changed to honor benefactors Mote, his wife, Lenore, and his sister, Elizabeth Mote Rose. The facility was moved to its present location on City Island in 1977. Mote Marine has been a world leader in shark research and the causes and prevention of red tide, among other issues. William died at age ninety-three on July 18, 2000.[228]

Theatregoers have an enviable list of choices: the Asolo Repertory Theatre Company, Historic Asolo Theatre, Banyan Theatre Company, Florida Studio Theatre Cabaret, the Venice Little Theatre, Florida Studio Theatre Main Stage, FSU/Asolo Conservatory for Actor Training Learning Theatre, Inc., Lemon Bay Playhouse and the Players Theatre. Golden Apple Dinner Theatre has been a mainstay in downtown Sarasota since 1962 when Robert Turoff and Roberta McDonald opened in what had been a Morrisons Cafeteria with the off-Broadway musical from which it drew its name, *The Golden Apple*.

Those interested in visual arts enjoy the world-famous John & Mable Ringling Museum of Art, the Art Center Sarasota, Englewood Art Center, Longboat Key Center for the Arts, Selby Gallery at Ringling School of Art and Design, an artist colony at Towles Court, Venice Art Center and numerous art galleries.[229]

This plethora of activities is a far cry from the days of the Sarasota Brass Band, the Czecho-Slovakian Band and the Sarasota Minstrels of yore.

Sarasota County has forged a reputation as the home of several fine institutions of higher learning. As a billboard in front of the new campus for the University of South Florida put it, "We Are A University Town."

In March of 2006, *The Princeton Review* ranked New College of Florida number one as "Best Value Public Colleges."

The drive to have this four-year college in Sarasota began in 1959. Ground was broken at East Campus in ceremonies held on July 21, 1964. Its first president, Dr. George F. Baughman, called New College "a free private institution dedicated to a free people." Dr. Baughman also paid tribute to David Gray, a retired diplomat and uncle of Eleanor Roosevelt, and to Sarasota's own A.B. Edwards, who were on hand for the ceremony. Good wishes were sent by President Lyndon B. Johnson, who wired, "This will be of immense significance both to Florida and the nation." Governor Farris Bryant and U.S. Representative James A. Haley also sent their best wishes.

Classes began in the Charles Ringling mansion (renamed College Hall) on the morning of September 21, 1964, with 101 students and a faculty of 22. The renowned architect I.M. Pei designed the New College dorms.

In 1975 the college became public when it merged with the State University system of Florida and became known as University of South Florida/New College.

By legislative action on July 1, 2001, it became the independent public honors college for the State of Florida, becoming New College: The Honors College of Florida.

After a bitter battle between Sarasota and Bradenton, each wanting to be the site of a two-year college, Manatee Junior College (today's Manatee Community College, or MCC) began classes on September 2, 1958, in the old Bradenton High School on Manatee Avenue with Dr. Samuel R. Neel as its president.

When the campus was dedicated on October 30, 1960, all Sarasota and Manatee residents and their guests were invited to attend. The college has proven to be a boon to many students

in Manatee and Sarasota Counties; its nursing program, among others, is highly regarded. Neel was replaced by Dr. Wilson F. Wetzler as president in 1976.

MCC opened a branch in Venice in 1977 at the Brickyard Shopping Center on the U.S. 41 bypass with Dr. Jack Dale as the director of the Venice Center of Manatee Junior College. On August 9, 1983, ground was broken for the new MJC (Manatee Junior College) South Campus.

Stephen J. Korchek, who came to Sarasota in 1970 as an instructor for the Kansas City Royals Baseball Academy, was hired as a part-time instructor of health and physical education at Manatee Junior College before being elevated to the presidency. Korchek served in that capacity for sixteen years before retiring, effective July 31, 1997.[230] In 1997 Dr. Sarah H. Pappas became the college's fourth president.

Today's Sarasota

T HERE WAS A SENSE OF foreboding and apprehension in some quarters as we approached the new millennium; a belief that at precisely midnight, a world dependent on technology, especially on computers, would fail all at once as the midnight hour struck. It became known as the Y2K problem and the Y2K bug. In this scenario, planes would fall, elevators would stop running, cash registers would not work, gasoline could not be pumped, banking could not be conducted, lift stations would not be able to provide tap water and on and on. The list of fears about what might and could happen engendered a sense of anxiety. Some prepared for these eventualities by choosing not to fly if they would be in the air at midnight, stocking up on food and water, getting extra money and filling up their cars with gas—much like preparing for a hurricane that, thankfully, did not strike.

In Sarasota the momentous step into the year 2000 was ushered in with a grand celebration, particularly in downtown, the traditional heart of the community ever since the Scots landed in Sarasota Bay in 1885 and celebrated their New Year as best they could, the pall of being dumped into a wilderness hanging over them.

That was all ancient history of course; no one was thinking of the misled Scots of long ago; Sarasota's revelers jammed onto Main Street, celebrating in no-holds-barred style not only the New Year but also the new millennium.

And if the revelers had no thought of the Scots' plight neither did they have a care about the future of Sarasota, and the new boom that was just around the corner, which would, forevermore, change the face of Sarasota just as dramatically as the frenetic Florida land boom of the 1920s.

The City organized a grand bash that was expected to attract forty thousand revelers. Buses were pressed into service to pick up partygoers at the fairgrounds, Van Wezel Performing Arts Hall and Ed Smith Stadium. Paul Thorpe, the executive director of the Downtown Association, one of the organizers, planned a continuous celebration that would run from 7:00 p.m. until 1:00 a.m. with live music on five stages, children's games and rides, dancing, fireworks, food and drink along the length of Main Street from Orange Avenue to Gulf Stream Avenue. The climax would be the "dropping" of a large orange ball, a la New York City.

Again Sarasota was on its way.

Where it was historic news when W.H. Pipcorn of Milwaukee paid $1,000 for a front foot of downtown property on which to build the Hotel Sarasota in 1925, by 2005 property sales were being recorded in millions of dollars and tens of millions of dollars for sites on which to build ritzy condominiums and palatial homes, dubbed McMansions.

All property seemed to be rising in price. By any standard of measurement the numbers were staggering. Homes priced at $100,000 at the beginning of 2000 were selling for $400,000 by

To the left, the perennially popular Hart's Landing, the first stop for many fishermen, with Golden Gate Point in the distance. *Photo by Ed Lederman.*

2005—and quickly. It was a seller's market, often requiring little more than the planting of a For Sale sign in the front yard for a quick sale.

Sarasota's Michael Saunders, president of Michael Saunders & Company, the leader in the local luxury housing market, reported that her company did over $3 billion in real estate transactions in 2005.

Examples of skyrocketing prices (skyrocketing was the operative word often used to describe price rises in the early 2000s): In August 2005, an Atlanta developer offered $50 million for Pier 550, a small building of condominiums on 2.5 acres on Golden Gate Point. That worked out to $980,000 per unit for condominiums that had been selling a few months earlier for $360,000.[231] Cheryl Loeffler, an agent at Prudential Palm Realty, sold "nearly $70 million worth of property" in 2004[232]; in the same article, Matt Orr of Michael Saunders & Company reportedly sold more in one month in 2005 than he did in all of 2004.

Between 2000 and 2005 in downtown Sarasota, 788 condo units were completed, 659 more were under construction, 493 more had been approved but were not yet under construction and 800 were planned but not yet approved.[233]

Looking up lower Main Street toward Five Points. *Photo by Lorrie Muldowney.*

At Five Points in 1999, where over a century earlier A.B. Edwards had watched engineers of the Florida Mortgage and Investment Company plat Sara Sota, the Southeast Bank building (formerly the Palmer Bank), which had been extensively remodeled, was razed. It would be replaced by the fourteen-story Five Points Tower, which generated a great deal of controversy because of its size. As much a symbol of the booming 2000s as the Palmer Bank had been of the 1920s, it was ready for occupancy in early 2006. The building was designed by the busy Sarasota architectural firm The ADP Group, led by Bruce Franklin. Its anchor tenant is the First Third Bank of Cincinnati. The rest of the building is taken up with condominiums, offices and retail establishments and parking.

Just as the construction of the Mira Mar Hotel had signaled the start of the '20s land boom, many pointed to the Ritz-Carlton Hotel as the beginning of the new millennium's real estate spree.

Ground was broken for the 266-room luxury hotel with 49 condominium apartments on February 17, 2000, with three hundred people in attendance. Developed by Core Development, Inc., headed by Kevin Daves with C. Robert Buford, it was prophesized that the $100 million plus hotel would generate jobs and an $8.5 million payroll, and would give Sarasota bragging rights as the location of a world-renowned five-star hotel, one of only forty-nine worldwide.[234]

The hotel was opened on November 16, 2001, with Carter Donovan as its first manager and quickly became one of the best hotels in the nation, ranked seventeenth by Conde Nast *Traveler*'s Reader's Choice survey.[235]

There were, however, many who had worked hard at trying to save the John Ringling Towers from destruction who felt that the community would have been better served if they had both the Ritz and the Towers—the best of yesterday and today, standing side by side.

A good example of the frenzied pace of downtown condo selling and buying was illustrated by the construction of a condominium tower at 1350 Main Street, which sold out the 134 available condominium units in ninety minutes, before the first shovel of dirt was turned.[236]

Phenomenal numbers by any yardstick of measurement and with them the look of downtown Sarasota was transformed—no one would mistake it for a small town, sleepy or otherwise.

One of the newest additions to downtown Sarasota is the *Sarasota Herald-Tribune* building. Designed by Bernardo Fort-Brescia of the Miami-based firm of Arquitectonica, it incorporates the flavor of the Sarasota School of Architecture.

The newspaper had been founded during the peak of the boom by twenty-nine-year-old David Breed Lindsay, its publisher; his father and editor of the paper, George D. Lindsay; Paul Poynter; and Edward E. Naugle as the *Sarasota Herald*. The first edition was published on October 4, 1925. It acquired the *Sarasota Daily Tribune* in 1938.

The paper had originally been housed on Orange Avenue in an area known as Herald Square from 1925 until 1957, when it moved to 801 South Tamiami Trail in a building designed by Ralph and William Zimmerman of the Sarasota School of Architecture. It remained there until February 2006.

The *Herald* was run by the Lindsay family until 1982 when it was sold to the New York Times Company. Its current publisher is Diane McFarlin, who had started with the paper as a journalist right out of college and moved up the ranks. Michael K. Connelly is the executive editor and Thomas Lee Tryon is the editorial page editor.

The influx of newcomers flooding into Sarasota County and the rapidly rising housing and condominium market had its share of detractors. To help stem the vagaries of the development tide that seemed to be washing over "yesterday's Sarasota," an organization with the apt name Save Our Sarasota was formed in June 2004 by Janice Green, Linsley Pietsch and Jude Levy. The three grew tired of the unbridled growth and wondered if there were more like themselves who were "no longer willing to sit on the sidelines of urban history." At their first meeting at Selby Library 250 others of like mind attended. They are trying to "preserve the quality of life in our great city," and to that end make their presence felt at commission meetings, within the general community and in the press.

Dan Lobeck, president of Control Growth Now, Inc., is another high-profile presence in trying to hold commissioners and developers accountable for the impact major projects have on the community.

The Downtown Partnership, with Tony Souza as its head, began lobbying in 2006 for a downtown Historic District in an effort to keep as much of the charm of yesterday's Sarasota intact as possible.

In a poll conducted by the *Sarasota Herald-Tribune* and reported on October 8, 2005, journalist Doug Sword pointed out that 33 percent of the respondents were dissatisfied with population growth and new development. For the first time in the seven years the poll had been conducted, it "found that more people think the county is a worse place to live than it was five years ago." Sword spoke for many when he began his article, "Paradise ain't what it used to be."

For many old-time residents and those who had moved to Sarasota a handful of years before the new boom, downtown in particular and Sarasota County in general was losing its character to giant condominiums without any setback from the sidewalks, minimal landscaping and also the mega-houses out of scale with their neighborhoods.

Homes in desirable locations—Bird Key, Casey Key, McClellan Park to name but a few—were purchased to be torn down and replaced with aforementioned McMansions. "Super size" in Sarasota came to mean more than a fast-food marketing gimmick. Some of the demolished homes and buildings had been listed on the National Register of Historic Places; some were examples of the Sarasota School of Architecture, significant for that reason alone.

Redevelopment meant the closing of some hotels, beachfront motels, mobile home parks, golf courses and restaurants, all making way for luxury condominiums and marinas. One of the most significant of these was the Summerhouse, Sarasota School of Architect's Carl Abbott's delightful and award-winning design. One of the most picturesque and romantic restaurants in Sarasota, it was spared the bulldozer and was transformed into a clubhouse for adjacent condo owners and will be open for public use seventeen times a year.

Another downside to the increase in property values was that some homeowners felt trapped where they lived. If they sold to move to another house or condominium in Sarasota, their taxes would increase dramatically to reflect the price of their new home; a definite consideration to anyone paying taxes on a home purchased for $250,000 wanting to move to a comparable home now worth over a half a million dollars or more.

Looking from the Ringling Causeway toward the Ritz-Carlton Hotel and Sarasota's skyline. *Photo by Ed Lederman.*

Concurrent with the rise in home prices, affordable housing became difficult to find throughout the county. This dramatically impacted first-time buyers, young professionals and members of Sarasota's various service industries who could not afford to live in the area. There was concern that Sarasota was becoming a bastion for the affluent.

Whereas the '20s boom was rife with "binder-boys" selling a binder on a piece of property, which might change hands several times at ever-escalating prices, often in the same day, the boom of the 2000s was characterized by "Condo Flippers." Just as the binder was in and of itself the commodity, with the hopeful speculator never planning to buy the property it represented, the condo flipper purchased a contract on a pre-construction unit with only the intention to resell it at an escalated price when the condo was completed.

Talk during the halcyon days of the 1920s Florida land boom had it that a mighty bust was inevitable. In 2005 speculation was rife that Florida and Sarasota were in the midst of a giant bubble that was bound to explode, taking investors with it.

The real estate community was banking (in the real sense of the word) that the 1,000-a-day newcomers to the Sunshine State, seeking their slice of paradise, would not diminish. As of the beginning of 2006, property prices have slowed but no crash is in sight.

Most newcomers, of course, were arriving by car and most of these by way of I-75, the 1,775-mile highway that runs from Sault Ste. Marie, Michigan, south to FL 826 (the Palmetto Expressway) in Fort Lauderdale. It gathers motorists as it passes through Michigan (395 miles), Ohio (213 miles), Kentucky (193 miles), Tennessee (162 miles), Georgia (339 miles) and Florida (473 miles). Sarasota's segment was completed in the early '80s and over the years the areas around the interchanges have been developed, spurring on more growth.

Burgeoning Lakewood Ranch, east of I-75, developed by Schroeder-Manatee Ranch, Inc., is a self-contained village, a "master planned community" offering every imaginable amenity. The property was amassed by John Schroeder of Milwaukee in the early 1900s and acquired by the Uihlein family of Schlitz Brewery fame in 1922. They continued the agriculture operations, expanding them over the years, and adding the massive Lakewood Ranch component in 1994. The area has grown dramatically ever since.

John Clarke, president of Lakewood Ranch Realty Co. Inc., indicated that within a thirty-one-acre district would be offered retail shops, restaurants, offices, grocers and condominiums in an effort to have the town "be alive night and day."[237]

Preceding Lakewood Ranch in concept if not size was The Meadows Village of Taylor Woodrow Homes on what had been pastureland off Seventeenth Street. The project was approved by the county as a Planned Unit Development in 1974. Offering homes and villas in four separate neighborhoods with beautiful views, condominiums, golf, swimming pools, a scenic trail and a shopping village, it advertised, "Live Where The Good Times Roll." Frank Taylor, who had founded the company, was knighted by Queen Elizabeth in 1974 and was declared the Lord of Hadfield in 1983.

The city's Downtown Master Plan 2020, formulated with community input during an eight-day charette in 2000, was often called the Duany Plan after urban planner Andres Duany, head of the firm Duany Plater-Zyberk & Company of Miami. This plan had as one

of its goals the reuniting of downtown with the bay front. As he put it, "It is essential to recapture the lost vision of a waterfront city and to recover the access to the bay that has been lost by citizens in general, except for those in the front echelon buildings." His plan called for reducing the speed limit in the area to twenty-five miles per hour by designating a portion of U.S. 41 as a state highway. He also recommended a free-flowing roundabout at U.S. 41 and Gulf Stream Avenue. The visual appeal could be enhanced by "eliminating the surface parking."[238]

Duany felt that there was a contradiction in the Sarasota motto, "A city of urban amenities with a small town feeling," which his plan hoped to resolve.[239]

The plan sought a downtown that was "pedestrian friendly" and setbacks of buildings above the fourth floor so that a canyon effect would not be created.

In March of 2002, before the plan could go into effect, it was challenged by city residents, local real estate developers and other business groups who didn't agree with various elements of it. Several features of the plan had previously been changed or eliminated. Duany's proposal to add commercial space to the bay front was deleted by the city commission.

Duany felt the city was dragging its feet and said of his experience, "This process...has been the most difficult I've ever experienced. This is a very difficult political situation." He also felt that the city planners had "watered down" his proposals, thus making them less effective.[240]

As of 2006 many of the plan's goals had not been met.

As an editorial in the *Sarasota Herald Tribune* put it, the plan would, among other things, "restore liveliness and walk-ability; and turn back a concrete tide that had threatened to transform Sarasota's 'small town' heart into a big-city jungle of 18-story monsters."[241]

Venice had been more restrictive in its building heights. While the Planning Commission there had recommended against setting a thirty-five-foot cap in an area between downtown Venice and the beach, it was the city council that had the final say and in March of 2006 considered seeking help on the issue by hiring a Tampa consulting firm to determine the impact the thirty-five-foot cap would have on the community.

Herb Levine, president of the Venice Taxpayers League, said the issue was "not property rights but the right of a city to preserve its character."[242]

Part of the boom in south Sarasota County centered on undeveloped ranchland property. A list of projects slated for the areas of Venice, Nokomis, Osprey and Port Charlotte in 2005 included 15,000 homes for Thomas Ranch on 7,800 acres in North Port, complete with different types of neighborhoods with shops, offices and parks; a 15,000-home development called Isles of Athena, also in Port Charlotte; 2,200 homes in Osprey and Nokomis; 3,000 homes on Laurel Road; 1,400 homes off River and Center Roads; and a 639-acre village with 1,278 homes around the Myakka Pines Golf Club near Englewood.[243]

Much of this type of development sprang from the 2050 county "Village" concept, which allowed for higher density. To his critics, Brian Tuttle, a major developer, was quoted in Rothchild's comprehensive article, "For every person who doesn't like what I do, there are a lot more who buy the houses and live in the properties."[244]

One of those unhappy with the unbridled growth, B.T. Longino, a rancher and former county commissioner, said when he gets an inquiry from a developer he throws it in the trash. "It's my goal to keep this ranch just the way it is for my great-great-grandchildren."[245]

In the spirit of perpetuating the wilderness of Florida, retired pediatricians Dr. Allen and Dr. Mary Jelks donated $1 million to preserve six hundred acres along the Myakka River, a section set aside as the Jelks Preserve.

In Osprey the Glueck family became newsworthy for their desire to maintain their valuable twenty-three-acre Osprey property, said to be worth between $2 to $9 million, as a family business, Glueck's Auto Parts. It had been founded by Albert Glueck Sr. and had been run by family members for over forty years.

In 2005, in order for Sarasota County government to keep pace with the spiraling growth, its budget ran over $1 billion for the first time.[246]

As late as 1960 more people were living in the city limits of Sarasota than in the rest of the county. But between 1970 and 1977, while the city population increased by only 7,179 (from 40,237 to 47, 416), the county population soared from 120,413 to 170,621, a jump of 50,208. Ten years later, the county population was 251,253 while the city's count was 51, 259.

Ed Hoyt, who had spent sixteen years working for the City of Sarasota in various capacities under Ken Thompson, became county administrator in 1971. A "home grown boy," he had moved to Sarasota with his sister, Mary L., and their mother, Florence, in 1925 and graduated from Sarasota High School in 1934.

He recalled that during his tenure, the water supply to Sarasota County was a key issue. It was he who negotiated with Chris Angelidis of Manatee County for the necessary supply of water to keep pace with the growing county. Sarasota County was growing, but not at the frenetic pace that was around the corner.[247]

Hoyt worked for the City of Sarasota when Arvida came to town with their grand plans for Bird Key and Longboat Key. During negotiations with the city, it was decided that a study should be done to determine the impact on the bay of increasing the size of Bird Key. The Coastal Engineering Lab at the University of Florida was hired to study the project's effect on the bay bottom. Using a scale mock-up of Sarasota Bay, they were able to regulate currents, and by using dye could see where the currents would flow. They determined that Arvida's Bird Key would not be deleterious to the bay, except on the bottom grasses and for the fish that lived there. Hoyt felt that with all the regulations in place today, the Arvida plan would not be approved.[248]

Ed Maroney was hired in 1975 to replace Hoyt. Maroney took over when the county budget was a paltry $13.5 million. By the time he left, eleven years later, it had jumped up to $242 million and the days of Sarasota being a sparsely populated, backwater county were over.

Maroney was in office when the new jail was built, the construction of the criminal justice building was underway, countywide improvements in roads and bridges were taking place and the purchase of the thirty-three thousand-acre MacArthur Tract to help Sarasota become self-sufficient with its water needs was effected. Maroney resigned in 1986.

John Wesley White was the county administrator during the next ten years of full-bore, countywide growth. Hired in 1987 to replace Maroney, White was often at loggerheads with the county commissioners and some of the county's movers and shakers, particularly the powerful Argus Foundation, which had sought his ouster. The rap on White was that he was too independent, a consequence of being a take-charge guy who wanted to get things done. Where Harry Truman had "The Buck Stops Here" message on his desk, White's slogan was, "Get It Done."

In January 1997, with the commission stacked four-to-one against him, White tendered his resignation. In some ways, White's strong leadership style could be compared to former City Manager Ken Thompson. County Commissioner Charley Richards said of him during a 1992 evaluation, "I don't think anyone could be more job knowledgeable than Mr. White." This sentiment was echoed by county commission Chairman Bob Anderson, who said, "The progress that's been made has been rather phenomenal."[249]

But in the end, charting his own course ultimately cost White his job.

Interviewed shortly after his resignation was accepted, White recalled that of his many accomplishments, the one he was the proudest of was his tree-planting program, which he had fought so hard for. His greatest regret? Not buying the Maas Brothers property at the northwest corner of Main Street and Washington Boulevard when it was available "for a song."[250]

Waldo Proffitt editorialized of White's tenure in the *Sarasota Herald-Tribune*, "But, he was, in every setting in which I had an opportunity to observe him, the quintessential professional administrator. He knew his business."[251]

Jim Ley took over from John Wesley White in August of 1997. Having served as the assistant county administrator for Clark County, Nevada, which includes Las Vegas, Ley was well tuned to the problems associated with a tourist area undergoing rapid growth.

His first task was to ensure the extension of the county's one-cent "local-option" sales tax to ensure the county's ever increasing services and provide funds for the municipalities and the school system.

After one year in office, the county commission gave him a three-year contract and lauded his management style, which included allowing subordinates to make important decisions. Commissioner David Mills said during Ley's evaluation, "I think things are going very well. I'm pleased with Mr. Ley's performance and the way the county is moving along."[252]

Tomorrow's Sarasota is, as psychologist Carl Rogers might have put it, " in the process of becoming." The transformation throughout the county that is currently taking place is not nearly completed. In the works and on the drawing boards are many new projects, some gargantuan in scope.

Irish developer Patrick Kelly, for instance, has grandiose plans for the 10.5-acre area around the Sarasota Quay on Sarasota Bay. On the property located between the Ritz-Carlton Hotel and the Hyatt House Hotel, the gentleman from Ireland is planning $1 billion in development of condominiums, a hotel, offices, retail shops and perhaps a conference center.[253]

In downtown Sarasota, a controversial project called Pineapple Square is moving forward. The $200 million proposal by Isaac Group Holdings LLC calls for 275 residences, parking and dozens of upscale retail establishments and restaurants on State Street. Mayor Mary Anne Servian said of the plan: "Pineapple Square is the project that we need to accomplish our vision for this city."[254] Commissioner Lou Ann Palmer, the lone vote against the project, said she was "very, very reluctant to commit city resources."

As this book was being completed, two items of historic note occurred. The name of the criminal justice building on Ringling Boulevard was changed to honor one of Sarasota's own. On February 23, 2006, in an impressive ceremony, the building's name was changed to the Judge Lynn N. Silvertooth Judicial Center. Silvertooth had served as a circuit court judge for the Twelfth Judicial Circuit from 1964 to 1988 and was a nationally known jurist respected for his knowledge of the law and his fairness.

The other event was the saving of two of Sarasota's oldest structures, the Bidwell-Wood House (where the assassination of Charles E. Abbe was plotted) and the Crocker Memorial Church. These buildings were saved from demolition by the Historical Society of Sarasota County, led by Arnie Berns, its president, and Chris Blue, the executive director. Backed by the City commission, the group raised the necessary funds to move the buildings to Pioneer Park.

Less certain is the future of Riverview High School, which the Sarasota County School Board may demolish. Designed by world-renowned Paul Rudolph, the school is internationally known and appreciated; less so here where it is taken for granted. It has been featured in numerous architecture publications. A group led by, among others, Mollie Cardamone and Carl Abbott, the architect who designed the Summerhouse, has banded together and is fighting the battle to save it.

EPILOGUE

S IXTY YEARS HAVE SWEPT PAST since Grismer told us his story of Sarasota. World War II had just ended and the Greatest Generation, as they are called today, buckled down to building America into a world powerhouse.

The spirit of optimism was pervasive and replaced the gloom of the Great Depression and the miseries of the war. Sarasota as we have seen was topped off with some notable Works Progress Administration projects in the 1930s and emerged from the war as a jewel of a county that was on the verge of resurgence, paced at first by the attractions and development within the city of Sarasota.

When the fifty-three men gathered at the city pier in 1902 and voted to incorporate Sarasota as a town, they chose for the town seal the sun rising over a mullet, palmettos and sea shells. Simple symbols, each of which Sarasota had in abundance. The community was then tied to fishing and agriculture for its success.

Their chosen motto, "May Sarasota Prosper," was a hopeful prayer. No one at that momentous meeting could have envisioned that within twenty years Sarasota would be a booming city, brimming with optimism and filling with newcomers looking for a winter paradise or a place to strike it rich.

The '20s boom time was short-lived but accomplished the monumental task of providing the foundation for the steadier and sounder post–World War II growth and development that began as Grismer's *The Story of Sarasota* was hitting the bookstores.

I called that Sarasota *Quintessential Sarasota*, the title of my first book. It was the Sarasota that longtime residents, like me, had such fond memories of, and it lasted from the 1920s through the 1960s.

It was a Sarasota of the Mira Mar Hotel and the John Ringling Hotel, Badger's Drugs, the Plaza, the two train depots on Main Street, the Lido Casino, miles of undeveloped waterfront, the circus, orange groves, two-lane roads and a relaxed pace: a community where no one was a stranger.

The spread outward was on the horizon in the 1960s, and the city of Sarasota, particularly downtown, the original magnet for the area's success, fell into a doldrums that was all too obvious in the 1970s and the 1980s.

Today, downtown Sarasota's renaissance is phenomenal and is once again the focal point for the entire county; flush with activity, it is a lightning rod that is attracting nationwide attention to the entire county.

The downside to the rampant development is that it is changing the character of the community, giving it a look of Anywhere, USA, as the landmarks of yesteryear are lost in the shuffle. The numerous high-rises are subtracting from the small-town ambiance that was once Sarasota's hallmark.

While it is nice to see the town bustling with activity as a go-to place, the tradeoff has been hard for many longtimers to accept.

Perhaps paraphrasing a Billy Joel song says it best: "The good old days weren't always good, and today ain't as bad as it seems."

WHO'S WHO IN SARASOTA

Information taken from *The Story of Sarasota*, by Karl H. Grismer, obituaries from the *Sarasota Herald-Tribune* and *Dreamers of our Past* by Peg Russell.

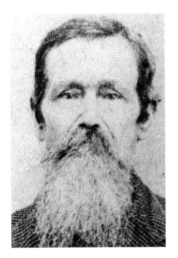

1. William Whitaker

The first white settler in the Sarasota Bay region was born in Savannah, Georgia, on August 1, 1821. He spotted Sarasota while sailing down the Gulf Coast and determined to build his house on Yellow Bluffs, just north of today's Tenth Street. Initially he earned money by selling dried salt mullet and dried roe to Cuban traders who sailed up and down the coast. In 1847 he went into the cattle business; these formed the famous '47 herd. On June 10, 1851, he married Mary Jane Wyatt, daughter of Colonel William Wyatt and Mary, who were among the first settlers who founded the village of Manatee. The Whitakers had eleven children.

Mr. Whitaker served at one time as sheriff of Manatee County. He died on November 18, 1888. Mary died in Tampa on March 6, 1908.

Many of the Whitaker children played active parts in the development of Sarasota and many of their descendants were prominent in the affairs of the area.

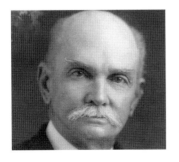

2. Charles L. Reaves

Born in Georgia on August 12, 1847, Reaves became the founder of the Fruitville community. He was appointed the first postmaster at Fruitville. He married Martha Tatum in 1875 and the couple had four children: O.K., who became a circuit court judge; Frances Rebecca, who married Dr. C.B. Wilson; George Franklin; and Edythe Mae Reaves.

Reaves founded the school in Fruitville for which he deeded the land to the school board and also paid a portion of the cost of building the first highway from Sarasota to Fruitville.

He died on September 17, 1931. Martha died on July 13, 1935.

3. A.B. Edwards

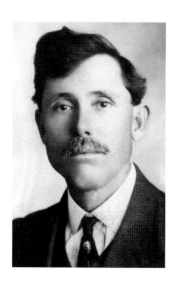

Arthur Brittan Edwards was born in what is today the northern part of Sarasota County on October 2, 1874. His parents died when he was fifteen years old and he was truly a self-made man and a perennial Sarasota builder and booster. On July 22, 1900, Edwards married Fannie F. Lowe, granddaughter of Jesse Knight, founder of Horse and Chaise. In 1903 Edwards opened the first real estate office in Sarasota and also the first insurance office. He was the first elected tax assessor of the town of Sarasota, serving from 1907 through 1913. When Sarasota was incorporated he was elected as the first mayor. He was again elected in 1918 to head the city through 1919 and 1920. He had been a continuous member of the Chamber of Commerce since it was first organized in 1904 as the Board of Trade. He was the first president of the Sarasota Citrus Growers Association and a charter member of the Sarasota County Fish and Game Association. He was also a member of the State Game and Fresh Water Fish Association. He played a vital part in the creation of Myakka State Park. Mrs. Edwards was active in the Woman's Club. The couple had four daughters: Louise, Pauline, Frances and Martha.

Edwards, along with J.H. Lord, is credited with convincing Bertha Palmer to locate here.

Known for many years as Mr. Sarasota, Edwards died on November 14, 1969. Fannie died on July 10, 1963.

4. Dr. Cullen Bryant Wilson

Dr. Wilson was born in the eastern part of what is now Sarasota County on July 11, 1878, and was educated at the South Florida Military Academy (now the University of Florida). He practiced medicine in Sarasota from 1907 to 1941. He owned the first automobile in Sarasota. In 1924 and 1925 he was president of the First Bank & Trust Company of Sarasota and from 1925 until 1941 was president of the First Trust Co. of Sarasota. He served on the staff of the Sarasota Hospital from the time it was founded until his death.

He married Frances Rebecca Reaves, daughter of Mr. and Mrs. Charles L. Reaves of Fruitville. They had two children: Reaves Augustus Wilson, a physician, and Clyde H. Wilson, a respected attorney in Sarasota for many years. Dr. Wilson died on February 24, 1941. Frances died August 26, 1973.

5. Carrie Spencer Abbe

Born in Bolton, Connecticut, in 1857, Abbe came to Sarasota in 1878 on her honeymoon with Dr. Myron Abbe, who was the cousin of murdered Postmaster Charles E. Abbe, killed by the Vigilantes on December 27, 1884. Following the death of postmaster Robert Greer, Mrs. Abbe was appointed postmistress of Sarasota in 1891, a position she held until she resigned in 1922.

She was also in charge of the town's first telephone, relaying messages throughout the community on foot. She was active in the Woman's Town Improvement Society and was a charter member of the Sarasota Woman's Club.

The *Sarasota Times* said, "When the history of Sarasota is written there is no person who will stand out more prominently in its pioneer days than this dearly loved woman who has been a mother to everyone in sorrow and distress." She died November 19, 1940.

6. Henry Hawkins

One of Sarasota's pioneer ranchers, Henry came to the area with his parents in 1857. In 1881 he married Rebecca Tatum, daughter of George and Lucy Tatum, pioneer settlers of Tatum Ridge. They had five children: Will, Frank, Andrew, Mollie and Lizzie. After Rebecca died in 1893, Henry married Hannah Mann of Bartow. They had three children: Emma, Lewis and Minnie-Lee.

After his first marriage, Hawkins settled near the Myakka River where he became one of the area's largest cattlemen with approximately 2,200 head of cattle, 1,600 sheep and 1,200 hogs.

Hawkins died on September 26, 1946. A picture of him taken at his ninetieth birthday party attended by one hundred family members and friends shows him still in the saddle.

7. Harry Higel

Born in Philadelphia on December 31, 1867, Higel came to the Venice area in 1884 with his parents, Frank and Adelaide. For a few years he helped his father experimenting on how to make starch from cassava roots and in making syrup and canned preserves.

Higel came to Sarasota shortly after the town was founded. He purchased the dock at the foot of Main Street from the Florida Mortgage and Investment Company and also the company's store. For a time he operated his boat, *Nemo*, conducted a general mercantile business and handled land sales for J. Hamilton Gillespie.

After a channel was dredged through Sarasota Bay in 1895 and the steamer *Mistletoe* began making regular runs between here and Tampa, Higel acted as Sarasota agent for John Savarese, owner of the steamship line. Later Higel owned and operated the steamer *Vandalia*.

Higel was Sarasota's first retailer of gasoline and kerosene. In 1907 he started the development on the north end of Sarasota Key, which he named Siesta.

He led the movement to form the Sarasota Yacht Club and became its first commodore.

On January 18, 1896, Higel married Gertrude Edmondson, granddaughter of William and Mary Whitaker.

He served five terms as a member of the town and city council and three terms as mayor.

The Higels had three children: Genevieve, Louise and Harry Gordon, who would later become postmaster of Sarasota. Higel was murdered on January 6, 1921. Gertrude died on September 9, 1953.

8. Samuel W. Gumpertz

Gumpertz was born in Washington, D.C., on September 6, 1869, and led a long and colorful life, joining the Buffalo Bill show as a rough rider, then becoming general manager of the Colonel John D. Hopkins Circuit of Theatres from Chicago to New Orleans. He also managed the Hopkins Transoceanic Vaudeville Show, engaging the famous strongman Eugene Sandow. Gumpertz was Harry Houdini's first manager and increased Houdini's earnings from $40 per week to over $3,000 weekly, touring him all over the world.

In 1903 he helped build Coney Island's Dreamland, one of the largest amusement parks in the world, and managed it until it burned down in 1911. He became involved in real estate, and as general manager of Realty Associates helped in the development and promotion of Brighton Beach in Brooklyn.

From 1932 to 1937 he was vice-president and general manager of the Ringling Bros. Circus.

He constructed, furnished and equipped the penthouse addition on the Halton Hospital in which over 1,500 underprivileged children were operated on by Dr. Halton without charge. He donated land at Crescent Beach to the Sunniland Council, which was later sold with the proceeds going to establish a trust for the Scouts.

Gumpertz died on June 22, 1952.

9. John Browning and Family

John Browning, his wife Jane Gault (Kerr) Browning and their children arrived with the original Scots colonists on December 27, 1885, and braved the harsh realities of Sara Sota, ultimately contributing to its success. Browning had been the owner of a lumber mill and woodworking shop in Scotland and was an expert craftsman. He did a lot of building for the Florida Mortgage and Investment Company, remaining active in the construction business until his death on April 24, 1913. Jane died on September 17, 1915.

One of their sons, Alex, was born on June 5, 1866, in Paisley and studied architecture in the office of James Lindsay in Edinburgh. He was nineteen years old when he arrived in Sarasota and drafted the plans for a number of Sarasota's first buildings. In 1890 he was an assistant architect on the Tampa Bay Hotel.

Alex supervised construction of large buildings in Chicago, Buffalo and Toronto. He returned to Sarasota in 1919 and was appointed commissioner of public works. With his son, Hugh Browning III, he did the contracting for many buildings, including the Frances-Carlton Apartments and numerous private homes.

Alex's son, John Bowie, was a well-known personality in Sarasota working for the *Sarasota Herald*, managing the circulation and advertising departments. Later he was the manager and vice-president of WSPB radio.

A descendant of the Brownings, John B. Browning Jr. still resides in Sarasota and is active in the civic affairs of the community.

Alex Browning

10. John Hamilton Gillespie

Sent over to revive the Florida Mortgage and Investment Company's failed Scots colony, Gillespie was born in Maffat, Dumfriesshire, Scotland in 1852. He studied law in Edinburgh and became a member of the Royal Company of Archers, Queen's Bodyguard for Scotland. By the time he arrived in Sarasota practically the whole colony had disbanded and left.

He was the only attorney in the community and served many times as justice of the peace. He was one of the founders of the short-lived railway, dubbed the Slow and Wobbly. He helped to get an appropriation from the federal government for the first dredging in Sarasota Bay in 1893–95 and he built the DeSoto Hotel (later known as the Belle Haven Inn), and after Sarasota was incorporated as a town, he served six one-year terms as mayor and one term as a councilman.

He introduced golf to Sarasota and Florida, laying out courses in Jacksonville, Kissimmee, Tampa, Bellair and Havana. He has been credited with having sold Henry B. Plant on the idea of popularizing golf throughout Florida as a means of attracting tourists. It worked.

Gillespie married twice. His first wife died in Scotland and his second wife, Blanche McDaniel, died on January 1, 1973.

Gillespie died of a heart attack on September 7, 1923, while he was walking on the golf course he founded. He is buried in Rosemary Cemetery.

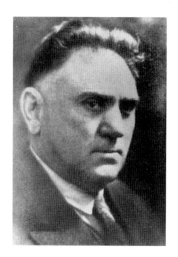

11. Joseph H. Lord

For many years J.H. Lord was the largest property owner in what is now Sarasota County. Born in Wells Depot, Maine, he was graduated from Brown University with an AB degree in 1885. He married Franc Mabel Webber and in the fall of 1885 came to Florida for health reasons and to prospect for promising phosphate lands. He was admitted to the Florida bar in 1886 and began practicing law in Orlando. He came to the Sarasota area in 1889 and over the next twenty years acquired more than one hundred thousand acres.

He began making extensive purchases in the town of Sarasota and by 1906 owned four of the five corners at Five Points as well as scores of other business and residential lots.

It was the blind ad that Lord took out in a Chicago paper that interested Bertha Palmer to come to Sarasota.

He built the Lord's Arcade and the building that would become known as the Palmer Bank (demolished as the Southeast Bank at Five Points). He served Sarasota in the state legislature.

He became the vice-president and manager of the Sarasota-Venice Company, organized to sell the property that he and Mrs. Palmer owned. This company started the Bee Ridge development and conducted a nationwide campaign to attract new settlers to this area.

He was very active in the Board of Trade and, later, the Chamber of Commerce. He maintained his headquarters in Chicago from 1910–14, where he handled sales for the Sarasota-Venice Company. Lord died in Chicago on December 24, 1936. Mrs. Lord died there on May 31, 1936. Both are buried at Manasota Burial Park.

12. C.V.S. and Rose Wilson

Rose Wilson

Cornelius Van Santvoord Wilson was born on July 10, 1837, and married Rose Phillips, his second wife, on March 8, 1898. His first wife died during the yellow fever epidemic, leaving him with six children. In 1885 he moved his family to Manatee and began publishing the *Manatee County Advocate*. In May of 1899 he moved to Sarasota, opening the *Sarasota Times*. Both he and Rose were progressive citizens who took an active interest in the community, pushing for Sarasota to break away from Manatee County, better educational facilities, the right of women to vote and the construction of the Tamiami Trail.

After Cornelius died in 1910, Rose took over the publication of the newspaper and ran it until 1923, when she sold the business. She ended her last editorial: "Now that larger plans speak of a greater Sarasota there are none who feel a greater interest and pride than those, who in the pioneer days caught the vision and paved the way. Mrs. C.V.S. Wilson." She died in 1964.

13. Leonard Reid

Born in Savannah, Georgia, in 1881, Reid came to Sarasota in 1900 and worked for many years for John Hamilton Gillespie as his manservant, right hand man and friend, helping Gillespie lay out some of the first golf courses in Florida. Early pictures of him show a tall, lean man holding the reins to Gillespie's carriage. He and his wife Eddie Coleman were married on June 21, 1906, by Reverend Lewis Colson and were among the

founders of Payne Chapel African Methodist Church.

A few days before he died in 1952, Reid had been singled out as a pioneer and honored at the fiftieth anniversary celebration of Sarasota. Sarasota writer Richard Glendinning wrote of him, "He was tall, light of step and he carried himself with the dignity of a Scottish chieftain…When that fine, respected man left his beloved Sarasota, his passing was a loss [to the community]."

Eddie died on January 2, 1970; she was eighty-six.

14. Ralph C. Caples

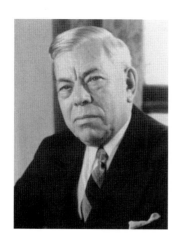

Born in Fostoria, Ohio, on December 23, 1872, after college, Caples worked for several railroads as a passenger agent and traffic manager. He joined the New York Central Railroad in 1905. During the presidential campaign of 1920, Caples had charge of Warren G. Harding's train.

On September 15, 1898, he married Ellen Fletcher and visited Sarasota for the first time in 1899 on a delayed honeymoon trip.

In the fall of 1911, Mr. Caples bought the home of Charles N. Thompson and an adjoining tract on Shell Beach and induced John and Charles Ringling to make Sarasota their winter homes.

In 1912 he and John F. Burket purchased the Belle Haven Inn. Caples also bought fifty-five city lots and built the Caples building on Main Street.

A perennial Sarasota booster, Caples went into the advertising business with offices in Chicago, New York, Omaha and Los Angeles, which handled the accounts of large railroads.

Very active in the civic affairs of Sarasota, he was a lifelong member of the Kiwanis Club and a supporter of the Salvation Army. He died February 7, 1949.

In 1962, the Ralph and Ellen Caples Hall was bequeathed to New College by Mrs. Caples. Mrs. Caples, known as Aunt Ellen to her friends, was supportive of the arts, music, theatre and education. She died on July 21, 1971, at age ninety-eight.

15. Owen Burns

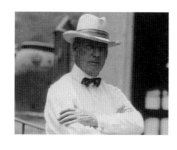

Born in Fredericktown, Maryland, on October 31, 1869, Burns was an avid fisherman and hunter who came to Sarasota for the first time in 1910. He immediately saw Sarasota's potential and purchased the holdings of the Florida Mortgage and Investment Company for $35,000 from

J. Hamilton Gillespie and at once owned 75 percent of the city limits of Sarasota.

Burns had made his fortune marketing metal home savings banks, which were sold to banks throughout the country.

In March 1911, Mr. Burns organized and became first president of the Citizens Bank of Sarasota, which later became the First National Bank. In November 1911 he was elected president of the Board of Trade. He also played a leading part in the reorganization of the Sarasota Yacht Club, aided in establishing the Woman's Club and in building St. Martha's Church.

He was responsible for constructing some of Sarasota's most important buildings, including the lavish El Vernona Hotel, the bungalows at Burns Court, the building at Herald Square, Ca'd'Zan and the John Ringling Bridge. He also dredged Golden Gate Point and around Lido Key and St. Armands Key, took over the Belle Haven Apartments, built the home that became known as the Karl Bickel House and built the seawall around the downtown bay front.

He married Vernona Hill Freeman in 1912 and the couple had five children: Lillian, Owen Jr., Vernona, Leonard and Harriet Burns Stieff, presently living in Sarasota.

Owen died in Sarasota on August 28, 1937. Vernona died December 24, 1974.

16. Dr. Jack and Dr. Joe Halton

Dr. Joe Halton

Born in St. Helens, Lancashire, England, on March 3, 1868, Dr. Jack Halton first came to Sarasota in 1904 and moved here in 1905, opening his office at the foot of lower Main Street. In 1908 he opened the Halton Sanitarium, which is where the Palmer party was put up in 1910 on their first visit here. Dr. Jack also operated the Belle Haven Inn for three years, served one term as a councilman and two years as the city physician. For many years he was a surgeon for the Seaboard Railway Company. He organized the department of proctology in the Tampa Municipal Hospital and was a staff member of St. Joseph's Hospital in Tampa and the Sarasota Hospital.

He was commissioned as a captain in the Army Medical Corps in August 1917.

He received the American Legion community service award for the work he had done for underprivileged children.

He was also one of the founders of the Episcopal Church of the Redeemer.

Blessed with a fine singing voice, he participated in many Sarasota musical, social and church functions and also sang with some national orchestras, including the Philadelphia Philharmonic Symphony. He died while performing in St. Petersburg on February 27, 1942.

He was survived by his wife Winifred Cadwell, daughters Edith, Mrs. Ed Roth and Mrs. Edward V. Roberts of Atlanta, Georgia; and one son, Jack Halton.

Dr. Joe Halton came to Sarasota several years after his brother and after establishing his practice here opened the private Halton Hospital on Pineapple Avenue. He served one term as a councilman in 1910–1911. He was honored by his fellow surgeons in 1957 when he was made the first life member of the Florida Medical Association. He was a fellow of the International College of Surgeons and a member of the Sarasota County Medical Society. Dr. Joe was also known as a humanitarian. In 1951, he was named Sarasota's Man of the Year by the American Legion for performing over 1,600 operations on needy children. He died on June 17, 1963. His wife, Mary Colt Halton, who had been active with the Founders Circle of the Garden Club, past president of the Woman's Club and active in the American Red Cross and the Woman's Auxiliary of the Church of the Redeemer, died October 24, 1958.

17. Thomas Reed Martin

Born on April 28, 1866, Thomas Reed Martin came to Sarasota at the behest of Bertha Palmer, one of his clients, to design her winter retreat, The Oaks. Martin loved the area and stayed to become one of Sarasota's most prolific architects. He is credited with introducing modern building methods to Sarasota and in employing skilled artisans on his projects. He designed the Municipal Auditorium and the Chidsey Library and also prepared the first plans for Ca'd'Zan.

His son, Frank C. Martin, joined his father in architectural work, forming the Martin Studio of Architecture and, for a time, so did his son Jerome K. Martin. Another son, Thomas Reed Martin Jr., joined the Palmer interests and was one of the sales managers of Palmer Farms Growers Cooperative Association.

Martin married Sadie W. Coffin of Chicago, a descendent of Benjamin Franklin.

18. Bertha (from Berthe) Palmer

Bertha Honore Palmer was born in Louisville, Kentucky, on May 22, 1849, and in 1871 she married Potter Palmer, a businessman and one of the largest property owners of Chicago. For a wedding present he gave her the Palmer House Hotel and regularly lavished gifts upon her.

A society woman of international renown, with homes in Paris, London and Chicago, Mrs. Palmer befriended royalty and her visit to Sarasota in February of 1910 cast the world spotlight on this unknown and out-of-the-way community on the Gulf of Mexico. Her pronouncement that Sarasota Bay was more beautiful than the Bay of Naples piqued the interest of many and brought to Sarasota important Chicagoans for a look-see.

In 1891 she was elected president of the Board of Lady Managers of the Chicago World's Columbian Exposition of 1893.

She purchased thousands of acres in the area and made her winter home at The Oaks in Osprey. She was an astute businesswoman who, through judicious investments, increased the $8 million left to her by Potter to a reported $20 million. (Potter Palmer's attorney reportedly pointed out that when he died, his wife would inherit a grand sum of money which might come under the sway of her new husband should she remarry. The attorney inquired, did he wish to take steps in his will to prevent this? Potter supposedly said, "No. He will need it.")[255]

Bertha died at The Oaks on May 5, 1918.

19. Honoré Palmer

After the death on May 4, 1902, of his father, Potter Palmer, Honoré Palmer, a Harvard graduate, became an executive of the Palmer estate and he devoted himself to the administration and development of its many projects. He was elected to the Chicago Board of Aldermen in 1901 and reelected in 1903.

On August 20, 1903, Honoré married Grace Greenway Brown at St. George's Church in London. They had two sons, Potter D'Orsay, who was born in 1905 and died in

1939, and Carroll Honoré, born in 1908 and died in 1938.

Honoré first came to Sarasota in 1910 with his mother, Bertha, and in 1911 he and his brother, Potter Palmer II, built their home "Immokalee" on a 140-acre tract. Later, Honoré acquired his brother's interest in this, and after Bertha's death, Potter II made his winter home at The Oaks.

Honoré was the chairman of the board of the Palmer National Bank & Trust Co., once Sarasota's flagship bank. As an editorial in the *Sarasota Herald* put it, he was a "Banker, rancher, philanthropist [who] took an interest in the affairs of Sarasota" for over fifty years.

The development of the Myakka River State Park was made possible by the outright gift in October 1934 of a strategic tract of 1,920 acres to the state by Honoré and Potter Palmer II.

Honoré died on March 4, 1964. His wife, Grace, died on April 18, 1966. His brother Potter Palmer II married Pauline Kohlsaat of Chicago on July 27, 1908. He died in Santa Barbara on September 3, 1943. Pauline died on July 7, 1956.

20. *Francis Allen Walpole*

Frank Walpole enjoyed a successful career in journalism, gaining a reputation as a fearless newspaper man, "Florida's fiery, red-haired editor," before he got into the drug business by buying the Manatee Drug Co. in 1907. He came to Sarasota in 1916 and bought out the drug businesses that had belonged to Fred Knight, Sarasota's pioneer pharmacist. Walpole operated the Sarasota Drug Store and Walpole's Pharmacy until he sold out to the Liggett Company in 1926 to enter the real estate market.

He played a prominent role in the creation of Sarasota County and was given the pen with which Governor Cary A. Hardee signed the bill.

Walpole was also active in banking as president of the Morris Plan Bank and director of the First Bank & Trust Company and The First Trust Company.

He was a member of the City Planning Board and was active with the Chamber of Commerce and the Sarasota Realty Board.

Mr. Walpole married Ruby Evans Hart and had three children: Francis Hart, Charles Richard and Robert M.

He died in Jacksonville on June 5, 1927. Ruby died on April 10, 1971.

21. *Emma E. Booker*

In 1918, Emma Booker came to teach at the Sarasota Grammar School, the only black school in the area that took pupils from Myakka and Tallevast. Classes for her students were held in rented rooms and students were given used books, discarded from the white schools. She was promoted to principal in 1923 and raised funds for a permanent school site. With the help of the Rosenwald fund, a building for Sarasota Grammar School was completed in 1925. According to *Renaissance Connection News*, children made their desks out of orange crates. The local school board refused to add a ninth grade, as it was believed by the local school superintendent that "An eighth grade education is enough for any Negro." When the Emma E. Booker Elementary School was named in her honor an editorial commented, "Emma Booker persevered, personally encouraging students, underwriting their continued education and pressuring intransigent administrators to provide for blacks the same educational opportunities available to whites." Emma Booker was born in 1886 and died in April 1939.[256]

22. *Lewis Colson*

Lewis Colson came to Sarasota in 1884 with the surveying company hired by the Florida Mortgage and Investment Company to plat Sara Sota. It was Colson who drove the stake in the center of Five Points that marked the hub of the town. In 1897, Colson and his wife, Irene, who was the midwife for the black community, donated land to the Bethlehem Baptist Church. Colson was its first minister. In those days the black community was located in Overtown, which grew as more and more African Americans came to Sarasota. Colson served as the pastor of the Bethlehem Baptist Church from 1899 to 1915. Both the Colson Hotel and Colson Street are named in his honor. Born in 1844, he died in 1922. He and Irene are the only black people buried in Rosemary Cemetery.[257]

23. John Henry Floyd

Born in Branford, Florida, John Floyd, a building contractor, came to Sarasota in 1925 and built several churches and buildings in the Newtown section of Sarasota. He was ordained a minister and served as pastor of Mount Moriah Baptist Church until his death. Under his leadership from 1957 until 1974, the church never borrowed money or had a mortgage.

It was Floyd who recognized the need for a retirement home for Sarasota's black citizens and led the effort to achieve that goal. Raising funds through benefit concerts put on by the Choirs Union, he purchased an acre of land and with the help of volunteer labor, Floyd built the first Old Folk Aid Home in 1960 and served as the president and director until a modern facility was completed in 1967. Born in 1900, Floyd died on April 4, 1974.

24. Calvin Nathaniel Payne

Having enjoyed a successful career in oil prospecting and also as a manager with Standard Oil of New Jersey, Payne came to Sarasota in 1911 and wintered here with his wife, Martha, for many years. After the hurricane of 1921, he led the movement to clean up the downtown waterfront by providing the fishing industry a place to relocate at Payne Terminal, formerly the Hog Creek Terminals. The Paynes also donated to the city the land for Payne Park and loaned money to repair the Sarasota Golf Holding Company's course and clubhouse.

Martha was active with the Woman's Club and also helped to build the Presbyterian Church for which she and her husband donated the land.

Payne died in Erie, Pennsylvania, on September 13, 1926. Martha died on March 13, 1934, and was survived by a son, Christy.

25. Albert Edwin Cummer

Born in Buffalo, New York, on August 3, 1876, Cummer and his father, who was an inventor, developed a process for the utilization of asphalt for road building. The first asphalt streets in Sarasota were laid with Cummer machinery. Their plant in New York City was said to have broken all records for asphalt production. Their company, F.D. Cummer & Son, became one of the world's largest manufactures of road building equipment.

Cummer first came to Sarasota in 1919 for health reasons, built his home on Gulf Stream Avenue and erected a building on the Southwest corner of Main and Pineapple (today the site of the First Watch Restaurant). He also built the Cummer Arcade on Pineapple, which housed Sarasota's first modern post office. He developed and sold Cummer Park, known today as Harbor Acres.

His wife, Louise West Cummer, was one of the founders of the Sarasota Garden Club and the first two annual flower shows were held in her home. Their son, Edwin West Cummer, was a college professor who became a Sarasota County Judge. A.E. died on June 17, 1956. Louise died on Thanksgiving Day, 1959. An editorial in the *Sarasota Herald* noted, "She was one of the most ardent protectors of the bayfront and was always interested in the beautification of the city." Edwin died on March 16, 1981.

26. Earnest Arthur Smith

E.A. Smith came to Sarasota as a retiree seeking a long vacation here. However, he was soon involved in Sarasota real estate and later became the president of the Sarasota Abstract Co. In 1922 he played a leading part in the reorganization of the Chamber of Commerce, served as executive vice-president for five years and as its president for two years.

He was elected mayor in 1931 (taking office in 1932) as the vagaries of the Depression were really being felt and finances here were in a chaotic state, owing $6,200,000 in principal and past due interest. He was reelected in 1933 and 1935, did not run in 1937 but ran again and was elected in 1939, 1941 and 1943. He succeeded in refunding the city's debt. When he left office, the city's financial affairs were in excellent condition and its credit re-established.

He led the effort to acquire the land on which the Municipal Auditorium, the playgrounds and the Chidsey Library were built. He also helped to secure several major WPA projects and aided in the development of the City Mobile Home Park and was active in the development and sale of Harbor Acres. He died in December of 1962.

Mrs. Smith was active in raising funds for the hospital and served as vice-president and chairman of two Red Cross drives. The Smiths had three children: Lane E. Smith, who died in the army during World War I, Elliot H. Smith and E.A.'s stepdaughter, Mrs. Frank Martin.

Charles Ringling

27. John and Charles Ringling

There were seven Ringling Brothers: Al, Alf T., Charles, John, Henry, August G. and Otto, but it is John and Charles who have become synonymous with Sarasota's growth and development during the real estate boom of the '20s, with John Ringling credited for planting the seeds to our claim of being the cultural center of the Gulf Coast.

While John, the more flamboyant of the two, concentrated his development efforts on Lido Key, St. Armands Key and Longboat Key, Charles built to the east, near downtown. His Sarasota Terrace Hotel was completed in 1926 and he donated the property to the county on which to build the Sarasota County Courthouse in his Courthouse subdivision. He also built the Ringling Office Building across the street from the Hotel.

Both brothers were hard workers who earned and lived the good life with yachts, private railway cars, Rolls Royces and sumptuous mansions. Both were active with the Chamber of Commerce, owned local banks and were perennial boosters of Sarasota.

Charles died in his home after a short illness on December 3, 1926, just shy of his sixty-third birthday. John died in New York City on December 2, 1936.

28. Andrew McAnsh

Andrew McAnsh was born in Scotland and was living in Chicago when Mrs. Palmer made her visit to Sarasota in 1910. He came to Sarasota in September of 1922 and bought property on the waterfront on Palm Avenue across from Sarasota Bay. He formed the Mira Mar Corporation and, after garnering concessions from the city council, built the Mira Mara Apartments, which were ready for occupancy in January of 1923. He followed this up with the Mira Mar Hotel and Mira Mar Auditorium. On Siesta Key he developed the Mira Mar Beach subdivision and built the Mira Mar Casino.

He and his wife, Bertha Deegan McAnsh, had two children, Byron and Mrs. W.D. Foreman of Chicago. Bertha died in Chicago on June 10, 1945. Mr. McAnsh died on October 23, 1946. It was noted in the paper that his buildings on Palm Avenue marked the beginning of the real estate boom.

George D. Lindsay

29. *George D. and David B. Lindsay*

It would be difficult to overstate the importance of George and David Lindsay and their newspaper, the *Sarasota Herald-Tribune*, to the success of the community and also in documenting its history.

David had first seen Sarasota from the air when he flew over the area looking for auxiliary landing fields for pilots training during World War I. In 1925, when David and two associates, Paul Poynter and E.E. Naugle, started the *Sarasota Herald*, it was at the peak of the real estate boom. His father, George D., served as the editor of the paper and in 1927, the Lindsays bought the others out and became the paper's sole owners.

David, who was a lieutenant in the Ninety-fourth Pursuit Group during World War I, also served as a major in World War II and was stationed for two years with the Flying Tigers in China before commanding the Kumming Air Base, terminus of the "Hump" supply route from India.

In 1940, along with Pearson Conrad, who is credited with its design, and H.R. Taylor, Lindsay opened the Sarasota Jungle Gardens. A plaque there reads: "To the honor of David Breed Lindsay whose foresight led to the creation of the Sarasota Jungle Gardens in 1940 and whose labors made a thing of great beauty for the enjoyment of those who love Nature."

David, who became editor and publisher of the *Sarasota Herald-Tribune* upon the death of his father, retired for health reasons in 1955 and turned over the operation of the paper to his son, David Jr.

David drowned in Sarasota Bay on May 3, 1968, and as per his request, his ashes were scattered by plane over Sarasota Bay.

George D. Lindsay was born on March 30, 1862, and was already active in the newspaper business when he came to Sarasota to become editor of the *Sarasota Herald*. He was a Presbyterian minister and pastor from 1899 until 1906. From 1906 until 1911, he practiced law in Marion, Indiana, where he acquired the *Marion Chronicle*.

He was known nationally for the publication of a series of nonsectarian religious editorials that were published in two volumes, which were widely read and quoted.

It was said of him, "Kindly, generous and gentle, he was loved by everyone who knew him, and he was respected by the people of Sarasota as few other men have been." He died on February 5, 1946.

30. Roger Flory

Roger Flory came to Sarasota from Chicago in 1925 at the peak of the real estate boom, leaving behind a successful career in law. In 1928 he began the annual publishing of the popular *Sarasota Visitors' Guide*, which showcased Sarasota's attractions, hotels, motels and restaurants. He served as president of the Board of Realtors, vice-president of the Florida Association of Realtors, president of the Chamber of Commerce, commander of the Sarasota Bay Post No. 30 of the American Legion and was Sarasota's representative on the Republican State Executive Committee. For many years, when Sarasota was a democratic stronghold, Flory was called Mr. Republican. In 1919 he was designated as a "Founder of the American Legion."

During his administration as president of the Sarasota County Chamber of Commerce in 1938, the campaign to build and finance the Lido Beach Casino was inaugurated.

In 1946 he was a member of the governing boards of the American Red Cross, the American Legion, Chamber of Commerce, Service Men's Club, Florida Association of Realtors and was president of the Sarasota Board of Realtors.

31. Karl A. Bickel

Bickel worked his way up in the United Press wire service organization to become president in 1922, serving in that capacity until 1935, when he retired. He was also chairman of the board of the Scripps-Howard Radio Company. Bickel and his wife, Helen Madira Davis, vacationed in Sarasota beginning in 1928 and, after he retired, bought the Burns Office Building just south of the John Ringling Hotel and made it their home.

Both he and Mrs. Bickel were active in the affairs of the community. He was a member of the Sarasota Park Board and was also active in the Chamber of Commerce, serving on the board of directors. He was the first president of the Longboat Cabana Club. He was the author of *New Empires—The Newspaper & Radio* and *The Mangrove Coast*.

He was the president of the Florida Historical Society, the operating committee of the board of control of the John and Mable Ringling Museum and the Sarasota County member of the Everglades National Park Commission.

Mrs. Bickel was an active member and president of the Federated Circles of the Sarasota Garden Club. Both fought to save the Memorial Oaks that lined Main Street but which fell to progress in the early 1950s.

In 1940 Mrs. Bickel organized the Sarasota County unit of the British War Relief.

Helen died on August 31, 1964. Karl died on December 11, 1972.

32. Frank G. Berlin

Born in Kankakee, Illinois, on February 3, 1905, Berlin began working in the drugstore business in 1923 and became employed by the Walgreen Company in 1925. He became district manager for Walgreen Company for the entire South and had his headquarters in Dallas, Texas.

Berlin married Mildred Cantrell in 1935 and had two children, Carol and Franklin G. Jr. He went into business for himself in Bradenton in 1938 and operated Bay Drugs with stores in Bradenton, Sarasota, Fort Myers and Clearwater. He made Sarasota his home in 1940 and became active in the civic affairs of the community.

He was elected president of the Chamber of Commerce in 1944 and 1945.

Berlin's development projects include Lakewood Estates, the Myakka Valley Ranches, Saddle Creek and Bel Air. He provided the 250 acres of land for the Gator Creek Golf Course. He and Dick Gilliland founded Cascade Realty, which marketed Myakka Valley Ranches.

He was an early supporter of New College and was active on the New College Foundation. He also supported the Hospice, Boys and Girls Club, Rotary and the YMCA, going personally to Atlanta to get a Y charter for Sarasota in 1945. In 1995 the YMCA facility at Euclid Avenue was named in his honor. Berlin died on June 16, 1997. Suellen Field, Rotary president, said of him at the time of his death, "He was always young on the inside—one of the most dynamic, loving and caring people I've known."[258]

Mildred Berlin died on May 12, 1996.

33. James B. and Taylor Green

Born in Crenshaw County, Alabama, February 28, 1882, James Green moved to Sarasota in 1925 at the height of the land boom. He established a plumbing and heating company that became known throughout the state. A mechanical engineer, he started the Green's Fuel Company in 1931, which was internationally known for developing a formula of hydrocarbon gases that could be maintained as a liquid

James B. Green

159

under pressure and used for general heating and cooking purposes. It became one of the fastest growing companies in the nation.

He married Jessie Taylor in 1907 and had one son, Nesbit Taylor, who became a leader of Green's Fuel.

James Green died on June 10, 1953. Jessie died on January 6, 1981; she was ninety-two.

Their son Taylor, born June 16, 1908, helped with the development of the new formula for liquid petroleum and was very active in the affairs of Sarasota, serving on the boards of the Salvation Army (a life member because of his outstanding service), Pines of Sarasota (which he served for twenty years), Jaycees, the Rotary Club and the Florida Children's Commission.

Taylor Green sold the company to Texas Natural Gasoline Corp. in 1954 but maintained the ownership of Southern Supply Inc., which he ran until he retired in 1971.

Taylor and his wife Harriet had three daughters: Susan Granger, Margaret Dungan and Caroline Bole. When he died on July 14, 1998, his friend Art Goldberg said of him, "He cared a lot about serving the community and people less fortunate than him."[259]

34. Benton W. Powell

Powell was born in Aurora, Indiana, July 25, 1899, and became affiliated with the Palmer Estate organization in 1926 in their Chicago office. He was transferred to the Tampa office of the Palmer organization in 1931 and two months later to the Sarasota office.

He published the *Sarasota Tribune*, which was later purchased by the Herald Publishing Company, thus becoming the *Sarasota Herald-Tribune*.

Powell was president of the Palmer National Bank & Trust Co. for many years. He served as a member of the board of directors of the Chamber of Commerce and was a director of the Kiwanis Club and a member of the advisory boards of the Salvation Army and the Sarasota Hospital Board. He was also a director of the Anglers Club and the Red Cross and was chairman of the Sarasota Housing Authority. He married Hazelle Hancock in 1921 and had one daughter, Arlys.

Powell, who had been a veteran of both World Wars, died on February 4, 1986.

35. Verman Kimbrough

One of Sarasota's most respected educators and civic leaders, Verman Kimbrough served two terms as superintendent of the Sarasota County public school system and one term as mayor. He was a teacher at Florida Southern College and came to Sarasota in 1931 to open and preside over the Ringling Art School, which he located in the old Bay Haven Hotel. At that time the school had a junior college program. Kimbrough ran the school until he retired in 1971.

Blessed with an impressive singing voice, during the years from 1932 to 1942 Kimbrough gave an annual concert that financed a summer camp for underprivileged children. Prior to coming to Sarasota he went to New York to study and sang in two Broadway shows, (interestingly) *The Student Prince* and *Princess Flavia*. He also studied music in Italy and France and made his operatic debut in Porto Maurizio, Italy, singing the baritone lead in *Il Trovatore*. His chances for an operatic career were dashed when he contracted a respiratory ailment.

He was the choir director and soloist of the First Presbyterian Church Choir for sixteen years. From 1956 until 1967 he was a member of the governor's Education Committee and was also a director of the Chamber of Commerce, YMCA, Salvation Army, Florida West Coast Symphony, Cancer Society, Sarasota Art Association, Happiness House and other community service organizations.

He married Edith Averyt, a dean of women and dietician at the Ringling School of Art and Design. Mrs. Kimbrough was active in the community with the Presbyterian Women's Organization, the Sarasota Garden Club's Tree Circle and the Field Club. They had one son, Robert.

Kimbrough died on August 12, 1972; Edith died on May 9, 1988. Their son, Robert, is a practicing attorney in Sarasota.

36. Arthur E. Esthus

Born in Chicago, Illinois, on October 13, 1894, Esthus came to Sarasota in 1926. He served in World War I, taking part in the St. Mihiel and Meuse-Argonne offensive as a member of the 108th Trench Mortar Battery of the 33rd Division. From 1926 until 1938 he operated the Esthus Transfer and Storage business and thereafter owned the Sarasota Typewriter & Key Shop, which became the Esthus Cycle and Key Shop in 1950.

Always active in community affairs, he was a past commander of the Sarasota Bay Post No. 30 of the American Legion, a member of the stewards of the First Methodist Church and a member of the Sarasota County Jury Commission. He was active in the Boy Scouts and served as chairman of the Sarasota District of Boy Scouts. He was also treasurer of the Sarasota YMCA and president of the Sarasota Rotary Club. For his public service work, Esthus was named Citizen of the Year in 1944.

During World War II he served on the draft board. He was elected to the first Sarasota city commission in 1945.

He supported and raised money for the establishment of New College.

Esthus married Clara W. Andersen in 1919. They had three children: Raymond, George I. and Marjorie. He died on March 2, 1965. Mrs. Esthus died on March 28, 1978.

37. George F. Higgins

Born August 16, 1905, George F. Higgins, a utility contractor, was a founder and trustee of New College and first chairman of the Ringling Museum board of trustees. He was active in the civic affairs of Sarasota for fifty years. He served as a twenty-five-year member of the board of Pines of Sarasota, helped organize the bell ringers for the Salvation Army Christmas kettle collection and was president of the Downtown Kiwanis club. He served for over thirty years on the Little League board and was vice-chairman of Sarasota County Little League. He was also on the board of directors of the Asolo Theatre Foundation and was a member of the State Task Force on Violent Crime. Additionally he was the liaison between the Salvation Army and the United Way Planning Council and was past president and campaign chairman of the United Way and its predecessor, Community Chest. He served as chairman of the board of the Woman's Exchange. An affable gentleman with a winning smile, Higgins always found time to devote himself to worthy community causes.

He died on May 20, 1990.

38. John C. "Jack" Betz Sr.

Born on December 12, 1925, Jack Betz came to Sarasota as an infant and became one of the most respected and well-liked public servants in the state. He was a city commissioner from 1964 to 1971 and served three terms as mayor. He cast the lone

"no" vote regarding the demolition of the Lido Casino, where he had once been a lifeguard. In his youth he had been the high-diving double for Boy in Tarzan movies and was the stuntman and diver in the film *The Creature From the Black Lagoon.* He qualified for the Olympic diving team but was later disqualified because he had been paid for coaching a student swim team. He taught math and coached swimming and football at Sarasota High. He went to work for Richmond Homes, where he was a general manager, and was then president of Richmond Construction Corp. and senior vice-president of Ryan Homes Inc., which purchased Richmond. He retired in 1981. He was very active in the Jaycees.

During World War II he served in the navy on submarines. He was close to both Governor Reuben Askew and Lawton Chiles, with whom he walked the state during the "Walkin with Lawton" campaign. Both governors often sought his advice. He was appointed by Askew to Florida's Environmental Regulation Commission and later to the Board of Business Regulation. Betz married Lucyle Cheney and had three children, Kim, Buff and John C. Jr.

After Betz died Askew said of him, "He was a totally honest guy, a smart guy, a warm person with a good sense of humor." He died on August 24, 1998.[260] Lucyle died on July 13, 1986.

39. Paul Thorpe

Paul Thorpe was born in Philadelphia, Pennsylvania, to Paul and Edna Thorpe on February 27, 1926. He was educated at Penn State University. He and his wife JoAnn have five children. He served in the navy for three years.

He was vice-president of the Palmer Bank. He served as executive director of the Downtown Association for twenty-five years. He was involved in numerous civic organizations and served on many boards. He was chairman of the Freedom Train in 1976 and served on the Ringling Bridge Dedication Committee, Tiger Bay Club, was co-chairman of the Sarasota Millennium celebration, eight-year director of the parade for the Suncoast Off-Shore Grand Prix, co-founded the Farmers Market in downtown Sarasota (the best of its type in Florida), spearheaded the new bus terminal and served on numerous committees for both the city and county. He was a board member of both the French Film Festival and the Sarasota Film Festival. He was also chairman of the Fourth of July Celebration. He

worked hard to bring to Sarasota the Hollywood 20 Theatre Complex, the Ritz-Carlton Hotel and the Whole Foods store, all enhancing the downtown area.

For his many years of effort, Thorpe is recognized officially by the city and the county as Mister Downtown.

40. Charles D. Bailey

Charles Bailey was chairman of the board of the local Ellis Banks and served as chairman of the Sarasota Chapter of the American Red Cross and president of the United Appeal of Sarasota.

"Charlie" was born in 1918 in Altha, Florida, into a family that migrated to this state prior to the Civil War. He was commissioned as an officer in the 106th Combat Engineers of the U.S. Army. He served during World War II in the South Pacific until he was wounded in New Guinea and sent home in the spring of 1944.

In 1946, he joined the Florida National Bank, where he advanced to officer status. In 1949, he moved to Miami and joined the Peoples National Bank. He was elected mayor of Miami Shores in 1956, but relocated to Sarasota the following year.

Upon his death in 1980, a *Sarasota Herald-Tribune* editorial noted that, "Mr. Bailey was a leader in banking and in a wide variety of business, charitable and service organizations… There is no way of counting how many good things got done in this community because Charlie Bailey said, 'I'll do it,' and as other people said, 'if he does, I will, too.'" As former Mayor Jack Betz said, "Every community deserves a Charlie Bailey."

Mr. Bailey's descendants still reside in Sarasota.

41. James and Jane Hanna Sr.

Known for many years as the Main Street Merchant, James Hanna was born on April 20, 1895, in Mosul, Iraq. Dissatisfied with his life there, Hanna and a friend decided to seek their fortunes in America and at the age of fifteen ran away from home. They came through Ellis Island in 1913 with hardly any money, able to speak very little English and knowing no one in the United States.

Hanna became employed in a machine manufacturing plant in Springfield, Massachusetts, and rapidly became skilled in running a lathe and other machines needed in tooling for

military equipment. When World War I broke out, he joined the army and wanted to go to Europe to fight but he was deemed too valuable at his job and remained in Springfield supporting the manufacturing side of the war effort.

Hanna returned to Iraq and married Jane, with whom he had been matched by his parents. They returned to the United States and opened a successful fine linen store in Charlotte, North Carolina, and later another in Blowing Rock. The Hannas had five children: George M, James H. Jr., Dr. John E., Margaret M. (Lanigan) and Rosalie (Shmalo).

The family moved to Sarasota in 1932 and opened their first store here on lower Main Street. It quickly became popular as a place to buy fine, exotic merchandise. The businesses in Sarasota and Blowing Rock flourished and as all the Hanna children worked in the stores they never required outside help.

In the 1950s, the Hannas began purchasing property throughout Sarasota, including St. Armands, where they built a beautiful store. When downtown Sarasota fell on hard times in the 1970s Hanna, who had purchased property there, was responsible for the "new look" of upper Main Street. He received an award from the Downtown Association of Sarasota for the new building construction along the 1400 block. Their property included the DeSoto Hotel, J.C. Penney and the Ritz Theatre. After demolishing some of the stores on upper Main Street between 1973 and 1976, they rebuilt almost the entire north side of the 1400 block of Main Street. The Hannas moved their business back downtown from St. Armands in 1973, occupying a new space where the old DeSoto Hotel had been located.

James Hanna died at eighty-three on May 23, 1978; his wife, Jane, is ninety-five and still living in Sarasota.

42. George and Diane Esthus

George Irving "Pete" Esthus was born in Sarasota, Florida, October 10, 1929, the son of Arthur Engen and Clara Wilhelma (Andersen) Esthus. Art and Clara, with their three-year-old daughter, Marjorie, and one-year-old son, Raymond, moved to Sarasota from Chicago, Illinois, in 1925. Doctors said that Marjorie, suffering from bronchial distress, could not survive another Chicago winter. In Sarasota, Art owned a succession of businesses: Esthus Transfer Co., Sarasota Typewriter & Key Shop and Sarasota Cycle & Key Shop.

After graduating from Sarasota High School in 1946, Pete served four years in the U.S. Coast Guard air-sea rescue as an aviation radio operator. He then returned to Sarasota and attended the University of Florida in Gainesville. While attending the University he met Diane Hine, also a student, in 1953 and they married January 29, 1955.

Diane's great-grandparents, Miller and Elizabeth Hine, homesteaded at the community of Rye along the Manatee River in 1882. Because of poor economic conditions in Bradenton in 1930, Diane's parents, Frank and Sadie (Odum) Hine, moved to Boston, Massachusetts. There, Diane and her older brother, Kenneth, were born in 1934 and 1932, respectively.

After graduating from the University of Florida in 1956, Pete joined his father in business. In 1962 he and Diane bought the business, later changing the name to Sarasota Lock & Key Shop. They are the proud parents of daughter Pamela, born November 3, 1955, and son Kenneth, born May 14, 1960.

In 1965 Pete was bitten by the "history bug" and started collecting memorabilia and photographs of early Sarasota, which he displayed in his key shop building. In 2005 when they sold the business and the building in downtown Sarasota, they had to remove, relocate or put into storage about eight hundred photographs that had been on display. Much of the memorabilia, including the collection of sixty years of Sailor's Logs, the annual yearbooks from Sarasota High School, was donated to the Sarasota County History Center.

In 2005 Pete and Diane retired from business, but they remain active in community affairs. Diane is active in the Sarasota Seahorse Society, the Sarasota High Grand Reunion Committee and is president of the Friends of the Sarasota County History Center. Pete is the treasurer of the Historical Society of Sarasota County and serves on the board of directors of the Sarasota County Agricultural Fair Association as their first historian.

43. Dr. Robert E. and Lelia Harmon Windom

Dr. Windom was born in Columbus, Ohio, and moved to Sarasota in 1946 when his father was hired as Sarasota's first city manager. He graduated from Sarasota High School in 1948 with classmate Lelia Harmon. The two were married in 1953 and returned to Sarasota in 1960 when he opened the practice of internal medicine. Until 1986, Windom served as president of the

Sarasota County Medical Society, Florida Medical Association, Florida Heart Association and Sarasota County Chamber of Commerce. He was chief of staff of both Sarasota Memorial Hospital and Doctors Hospital. He organized the first local Heart Association benefit ball, promoted cancer prevention programs and formed the Sarasota Medical Foundation. He was a board member of the New College Foundation and was awarded the Distinguished Alumnus by Duke Medical School and Internist of the Year by the American Society of Internal Medicine.

In 1986 Dr. Windom was nominated by President Ronald Reagan and confirmed by the U.S. Senate as assistant secretary for health, Department of Health and Human Services. He oversaw the administration of the National Institutes of Health, the FDA Centers for Disease Control/Prevention, Indian Health Service and the National Institute of Environmental Health. He represented the United States before ministers of health in ten foreign countries. Two trees are planted in his honor: one in Tiblisi, Georgia, and the other in Kiev, Ukraine.

After his work for the Department of Health and Human Services, the Windoms returned to Sarasota in 1989 and became actively involved with the United Way, Goodwill Industries, Salvation Army and Pines of Sarasota.

He has served on the boards of the Sarasota Military Academy, the Salvation Army, Sun Trust Bank, Pines of Sarasota, the Glenridge on Palmer Ranch and the Tiger Bay Club.

He is president of WorldDoc Foundation and president of WorldImmunoSociety for Health Foundation. He is a voluntary faculty at USF College of Medicine and College of Public Health.

Since 1999 he has been chair of the Florida Leadership Council for Tobacco Control and senior advisor to the secretary of the Florida Department of Health. He is chairman of the Board of Trustees, St. Martinus University School of Medicine, Curacao, Netherlands Antilles.

Lelia Harmon Windom's parents moved to Sarasota in 1926 and she was born at Sarasota Memorial Hospital in 1931, when there were only forty-five beds. She attended McClellan Park School, Southside Elementary and Sarasota High School.

Her memories of yesterday's Sarasota include lots of pine trees, fruit trees, quiet streets, the wooden bridge from Golden Gate Point to St. Armands and no air conditioning.

She attended college at William and Mary for one and a half years before graduating from Duke University in 1952. In 1953,

the year she was married to Windom, she was the queen of the Sara de Sota Pageant.

The couple had three sons and Lelia served as president of the Southside School PTA and for two years as president of the Junior Welfare League of Sarasota. She was on the board of the New College Foundation and the Van Wezel board for many years. She also served on the board of the Sarasota Medical Auxiliary for a number of years, and also on the board of the New College Library Association. She is on the board of the Alzheimer LifeLiners and a volunteer at the Church of the Palms, Presbyterian. Her hobby is playing bridge.

44. Drs. Mary and Allen Jelks

Dr. Mary Larson Jelks was born of Henry and Nelle Larson in Altona, Illinois, in 1929. She was educated in the public schools there and received a BS and an MD degree from the University of Nebraska. Dr. Allen Jelks was born of Howard and Beulah Jelks in Macon, Georgia. He was educated in the public schools of Fort Lauderdale and received his BS and MD from Duke University.

Mary and Allen met as pediatric interns at Johns Hopkins Hospital in 1955 and married in 1957. They taught at the University of Florida Medical School from 1959 until 1961, when they moved to Sarasota and built their pediatric office at 1700 South Osprey Avenue. They practiced medicine there until 1985.

The Jelks have four children: Helen, Allen Jr., Howard and Alice. All are married and live in Florida. They also have three grandchildren.

Mary became a certified allergist and for over forty years has collected daily slides from their home on Clematis Street. She is a member of many state and national allergy groups and is known as the "Queen of the Pollen Count." She is a founder of the Friends of Myakka River and a member of many local environmental advisory groups.

Allen has been a member of the Rotary Club of Sarasota Bay since 1963, where he has held many offices. He is also active with the National Railway Historical Society.

Both are members of the First United Methodist Church, where Mary taught children for many years.

In 1995 the family formed the Jelks Family Foundation, which has made annual donations to many local organizations.

In 1999 it helped Sarasota County establish the Jelks Preserve along the Myakka River in south Sarasota County.

In 2004 Mary and Allen were honored as recipients of the Community Video Archives.

They believe that "Sarasota is a view of paradise."

45. Lillian Burns

A native Sarasotan, Lillian Grant Burns was the daughter of Vernona and Owen Burns, a key figure in transforming Sarasota. She attended a private school run by Miss Josephine Y. Pearce, which was located at the foot of Palm Avenue on Hudson Bayou, and was the first graduate of Out-of-Door School. In 1934, she graduated from Hollins College in Virginia and returned to Sarasota to teach fifth grade at the Out-of-Door School in Sarasota and assisted with early Players Theater productions.

While she would live elsewhere, Sarasota always was her home. Lillian Burns had an interesting and exciting life, from working with NBC to her World War II experiences as a hospital worker and with the Red Cross Military Welfare Service, from being a campus planner at the University of Pennsylvania to a city planner working with the revitalization of old cities for the American City Corporation.

In 1976, she began taping oral histories of Sarasota's old-timers, and these tapes combined with her records document a Sarasota that only a few here remember. In 1979 she moved here permanently and became actively involved in historical and preservation efforts. She served as president of the Sarasota County Historical Society and edited its newsletter; she was the president of the Gulf Coast Heritage Association as Historic Spanish Point opened; she served on the City Historical Preservation Task Force, Sarasota County Historical Commission and Historic Preservation Coalition; and was president of the Founders Circle Garden Club. In 1991 Lillian was honored by being the only Florida recipient of the American Association for State and Local History's Achievement in Preservation and Interpretation for Local, State and Regional History.

Lillian Burns was born on June 12, 1913, and died on February 24, 2001. She is buried in the Burns family plot in historic Rosemary Cemetery. The city commissioners of Sarasota paid tribute to the memory of Lillian with a plaque in honor of her work preserving Sarasota's history.

46. Ken Thompson

Ken Thompson was born on June 23, 1910, in Isle of Pines, Cuba, then a U.S. territory, to Charles Henry Thompson and Eliza Kathleen Stevens. He received a BS degree in electrical engineering from the University of Florida and attended one semester at Harvard and MIT.

Ken Thompson was handpicked to be Sarasota's city manager and served in that capacity for thirty-eight years, longer than any other city manager in the United States. He was instrumental in developing the Sarasota bay front, including Island Park, the Marina Jack development and boat marina. He was an expert in the science of beach preservation and a founding member of the Florida Shore and Beach Preservation Association, as well as director of the American Shore and Beach Preservation. He was past president of the Florida City and County Managers Association. He was instrumental in fostering advanced wastewater treatment, leading the nation in using reverse osmosis methods.

A visionary, Ken Thompson helped to pave the way for the Van Wezel Performing Arts Hall, the current city hall and a host of other development projects. He helped upgrade city services, especially in the area of the police force and the fire department. He was known as a person willing to lend a helping hand to the disadvantaged.

He had a keen interest in sailing and the arts and was known for his expertise on the trampoline as well as his talent in his hobby of wire sculpture. He had a pilot's license and loved flying over and observing the bay shore and the city's growth.

He received many government and civic awards and honors for his service as city manager of Sarasota, including commendation from the Florida Senate, the Florida Engineering Society, Goodwill Industries' Distinguished Citizen of 1986, Fraternal Order of Police's Citizen of the Year and Veterans of Foreign Wars' Man of the Year Award. Ken Thompson Park on City Island is named to honor him for his many years of dedicated service to Sarasota.

Ken Thompson was married to Barbara Ellen Davies. They had two children, Laura Davies and Kenneth Frederick. He had one son by a former marriage, Charles Henry.

Appendix:
Sarasota County in Review

The Town of Sarasota

The town of Sarasota was surveyed by Richard E. Paulson for the Florida Mortgage and Investment Company and the first sales from it were made in Scotland and England in the late summer and fall of 1885.

The town plat was recorded in the courthouse of Manatee County at Bradenton on July 27, 1886. Sarasota was incorporated as a town under the general laws of Florida at a meeting on October 14, 1902. The incorporation was recorded in Manatee County on November 14, 1902. The original town seal was a mullet with a rising sun over palmettos with shells at the base. The town's motto was, "May Sarasota Prosper." The first officials were elected October 14, 1902. The town's incorporation was validated by the state legislature in the spring of 1903 and signed by Governor William Jennings on April 30, 1903. The first mayor of the town was John Hamilton Gillespie.[261]

The City of Sarasota

Sarasota was incorporated as a city by a special act of the state legislature signed by Governor Park Trammell on May 16, 1913. The act became effective January 1, 1914.

A.B. Edwards was the first mayor elected under the new charter.[262]

Venice-Nokomis

Originally known as Horse and Chaise, first settled by Jesse Knight, the name Venice was approved by the government when a post office was established in 1888 with Darwin O. Curry as the first postmaster. The name Nokomis was adopted for the old community after the Seaboard had extended its tracks through the settlement.

Dr. Fred Albee began buying large tracts of land in the Venice-Nokomis region and in 1921 erected the Pollyana Inn at Nokomis, which was formally opened on January 8, 1922. He soon organized the Venice-Nokomis Chamber of Commerce and in 1925 organized the Venice-Nokomis Bank.

The present city of Venice was built by the Brotherhood of Locomotive Engineers in 1925–27 at an estimated cost of $16 million. The city was incorporated by the state legislature

late in 1926. The first meeting of the city officials, appointed by the governor, was held on December 9, 1926.

During the Depression of the 1930s, Dr. Albee acquired a large part of the Brotherhood's holdings. In June 1945, a syndicate of St. Petersburg businessmen headed by Robert S. Baynard purchased most of these holdings from Dr. Albee's widow. It was reported that the fourteen thousand acres were acquired for $400,000 and that the deal included large portions of the city of Venice, the town of Nokomis, parts of the residential developments of Bay Point and Treasure Island and twelve thousand acres of farmland.[263]

ENGLEWOOD

The town of Englewood was established in 1896 by Herbert N. Nichols of Chicago, who named it after a Chicago suburb. The town plat was recorded August 17, 1896.

Nichols advertised the community widely and in 1897 organized a company that built a forty-room hotel on the shore of Lemon Bay called the Englewood Inn. Lack of transportation facilities, however, stymied the growth and Englewood remained only a fishing hamlet. The hotel burned about 1910.

During the Florida boom, the community experienced some growth and opened a bank and several new stores. The bank failed during the crash and all but one of the stores closed. In 1946 Englewood was prophesized to be on the verge of new growth and development.[264]

Data collected by Karl E. Grismer, Pete and Diane Esthus and Hope Black.

These names were found in a file at the Sarasota County History Center titled "The Scotch Colony who founded the City of Sarasota—1886." Its author is unknown.

THE SCOTS COLONISTS

Mr. John Lawrie
Mrs. John Lawrie—nee Elen Browning
Miss Weina W. Lawrie
John Lawrie Jr.
Alex Lawrie
Robert Lawrie
James Lawrie
David Lawrie
Will Lawrie
Mr. John B. Browning
Mrs. John B. Browning—nee Jane Galt Kerr
Alex Browning
Hugh K. Browning
Jessie M. Browning
Ewina W. Browning
Maggie K. Browning
Mr. Isaac Brereton
Mrs. Isaac Brereton
Issac Brereton
Annie Brereton
Jenny Brereton
Mr. Robert McCausland
Minnie McCausland
William McCausland
Mr. Scott
Mrs. Scott
Bennie Scott
Alex Scott
David Scott
George Scott
Mr. Tom Booth
Mrs. Tom Booth (later married George Valentine)
Mr. Frank Pepper
Mr. Pearson

Ted Pearson—son
Willie Phillips—nephew of W. Pearson
Mr. Robertson
Mrs. Robertson
Two Robertson children
Robertson brother and his child
Mr. George Valentine
Peter Bruce Stewart—druggist in Tampa
Alex Harvey
Dan McKinlay
Tom Burgess
Alex Young
Robert or Alex Provan
Mr. Dolton
Mr. Durrant
Mrs. Durrant
Mr. Archibald
Mrs. Archibald
Four or five of their children, one of which was named Jessie
Dr. Wallace, MD
Mr. Moore
Mr. Moore (the Moores were twin brothers)
Mr. McCutcheon
Mrs. McCutcheon
Bob McCutcheon
Robert Crawford (Glasgow)

CLERKS OF CIRCUIT COURT

Otto E. Roesch	1921–1936
John R. Peacock	1936–1945
William A. Wynne	1945–1965
Robert W. Zinn	1965–1972
Raymond H. Hackney Jr.	1972–1987
Karen E. Rushing	1987–

CHIEFS OF POLICE OF SARASOTA

L.D. Hodges town marshal and police chief	1908–1921
S. Tilden Davis	1921–1937
Edgar A. Garner	1937–1949
Robert N. Wilson	1949–1959
Francis L. Scott	1959–1982
Earl D. Parker	1983–1988
John P. Lewis	1989–2000
Gordon R. Jolly	1992–1996 and 2000–2002
Peter Abbott	2002–

CHIEFS OF POLICE OF VENICE

George C. Duncan	December 9, 1926–December 5, 1928
Joseph L. McAllister	December 5, 1928–September 15, 1934
Walter B. Surls	September 15, 1934–January 10, 1936
Willis E. "Bill" Hill	January 10, 1936–September 8, 1937
James Dewey Stephens	September 8, 1937–April 4, 1944
Frank S. Kelso	April 4, 1944–December 31, 1945
Gerald L. Pestotnik	December 31, 1945–June 10, 1948
Herbert O. Hanchey	June 10, 1948–December 4, 1951
John Carey Shockey	December 5, 1951–June 23, 1974
Robert J. Ferry	June 24, 1974–August 23, 1977
Ray V. Waymire	November 7, 1977–December 21, 1984
Vincent L. Ball	December 21, 1984–December 25, 1987
Richard J. O'Shaughnessy	December 25, 1987–May 28, 1993
Joseph P. Slapp	May 28, 1993–April 10, 2001
James P. Hanks	April 10, 2001–March 1, 2006
Julie A. Williams	2006–[265]

SHERIFFS OF SARASOTA COUNTY

Burna Dale Levi	July 1921–1922
L.D. Hodges	1923–1928
W. Albert Keen	1929–1932
Clem Bonner Pearson	1933– May 1939
Byrd Douglas Pearson	1939–1952
Ross E. Boyer	January 1953– 1972
Jim D. Hardcastle	January 1973–1984
Geoffrey Monge	January 1985–2000
William Balkwill	2000–

CHIEFS OF SARASOTA FIRE DEPARTMENT

Henry G. Behrens	1912–1921
Clarence I. Stephens	1921–1924
Harry M. Knowles	1925–1952
James R. Cowsert	1953–1966
Harold R. Stinchcomb	1966–1988
Thomas Fields	1988–1992
Julius E. Halas	1992–

MAYORS OF THE TOWN OF SARASOTA

J.H. Gillespie	1902–1907
J.B. Chapline Sr.	1907–1908
G.W. Franklin	1908–1909
J.H. Gillespie	1909–1910
Hamden S. Smith	1910–1911
Harry L. Higel	1911–1914

MAYORS OF THE CITY OF SARASOTA

A.B. Edwards	1914–1915
Harry L. Higel	1916–1917
G.W. Franklin	1918–1919
A.B. Edwards	1920–1921
E.J. Bacon	1922–1931
E.A. Smith	1931–1936
Verman Kimbrough	1937–1938
E.A. Smith	1939–1944
J. Douglas Arnest	1945–1947
J. Fite Robinson	1948–1950
John L. Early	1951–1953
Leroy T. Fenne	1953
Ben Hopkins Jr.	1954
John D. Kicklighter	1955
A. Ray Howard	1956
Frank Hoersting	1957–1958
Fred W. Dennis	1959
Frank Hoersting	1960
Marshall Marable	1961
John O. Binns	1962
Herschel Hayo	1963–1964
David Cohen	1964–1966
John C. Betz	1966–1969
D. William Overton	1969
John C. Betz	1970
Gerald E. Ludwig	1971
Fred E. Soto	1972
T.J. "Tony" Saprito	1973–1974
Elmer Berkel	1975
Ronald Norman	1976–1977
Elmer Berkel	1978
Fred E. Soto	1979–1980
Ronald Norman	1981–1982
Rita Roehr	1982–1983

MAYORS OF THE CITY OF SARASOTA (CONTINUED)

Annie Bishopric	1983–1984
William Kline	1985–1986
Kerry G. Kirschner	1986–1987
Fredd Atkins	1987–1988
Rita Roehr	1988–1989
Kerry G. Kirschner	1990–1991
Fredd Atkins	1991–1992
Jack Gurney	1992–1993
Gene M. Pillot	1993–1994
Nora Patterson	1994–1995
David E. Merrill	1995–1996
Mollie C. Cardamone	1996–1997
Gene M. Pillot	1997–1998
Jerome Dupree	1998–1999
Mollie C. Cardamone	1999–2000
Gene M. Pillot	2000–2001
Albert F. Hogle	2001
Carolyn J. Mason	2001–2003
Lou Ann Palmer	2003–2004
Richard Martin	2004–2005
Mary Anne Servian	2005–2006

MAYORS OF VENICE

Edward L. Worthington	1926–1928
James T. Blalock	1929–1941
Clyde Higel	1941–1942 (resigned)
M. Cousins	1943–1945
Clyde Higel	1946–1947
Louis Suter	1948–1949
Frank C. Raeburn	1950–1951
George Youngberg	1952–1953
James P. Kiernan	1954–1957
Smyth D. Brohard	1958–1971
Thomas H. Humphris	1972–1973
William McCracken	1974–1975
Harry E. Case	1976–1980
William Frank Proctor	1981–1983
Richard W. Louis	1984–1986
Harry E. Case	1987–1992
Kathy A. Schmidt	1992–1993
Merle L. Graser	1993–1998
Dean Calamaras	1998–2006

Mayors of Longboat Key

David Zimmerman	1955 (president)
Wilfred LePage	1956
Lucille Lundbald	1957
Joseph Zwick	1957
Lucille Lundblad	1958
Joseph Zwick	1959
Howard Ridyard	1960–1961
Douglas Wray	1962–1963
Joseph Zwick	1964
Nelson O. Webber	1965–1966
William F. Blake	1967
Michael J. Brescia	1968
Samuel Gibbon	1969–1973
William J. Kenney	1974–1976
Howard Ridyard	1977 (temporary chairman, during commission reorganization)
Edward J. Petrick	1977
Sidney O. Ochs	1978
J. Kennedy McCall	1979–1980
Claire C. Bell	1981
Henry G. Ritter IV	1982
Harry P. Kirst	1983–1984
James V. Edmundson	1985
Carleton Stewart	1986
Catherine G. Fernald	1987
Lewis S. Pollock	1988
A. Hart Wurzburg	1989
James P. Brown	1990–1994
James H. Patterson	1995
Robert A. Drohlich	1996
Raymond W. Metz	1997
Harold Lenobel	1998–1999
J. Kennedy Legler Jr.	2000–2003
Ronald Johnson	2004–2005
Joan Webster	2006

Mayors of North Port 1959–1991

William Gregory	1959–1963
Flavius C. Wood Jr.	1963–1965
Franklin W. Wagner	1965–1967
Harry E. Brown	1967–1969
Roscoe B. Kirk	1969–1971
William F. Butler	1971–1973
Margaret M. Gentle	1973–1987
Frank Coulter	1987–1989
John P. Higgins	1989–1991*

(*November 5, 1991, charter amendment did away with the position of mayor)

City Managers of Sarasota

In 1945, the city's freeholders voted a new city charter that provided for five commissioners and a city manager. Ross Windom started work here February 1946.

Colonel Ross E. Windom	1946–1948
Carl Bischoff	1948–1949
Charles Pickett (acting)	1949–1950
Ken Thompson	1950–1988
David R. Sollenberger	1988–2001
Mike McNees	2001–

Property Appraisers

T.A. Hughes	1922–1928
J. Paul Gaines	1928–1940
Glover E. Ashby	1940–1960
William N. Stuart	1960–1972
John W. Mikos	1972–1996
Jim Todora	1996–

TAX COLLECTORS

E.G. Easterling	1922–1924
Charles E. Ragan	1924–1932
Charles G. Strohmeyer	1932–1944
Charlie Hagerman	1944–1975 (died in office)
Jane Folds	1975–1976 (appointed)
Rebecca Eger	1976–1984 (elected)
Barbara Ford-Coates	1984–

SUPERVISOR OF ELECTIONS

R.B. Chadwick	1922–1936
W.T. Dixon	1936–1950 (died in office)
Kathleen M. Outler	1950–1952 (appointed)
Virginia H. Meade	1952–1964 (elected)
Mary J. Orr	1964–1976
Joanne E. Koester	1976–1996
Marilyn Gerkin	1996–2000
Kathy Dent	2000–

Sarasota County Commissioners

Year	District	Commissioners
1921	1	Frank A. Walpole (chairman)
	2	L.L. May
	3	F.J. Hayden
	4	P.E. Buchan
	5	Henry Hancock
1922	1	Frank A. Walpole (chairman)
	2	L.L. May (until July 3, 1922—T.A. Albritton appointed)
	3	F.J. Hayden
	4	P.E. Buchan
	5	Henry Hancock
1923	1	M.L. Wread
	2	T.A. Albritton
	3	M.L. Townsend (chairman)
	4	J.D. Anderson
	5	W.F. Hancock
1924	1	M.L. Wread
	2	T.A. Albritton
	3	M.L. Townsend (chairman)
	4	J.D. Anderson
	5	W.F. Hancock
1925	1	M.L. Wread
	2	George B. Prime (chairman)
	3	M.L. Townsend
	4	Floyd L. Ziegler
	5	J.J. Crowley
1926	1	M.L. Wread
	2	George B. Prime (chairman)

Year	District	Commissioners
1926	3	M.L. Townsend
	4	Floyd L. Ziegler
	5	J.J. Crowley
1927	1	Louis Lancaster (chairman)
	2	J. Paul Gaines Sr.
	3	Guy M. Ragan (vice-chairman)
	4	Floyd L. Ziegler
	5	J.J. Crowley
1928	1	Louis Lancaster (chairman)
	2	J. Paul Gaines Sr.
	3	Guy M. Ragan (vice-chairman)
	4	Floyd L. Ziegler
	5	J.J. Crowley
1929	1	J.F. Miller
	2	W.S. Harris
	3	Guy M. Ragan (chairman)
	4	Floyd L. Ziegler (vice-chairman)
	5	W.D. Wyatt
1930	1	J.F. Miller
	2	W.S. Harris (vice-chairman)
	3	Guy M. Ragan (chairman)
	4	Floyd L. Ziegler
	5	W.D. Wyatt
1931	1	J.F. Miller
	2	W.S. Harris (chairman)
	3	George Higel
	4	F.J. Ziegler (vice-chairman)
	5	W.D. Wyatt
1932	1	J.F. Miller
	2	W.S. Harris (chairman)
	3	George Higel
	4	F.J. Ziegler (vice-chairman)
	5	W.D. Wyatt

Year	District	Commissioners
1933	1	John W. Davis
	2	W.S. Harris
	3	George Higel (vice-chairman)
	4	F.J. Ziegler (chairman)
	5	W.D. Wyatt
1934	1	John W. Davis
	2	W.S. Harris (chairman)
	3	George Higel
	4	F.J. Ziegler
	5	W.D. Wyatt (vice-chairman)
1935	1	John W. Davis (chairman)
	2	W.S. Harris
	3	J.L. McAllister
	4	P.E. Buchan
	5	W.D. Wyatt (vice-chairman)
1936	1	John W. Davis (chairman)
	2	W.S. Harris
	3	J.L. McAllister (vice-chairman)
	4	P.E. Buchan
	5	W.D. Wyatt (until January 17, 1936—A.Y. Carlton appointed)
1937	1	John W. Davis (chairman)
	2	W.S. Harris
	3	J.L. McAllister (vice-chairman)
	4	P.E. Buchan
	5	R.L. Johnson
1938	1	John W. Davis
	2	W.S. Harris (vice-chairman)
	3	J.L. McAllister (chairman)
	4	P.E. Buchan
	5	R.L. Johnson
1939	1	John W. Davis (chairman)
	2	W.S. Harris (vice-chairman)

Year	District	Commissioners
1939	3	J.L. McAllister
	4	P.E. Buchan
	5	A.Y. Carlton
1940	1	John W. Davis (vice-chairman until May 7, 1940—Bertha Davis appointed)
	2	W.S. Harris (chairman)
	3	J.L. McAllister (vice-chairman as of May 7, 1940)
	4	P.E. Buchan
	5	A.Y. Carlton
1941	1	Otis L. Howell (vice-chairman)
	2	W.S. Harris (chairman)
	3	J.L. McAllister
	4	P.E. Buchan
	5	A.Y. Carlton
1942	1	Otis L. Howell (chairman)
	2	W.S. Harris (vice-chairman)
	3	J.L. McAllister
	4	P.E. Buchan
	5	A.Y. Carlton
1943	1	Otis L. Howell (chairman)
	2	W.S. Harris (vice-chairman)
	3	J.L. McAllister
	4	P.E. Buchan
	5	J. Oliver Alderman
1944	1	Otis L. Howell
	2	W.S. Harris (chairman)
	3	J.L. McAllister
	4	P.E. Buchan
	5	J. Oliver Alderman (vice-chairman)
1945	1	Otis L. Howell
	2	W.S. Harris
	3	J.L. McAllister (chairman until August 23, 1945)
	4	P.E. Buchan
	5	J. Oliver Alderman (vice-chairman)

Year	District	Commissioners
1946	1	Otis L. Howell
	2	W.S. Harris
	3	M. Cousins (vice-chairman)
	4	P.E. Buchan
	5	J. Oliver Alderman (chairman)
1947	1	Otis L. Howell
	2	W.S. Harris (chairman)
	3	W.L. Woodard
	4	P.E. Buchan
	5	J. Oliver Alderman (vice-chairman)
1948	1	Otis L. Howell
	2	W.S. Harris (chairman)
	3	W.L. Woodard
	4	P.E. Buchan
	5	J. Oliver Alderman (vice-chairman)
1949	1	John L. Houle (vice-chairman)
	2	W.S. Harris (chairman)
	3	W.L. Woodard
	4	P.E. Buchan
	5	W.C. McLeod
1950	1	John L. Houle
	2	W.S. Harris (chairman)
	3	W.L. Woodard (vice-chairman)
	4	P.E. Buchan
	5	W.C. McLeod
1951	1	John L. Houle
	2	W.S. Harris (chairman)
	3	W.L. Woodard (vice-chairman)
	4	Ed T. Denham Sr.
	5	W.C. McLeod
1952	1	John L. Houle
	2	W.S. Harris (chairman)
	3	W.L. Woodard (vice-chairman)

Year	District	Commissioners
	4	Ed T. Denham Sr.
	5	W.C. McLeod
1953	1	Edwin F. McCann (vice-chairman)
	2	W.S. Harris
	3	Glenn Leach (chairman)
	4	Ed T. Denham Sr.
	5	J.F. Baumgartner
1954	1	Edwin F. McCann (chairman)
	2	W.S. Harris
	3	Glenn Leach
	4	Ed T. Denham Sr.
	5	J.F. Baumgartner (vice-chairman)
1955	1	Edwin F. McCann (vice-chairman)
	2	Albert D. Corson (chairman)
	3	Glenn Leach
	4	Gustin M. Nelson
	5	J.F. Baumgartner
1956	1	Edwin F. McCann
	2	Albert D. Corson
	3	Glenn Leach
	4	Gustin M. Nelson (chairman)
	5	J.F. Baumgartner (vice-chairman)
1957	1	Edwin F. McCann
	2	Albert D. Corson (chairman)
	3	James Neville
	4	Gustin M. Nelson
	5	Glenn E. Potter (vice-chairman)
1958	1	Edwin F. McCann
	2	Albert D. Corson (chairman)
	3	James Neville
	4	Gustin M. Nelson
	5	Glenn E. Potter (vice-chairman)

Year	District	Commissioners
1959	1	Edwin F. McCann
	2	Johnson Warren
	3	James Neville
	4	James Spanos (vice-chairman)
	5	Glenn E. Potter (chairman)
1960	1	Glenn Rose
	2	Johnson Warren
	3	James Neville (vice-chairman)
	4	James Spanos (chairman)
	5	Glenn E. Potter
1961	1	Boyd R. Gernhardt (vice-chairman)
	2	Johnson Warren
	3	Fred Haigh
	4	James Spanos
	5	Warren S. Henderson (chairman)
1962	1	Boyd R. Gernhardt (vice-chairman)
	2	Johnson Warren
	3	Fred Haigh
	4	James Spanos
	5	Warren S. Henderson (chairman)
1963	1	Boyd R. Gernhardt (vice-chairman)
	2	Johnson Warren (vice-chairman as of April 9, 1963, due to W. Henderson's election to Senate)
	3	Fred Haigh
	4	L.L. Parker (chairman as of April 9, 1963, due to W. Henderson's election to Senate)
	5	Warren S. Henderson (chairman until April 9, 1963—M. Huston appointed)
1964	1	Boyd R. Gernhardt
	2	Johnson Warren (vice-chairman)
	3	Fred Haigh
	4	LaVerne L. Parker (chairman)
	5	Masel C. Huston

Year	District	Commissioners
1965	1	Bruce S. Crissy
	2	Johnson Warren
	3	Leslie C. Miller
	4	LaVerne L. Parker (chairman)
	5	Robert M. Wright (vice-chairman)
1966	1	Bruce S. Crissy
	2	Johnson Warren
	3	Leslie C. Miller
	4	LaVerne L. Parker (chairman)
	5	Robert M. Wright (vice-chairman)
1967	1	Bruce S. Crissy
	2	William C. Cunningham (elected chairman as of June 23, 1967)
	3	Leslie C. Miller (chairman)
	4	William P. Carey (vice-chairman as of June 23, 1967)
	5	Robert M. Wright
1968	1	Bruce S. Crissy
	2	William C. Cunningham (chairman)
	3	Leslie C. Miller
	4	William P. Carey (vice-chairman, elected chairman as of September 26, 1968)
	5	Robert M. Wright (vice-chairman as of September 26, 1968)
1969	1	Daniel R. Howe
	2	William C. Cunningham (until April 15, 1969—H. Field appointed)
	3	Kenneth D. Brumbaugh (vice-chairman)
	4	William P. Carey (chairman)
	5	Larry Rhodes
1970	1	Daniel R. Howe (vice-chairman)
	2	Herbert P. Field
	3	Kenneth D. Brumbaugh (chairman)
	4	William P. Carey
	5	Larry Rhodes
1971	1	Daniel R. Howe (chairman)

Year	District	Commissioners
1971	2	Irving G. Snyder
	3	Kenneth D. Brumbaugh
	4	John M. Saba Jr.
	5	Larry Rhodes (vice-chairman)
1972	1	Daniel R. Howe
	2	Irving G. Snyder
	3	Kenneth D. Brumbaugh
	4	John M. Saba Jr. (vice-chairman)
	5	Larry Rhodes (chairman)
1973	1	Andrew Sandegren
	2	Irving G. Snyder (vice-chairman)
	3	William Muirhead
	4	John M. Saba Jr. (chairman)
	5	Larry Rhodes
1974	1	Andrew Sandegren
	2	Irving G. Snyder (vice-chairman)
	3	William Muirhead
	4	John M. Saba Jr. (chairman)
	5	Larry Rhodes
1975	1	Andrew Sandegren
	2	Beverly Clay
	3	William Muirhead
	4	John M. Saba Jr. (vice-chairman)
	5	Larry Rhodes (chairman)
1976	1	Andrew Sandegren (vice-chairman)
	2	Beverly Clay
	3	William Muirhead (chairman)
	4	John M. Saba Jr.
	5	Larry Rhodes
1977	1	Andrew Sandegren (vice-chairman)
	2	Beverly Clay (chairman as of August 1, 1977)
	3	William Muirhead (chairman until July 31, 1977—J. Neville appointed)

Year	District	Commissioners
1977	4	John M. Saba Jr.
	5	Larry Rhodes
1978	1	Andrew Sandegren (chairman)
	2	Beverly Clay (vice-chairman)
	3	James Neville
	4	John M. Saba Jr.
	5	Larry Rhodes
1979	1	Andrew Sandegren
	2	Beverly Clay (chairman)
	3	James Neville
	4	John M. Saba Jr.
	5	Larry Rhodes (vice-chairman)
1980	1	Andrew Sandegren (vice-chairman)
	2	Beverly Clay (Stackler)
	3	James Neville
	4	John M. Saba Jr.
	5	Larry Rhodes (chairman)
1981	1	Jerry Hente
	2	Beverly Clay (Stackler) (chairman)
	3	T. Mabry Carlton (vice-chairman)
	4	John M. Saba Jr.
	5	Robert L. Anderson
1982	1	Jerry Hente
	2	Jim Greenwald
	3	T. Mabry Carlton (chairman)
	4	Jeanne McElmurray
	5	Robert L. Anderson (vice-chairman)
1983	1	Jerry Hente (vice-chairman)
	2	Jim Greenwald
	3	T. Mabry Carlton
	4	Jeanne McElmurray
	5	Robert L. Anderson (chairman)

Year	District	Commissioners
1984	1	Jerry Hente (chairman)
	2	Jim Greenwald
	3	T. Mabry Carlton
	4	Jeanne McElmurray (vice-chairman)
	5	Robert L. Anderson
1985	1	Jerry Hente
	2	Jim Greenwald (vice-chairman)
	3	T. Mabry Carlton
	4	Jeanne McElmurray (chairman)
	5	Robert L. Anderson
1986	1	Jerry Hente
	2	Jim Greenwald (chairman)
	3	T. Mabry Carlton (vice-chairman)
	4	Jeanne McElmurray
	5	Robert L. Anderson
1987	1	Jerry Hente
	2	Jim Greenwald
	3	T. Mabry Carlton (chairman)
	4	Jeanne McElmurray (vice-chairman)
	5	Robert L. Anderson
1988	1	Jerry Hente (vice-chairman)
	2	Jim Greenwald
	3	T. Mabry Carlton
	4	Jeanne McElmurray (chairman)
	5	Robert L. Anderson
1989	1	Charley Richards
	2	Jim Greenwald (vice-chairman)
	3	T. Mabry Carlton (until June 10, 1989—B. Longino appointed)
	4	Jeanne McElmurray
	5	Robert L. Andersen (chairman)
1990	1	Charley Richards (vice-chairman)
	2	Jim Greenwald (chairman)

Year	District	Commissioners
1990	3	Berryman T. Longino
	4	Jeanne McElmurray
	5	Robert L. Anderson
1991	1	Charley Richards (chairman)
	2	David R. Mills
	3	AnnMarie Hill
	4	Wayne L. Derr
	5	Robert L. Andersen (vice-chairman)
1992	1	Charley Richards
	2	David R. Mills
	3	AnnMarie Hill
	4	Wayne L. Derr (vice-chairman)
	5	Robert L. Anderson (chairman)
1993	1	Charley Richards
	2	David R. Mills (vice-chairman)
	3	Eugene A. Matthews
	4	Wayne L. Derr (chairman)
	5	Robert L. Anderson
1994	1	Charley Richards
	2	David R. Mills (vice-chairman)
	3	Eugene A. Matthews
	4	Wayne L. Derr (chairman)
	5	Robert L. Anderson
1995	1	Charley Richards
	2	David R. Mills (chairman)
	3	Eugene A. Matthews (vice-chairman)
	4	Jack O'Neil
	5	Robert L. Anderson
1996	1	Charley Richards (vice-chairman)
	2	David R. Mills (vice-chairman as of November 19, 1996)
	3	Eugene A. Matthews (chairman)
	4	Jack O'Neil
	5	Robert L. Anderson (chairman as of November 19, 1996)

Year	District	Commissioners
1997	1	Raymond A. Pilon
	2	David R. Mills (vice-chairman)
	3	Shannon Staub
	4	Jack O'Neil
	5	Robert L. Anderson (chairman)
1998	1	Raymond A. Pilon
	2	David R. Mills (chairman)
	3	Shannon Staub (vice-chairman)
	4	Jack O'Neil
	5	Robert L. Anderson
1999	1	Raymond A. Pilon (vice-chairman)
	2	David R. Mills
	3	Shannon Staub (chairman)
	4	Nora Patterson
	5	Robert L. Anderson
2000	1	Raymond A. Pilon (chairman)
	2	David R. Mills
	3	Shannon Staub
	4	Nora Patterson (vice-chairman)
	5	Robert L. Anderson
2001	1	Paul Mercier
	2	David R. Mills (chairman)
	3	Shannon Staub
	4	Nora Patterson (vice-chairman)
	5	Jon Thaxton
2002	1	Paul Mercier
	2	David R. Mills
	3	Shannon Staub (vice-chairman)
	4	Nora Patterson (chairman)
	5	Jon Thaxton
2003	1	Paul Mercier
	2	David R. Mills

Year	District	Commissioners
2003	3	Shannon Staub (chairman)
	4	Nora Patterson
	5	Jon Thaxton (vice-chairman)
2004	1	Paul Mercier
	2	David R. Mills
	3	Shannon Staub
	4	Nora Patterson
	5	Jon Thaxton (chairman)

POPULATION

Year	County	Year	City of Sarasota
1910	840		
1920	2,149		
1925	8,284		
1930	12,440	1930	8,398
1935	13,789	1935	9,802
1940	16,106	1940	11,141
1950	28,827	1950	18,896
1960	76,895	1960	34,083
1970	120,413	1970	40,237
1980	202,251	1980	48,868
1990	277,776	1990	50,961
1995	301,528	1995	51,143
2000	325,957	2000	52,715
2003	348,635	2003	54,434

CITY OF VENICE POPULATION

Year	Population
1940	507
1950	727
1960	3,444
1970	6,648
1980	12,424
1990	17,052
2000	17,764

SARASOTA SERVICEMEN AND WOMEN KILLED WHILE SERVING IN THE U.S. MILITARY

World War II

Allen, James R.
Andress, Clifford
Bache, William H.
Barber, Richard D.
Beasley, Harold H.
Beason, Ross, Jr.
Bell, Walter
Benbow, John W.L.
Bingner, Hazel M.
Brownback, Joseph
Butler, Rhobie
Cameron, John L.
Campbell, Robert B.
Clarke, William D., Jr.
Clement, Thomas W.
Craig, Graham I.
Davis, John W., Jr.
Davis, Robert
Devane, Wallace W.
Dixon, John, Jr.
Dozier, Jack
Draper, Wallace B.
Dryden, Walter J.
Edwards, Owen
Ferrell, Nadler L.
Folse, Rupert E.
Frazee, Robert B.
Gibson, John B.
Glover, Harold E.
Goff, William L.
Greenwood, Clifford N.
Halliday, James H.
Harrell, Roland E.
Hinsey, Albert D., Jr.
Hunter, William D.
Johnston, Hugh B.
Jordan, Earl E.

Kennedy, Harvey, B.
Kimmel, Joseph G., Jr.
Kluge, Herman C.
Knight, Herman C.
Knight, Jerome C.
Livermore, Thomas L., III
Low, Fred S.
McAllister Carleton D.
McCracken, Richard H.
McDermott, Richard Z.
McGee, George E.
McMakin, Richard A.
Mann, William M.
Manning, James B.
Mashburn, Hugh D.
Matherly, Jones M., Jr.
Matausch, Constantin
Mays, Charles W.
Michael, Harold V.
Moore, Richard W.
Mulkey, Benjamin F., Jr.
Naves, Robert W.
Nevill, Hugh E.C.
Parsonage, Franklin C.
Pearson, Jeff L.
Peck, Stillman D.
Peters, Glen R.
Purdy, Frederick W.
Rembert, Andre G.
Roberts, Herbert, Jr.
Robertson, John F., Jr.
Robles, Orryl K.
Rotes, Paul N.
Royal, William E.
Rule, Robert E.
Russell, Elmer L.
Schucht, Hubert C.

Scott, Jasper N.
Searle, George M.
Sharpe, Emanuel M.
Shoor, Irving J.
Shute, George C.
Sines, Thomas C., Jr.
Skinner, Edwin M.
Smith, Christopher C.
Smith, Woodrow
Sullivan, Herbert I.
Surls, George A.
Surrency, Alfred H.
Timberlake, Franklyn L.
Tucker, Rufus H.
Walker, Philip E.
Ward, Earnest H.
Wells, Orrin S.
Wiechers, John
Willis, Henry Y.
Wilson, Jesse

Korean War

Campbell, Theron A.
Houston, Nathaniel J.
Kappellman, Ernest H., Jr.
Keys, Edward M.
Matthews, Henry T.
Meister, Adam G.
Murdock, Charles D.
Rice, Clifton L.
Rutledge, Robert D., Jr.
Tucker, John L.

Vietnam War

Ash, Frederic N.
Baker, Samuel H.
Barfield, Larry B.
Boicourt, Robert C.
Booth, Herbert Willoughby, Jr.
Campbell, Michael
Canter, William L.

Cheaney, Pruitt H.
Cleveland, Richard G.
Cochran, Robert M., Jr.
Costello, George S.
Deen, David K.
Georghegan, Gerald D.
Gibson, John B., Jr.
Giles, Clem C.
Gillespie, Wilbert L.
Gindlesberger, Gerald T.
Golden, Kenneth D., Jr.
Goodhue, Marlin J.
Gross, Robert H.
Hackett, Daniel H.
Hettich, Donald L.
Holt, Craig B.
Hoots, Richard M.
LeFebure, Ronald D.
Linthicum, Don W.
Lockhart, Harlan N.
Lucci, Christopher D.
Manigo, Eugene
Matheny, Russell L.
Mitchell, Thomas Peter
Murphy, Frank M.
Nereck, Lawrence T.
Nickerson, William Walter
Peters, Joseph C.
Peterson, James W.
Phillip, Roy F.
Strickland, Billie G.
Urban, Paul R., Jr.
Ward, Johnny N., Jr.
Webb, Daniel D.
Wernet, David P.[266]

Second Iraq War

Jackson, Kyle

TARPON TOURNAMENT WINNERS

1930	165.5 lbs.	William Bakewell, Daytona Beach, Florida
1931	141 lbs.	T.A. Morrison, Sarasota, Florida
1932	157 lbs.	F.F. Foster, Sarasota, Florida
1933	136.5 lbs.	Dr. Frank Cary, Green Bay, Wisconsin
1934	132 lbs.	Mrs. Charlotte Donnell, Geneva, Ohio
1935	139.5 lbs.	W.H. McLeod Jr., Tampa, Florida
1936	135 lbs.	Dr. Fred Collier, Trenton, New Jersey
1937	132.5 lbs.	Robert A. McGraw, Nashville, Tennessee
1938	138 lbs.	C.W. Mills, Sodus, New York
1939	138 lbs.	A.E. Mellon, Tampa, Florida
1940	133.5 lbs.	C.J. Muir, Detroit, Michigan
1941	137 lbs.	N.A. Cocke, Charlotte, North Carolina
1942–1945	Wartime, no tourney	
1946	126 lbs.	Roger Townsend
1947	141.5 lbs.	Otto Schedler, Milwaukee, Wisconsin
1948	138.5 lbs.	William R. Watts, Coral Gables, Florida
1949	184.5 lbs.	Lester Davis, Sarasota, Florida
1950	140.5 lbs.	Mrs. Mary L. Brown, Sarasota, Florida
1951	152 lbs.	Howard Elkins, Sarasota, Florida
1952	119 lbs.	Tom McKinney Jr., Sarasota, Florida
1953	134 lbs.	Leslie R. Moore, Haines City, Florida
1954	148 lbs.	Ralph Emmet, Sarasota, Florida
1955	183 lbs.	Jack Collins, Sarasota, Florida
1956	151 lbs.	Mrs. Johnnie Taylor, Osprey, Florida
1957	133.5 lbs.	Neal Taylor, Sarasota, Florida
1959	130 lbs.	Clarence H. Willis, Sarasota, Florida
1959	155 lbs.	James Hadden, Winter Haven, Florida
1960	157 lbs.	Don Davidson, Sarasota, Florida
1961	132 lbs.	Roy Buckelew, Nokomis, Florida
1962	152.5 lbs.	Bob Enlow, Sarasota, Florida
1693	154 lbs.	Don Tosh, Sarasota, Florida
1964	156.5 lbs.	Roy Buckelew, Nokomis, Florida
1965	177 lbs.	Eldon D. Scriven, Sarasota, Florida
1966	132.5 lbs.	Roy Buckelew, Nokomis, Florida
1967	145 lbs.	Don Gray, Sarasota, Florida

1968	135 lbs.	Billy Hathcock, Sarasota, Florida
1969	131.5 lbs.	Billy Hathcock, Sarasota, Florida
1970	150 lbs.	Dr. George D. Suddaby, Englewood, Florida
1971	167.5 lbs.	Lloyd Duncan, Sarasota, Florida
1972	153.5 lbs.	Tom Teffenhart, Venice, Florida
1973	156 lbs.	Wayne Tunison, Venice, Florida
1974	160 lbs.	J. Boisvert, Venice, Florida
1975	176 lbs.	Al Robinson, Sarasota, Florida
1976	158.5 lbs.	David Anderson, Venice, Florida
1977	139 lbs.	Robert Stetler, Arcadia, Florida
1978	145 lbs.	Jim Paris, Bradenton, Florida
1979	158 lbs.	Pete Glen, Miami, Florida
1980	153.5 lbs.	"Sandy" Hoffman, Sarasota, Florida
1981	155.5 lbs.	Don Avery, Sarasota, Florida
1982	153.5 lbs.	Peter Bonneau, Sarasota, Florida
1983	148.25 lbs.	Don Walker, Sarasota, Florida
1984	155 lbs.	Rex Sutherland, Sarasota, Florida
1985	72" length	Bill Chase, Sarasota, Florida
1986	74" length	Bill Liebel, Sarasota, Florida
1987	71" length	Russ Vannata, Sarasota, Florida
1988	78" length	Jay Langford, Burlington, Vermont
1989	74" length	Edward M. Harwell Sr., Sarasota, Florida
1990	78" length	Edward M. Harwell Sr., Sarasota, Florida
1991	No Tournament	
1992	77"length	Mike Mumma, Sarasota, Florida
1993	39" girth	Robert Flynn, Sarasota, Florida
1994	40.5" girth	Mike Mumma, Sarasota, Florida
1995	39" girth	Troy Morton, Sarasota, Florida
1996	43" girth	David Thomas, Sarasota, Florida
1997	40.5" girth	Jeffri Durrance, Sarasota, Florida
1998	42" girth	Bryan Sutherland, Sarasota, Florida
1999	41.5" girth	Aledia Hunt Tush, Sarasota, Florida
2000	41.5" girth	David Holifield, Bradenton, Florida
2001	46.25" girth	Chris Likens, Sarasota, Florida
2002	44" girth	Matt Fueyo, Sarasota, Florida
2003	39" girth	Karen Nash, Treasure Island, Florida
2004	41" girth	Dave Robinson, Sarasota, Florida

Professional Baseball in Sarasota

1924–1927	New York Giants
1928	No team
1928–1932	Indianapolis Indians
1933–1958	Boston Red Sox
1959	Los Angeles Dodgers
1960–1997	Chicago White Sox
March 30, 1988	Last game played at Payne Park, White Sox v. Rangers
1998–Present	Cincinnati Reds

Presidents of the Sarasota Garden Club

The first Garden Club was organized on May 6, 1927. It was later known as the Founders Circle and elected Mrs. John Ringling as its first president, 1927–1929. In 1933 the various Garden Clubs became the Federated Circles of the Sarasota Garden Club. The following are their presidents:

1933–1935	Mrs. John Williamson	1971–1973	Mrs. John B. Rutledge
1935–1937	Mrs. C.A. Martin	1973–1975	Mrs. Charles Fernandez
1937–1939	Mrs. Lillian Ayer	1975–1977	Mrs. Larson (Betty)
1939–1941	Mrs. Edson Hall	1977–1979	Mrs. Robert Ford
1941–1943	Mrs. Roy Brace	1979–1981	Mrs. Joseph Bretherick
1943–1945	Mrs. Lionel Drew	1981–1983	Mrs. Joseph N. Schneider
1945–1947	Mrs. Karl Bickel	1983–1985	Mrs. Richard LaBrie
1947–1949	Mrs. Athol Marcus	1985–1987	Mrs. Wilda Q. Meier
1949–1951	Mrs. James Younkman	1987–1988	Mrs. Joseph N. Scneider
1951–1953	Mrs. Bob Newhall	1988–1989	Mrs. Philip Coyle
1953–1955	Mrs. Edward Toole	1989–1991	Mrs. Joseph Bretherick
1955–1957	Mrs. Karl Bickel	1991–1993	Mrs. David Armstrong
1957–1958	Mrs. H. Barringer (Raoul)	1993–1995	Mrs. David Cook
1958–1960	Mrs. H.E. Jahns	1995–1996	Mrs. Richard LaBrie
1960–1962	Mrs. Wharton Ingram	1996–1998	Mrs. BenAmi Blau
1962–1964	Mrs. Leroy Crooks	1998–2000	Mrs. Raymond D. Angle
1964–1966	Mrs. G. Morton (Ihrig)	2000–2002	Mrs. Hollis Mercer
1966–1967	Mrs. Fred J. Holwill	2002–2004	Mrs. Brian Murphy
1967–1969	Mrs. H.E. Jahns	2004–2006	Mrs. Kathryn Johnson
1969–1971	Mrs. Francis Millican		

HISTORICAL MARKERS IN SARASOTA COUNTY AS OF MARCH 1, 2006

Placed by the Sarasota County Historical Commission, unless otherwise stated. Markers placed by other organizations are enclosed in parentheses.

1. Sarasota-Bradenton Airport—Airport Circle, Sarasota (1996)
2. Ca'd'Zan, House of John—U.S. 41 at University Parkway, Ringling Museum grounds, Sarasota (Historical Commission, Historical Society of Sarasota County)
3. Indian Beach—3701 Bay Shore Road, south of Sarasota Jungle Gardens (1986)
4. Bay Haven School—2901 Tamiami Circle West, west of U.S. 41, Sarasota (1995)
5. Booker Schools—Booker High School, 3201 North Orange Avenue, Sarasota (1988) (temporarily removed for repair)
6. First White Child—1232 Twelfth Street, Sarasota (Sara de Sota Chapter, DAR) (1936)
7. Yellow Bluffs—west side of U.S. 41, just south of Twelfth Street (1963) (temporarily removed) (Historical Society of Sarasota County and Florida Board of Parks)
8. Judah P. Benjamin—southwest corner of U.S. 41 and Tenth Street, Sarasota (United Daughters of the Confederacy)
9. Bidwell-Wood House—849 Florida Avenue, Sarasota
10. Rosemary Cemetery—Central Avenue between Sixth and Tenth Streets, Sarasota (1986)
11. First Black Community—southeast corner of Central and Sixth Street, Sarasota (1985) (temporarily removed for repair)
12. Edwards Theater—Sarasota Opera House, 61 North Pineapple Avenue, Sarasota (1983)
13. Seaboard Railroad—southwest corner of Lemon and First Street, Sarasota (1987)
14. First United Methodist Church—104 South Pineapple Avenue, Sarasota (First United Methodist Church)
15. Scots Landing—west corner of Main Street and Gulf Stream Avenue, Sarasota (Historical Society of Sarasota County and Florida Board of Parks) (1963)
16. Blue Star Memorial Highway—Bayfront Drive, between Main Street and Ringling Boulevard, Sarasota (Florida Garden Clubs and Florida State Highway Department)
17. Sarasota Terrace Hotel—101 South Washington Boulevard, Sarasota (1982)
18. Sarasota County Courthouse—2000 Main Street, Sarasota (2002)
19. Payne Park—Adams Lane, Sarasota (1996)
20. St. Armands—inside the north edge of St. Armands Circle, Sarasota (1988)
21. South Lido Park—end of Benjamin Franklin Drive, Sarasota, inside park on the bay side, near the picnic tables (1986)
22. Ringling Bros. and Barnum & Bailey Circus winter quarters—in median on Calliandra Drive just east of Beneva Road, Sarasota (1982)
23. Bobby Jones Golf Legend—Circus Boulevard, Bobby Jones Golf Complex, Sarasota (1994)
24. Fruitville Elementary School—601 Honore Avenue, Fruitville area (1991)
25. Friendship Baptist Church—5700 Palmer Boulevard, Fruitville area (1985)

26. Sarasota High School—1001 South Tamiami Trail, Sarasota (1990)

27. First post office—Cunliff Lane and McCellan Parkway, Sarasota (Daughters of the American Colonists)

28. Southside School—1901 Webber Street, Sarasota (1989)

29. Siesta on the Gulf, Harry Higel—Galvin Park, intersection of Higel Avenue and Siesta Drive, Siesta Key (1989) (temporarily removed for repair)

30. Siesta Public Beach—near pavilion, off Beach Road, Siesta Key (1986)

31. Edson Keith House—5500 South Tamiami Trail, Sarasota, close to house in Phillippi Estate Park (1990)

32. Bee Ridge Woman's Club—4919 Andrew Avenue, off Proctor Road, Bee Ridge (1989)

33. Bee Ridge Community—Bee Ridge Presbyterian Church parking lot, 4826 McIntosh Road, near the Proctor Road side, Bee Ridge (1991)

34. Bee Ridge Turpentine Camp—Demaco Corporation, 4550 Clark Road, corner of Clark and Deacon, Sarasota (1993)

35. Spanish Point at The Oaks—500 North Tamiami Trail, U.S. 41 and Seaman Road, Osprey (1985)

36. Laurel Turpentine and Lumber—northwest corner of Mission Valley Boulevard and Laurel Road, Laurel (1987)

37. Venice post office—Colonia Lane to Portia Street, left to southeast corner of Portia Street North and Hillcrest Drive/Oak Tree Lane, Nokomis (1988)

38. Nokomis Cemetery—Colonia Lane, half-mile east of U.S. 41, between Suncrest and Riverview Drive, Nokomis (1984)

39. Casey's Pass—south of Venice Inlet at the beginning of the South Jetty, Venice (1988) (temporarily removed for repair)

40. Bartlett's Landing—south of the north bridge over the Intercoastal Waterway, Venice (Daughters of the American Colonists)

41. Venice Horse and Chaise—corner of Nassau Street and Venice Avenue, Venice (1983)

*42. Heritage Court—east end of West Venice Avenue, Venice

*43. Pioneer Court—between Park Boulevard and Avenue des Parques, north

*44. Archaeological Court—between Armada and Park, south

*45. Indian Court—between Armada and Park, north

*46. Army Air Base Court—between Armada and Public Beach, south

*47. Veterans Court—west end of Venice Avenue

48. Buchan's Landing—south end of Dearborn Street and Englewood Road, Englewood (1981) (temporarily removed for repair)

49. Lemon Bay Women's Club—corner of Coconut and Maple Streets, Englewood (1989)

50. Lemon Bay Cemetery—corner of State Road 776 (Indiana Avenue) and Second Avenue, Englewood (1983)

51. Warm Mineral Springs—north of U.S. 41, Ortiz Boulevard to San Serando, North Port

52. Little Salt Springs—south of Price and Lochier Boulevard, North Port (Daughters of the American Colonists)

53. Blue Star Memorial Highway—corner of U.S. 41 and Pan American Avenue, North Port (Florida Garden Clubs and Florida State Highway Department)

54. Miakka School—corner of Myakka Road and Wilson Road, Old Miakka (1987)

55. Miakka Community—cemetery at Myakka Methodist Church, on Myakka Road, one and a half miles south of the east end of Fruitville Road, Old Miakka (1982)

56. Myakka River State Park—Founder's Marker, inside south entrance to Myakka River State Park, off SR 72

57. John Hamilton Gillespie—Ringling Boulevard, behind Sarasota County Terrace Building, 101 South Washington Boulevard, Sarasota (1995)

58. Osprey School—337 North Tamiami Trail, Osprey (1996)

59. Joseph Daniel Anderson—at Manasota Beach, Manasota Key Road, Englewood (1996)

60. Venezia Park—between Salerno Street and Sorrento Street, Venice (1996)

61. Sarasota County Agricultural Fair—3000 Ringling Boulevard, near fairgrounds, Sarasota (1997)

62. Lido Casino—400 Ben Franklin Drive, Lido Key (1997)

63. Venice Apartment District—John Nolen Park, Palmetto Court and Menendez Street, two blocks south of Venice Avenue, Venice (1997)

64. 337th Army Air Field Base—Airport Avenue, Venice Airport (Venice Aviation Society, Inc.) (1992)

65. Whitaker Gateway—west of North Tamiami Trail at Thirteenth Street, inside Whitaker Gateway Park, Sarasota (1998)

66. Municipal Airport/Lowe Field—corner of Twelfth Street and Beneva Road, Sarasota (1999)

67. Edgewood—Mundy Park, corner of Groveland Avenue and Country Club Way, Venice (1999)

68. Little White Church—4826 McIntosh Road, south of Bee Ridge Presbyterian Church, Bee Ridge (1999)

69. Judah P. Benjamin—southwest corner of U.S. 41 and Tenth Street, Sarasota (2000)

70. St. John's/Crocker Memorial Cemetery—Bee Ridge Road, east of Boston Market at U.S. 41, Sarasota (2001)

71. Franklin Field—corner of Rhodes Avenue at 2959 Fruitville Road, Sarasota (2001)

72. Atlantic Coast Line Railroad Depot—1 South School Avenue, Sarasota (2002)

73. Bispham Dairy—4613 South Tamiami Trail, Sarasota (2002)

74. Venice Train Depot—at Venice Train Depot, 303 East Venice Avenue, Venice (2003)

75. Historic Dearborn Street—300 West Dearborn Street, Englewood (2004)

76. Oaklands/Woodlawn Cemetery—at end of Gillespie Avenue, south of Twelfth Street, Sarasota (2004)

77. Nokomis School—234 Nippino Trail, Nokomis (2004)

78. Green Street Church and Museum—416 West Green Street, Englewood (2005)

*In median of West Venice Avenue, Venice (Venice Area Historical Commission)

NOTES

Introduction

1. *Sarasota Herald*, April 4, 1926.

Chapter I.

2. Ibid., June 2, 1935.
3. A.B. Edwards, interview by Dottie Davis (former Sarasota County historian), July 23, 1958, on file at the Sarasota County History Center.
4. Ibid.
5. Vernon E. Peeples, "The Sarasota Democratic Vigilantes," Sarasota County History Center.
6. *New York Times*, February 2, 1885.
7. Ibid.
8. Ibid.
9. Nellie Lawrie, "The Scotch Colony Comes To Sarasota," Sarasota County History Center.
10. Alex Browning, memoirs, March 21, 1932, Sarasota County History Center.
11. Excerpt from the McKinlay diary taken from *Sarasota Sunday Tribune*, October 1937.
12. *Sarasota on the Gulf*, 1888, Sarasota County History Center.
13. Peg Russell, *Dreamers of our Past*, Sarasota County Community Services, May 2000.
14. Ibid.
15. *Englewood Herald*, August 17, 1956.
16. Ibid.

Chapter II.

17. *Sarasota Herald*, June 2, 1935.
18. *Sarasota Times*, March 10, 1910.
19. Ibid., February 24, 1910.
20. Ibid., February 23, 1911.
21. Ann A. Shank, "A Look Back," *Sarasota Herald-Tribune*, March 25, 1998.
22. Karl H. Grismer, *The Story of Sarasota*, M.E. Russell, 1946, 313.
23. Ibid., 314.
24. Philip C. Smashey, "The Founding Of Osprey, Florida," July 1, 1971.
25. Russell, *Dreamers*.

Chapter III.

26. Letter on file at Sarasota County History Center.
27. *Sarasota Sunday Tribune*, October 1937.
28. Edwards, interview by Davis.
29. *Sarasota Times*, March 21, 1912.
30. *Sarasota Herald-Tribune*, November 15, 1964.
31. *Sarasota Times*, February 19, 1914.
32. Grismer, *Story of Sarasota*, 152.

Chapter IV.

33. *Sarasota Times*, January 23, 1912.
34. Ibid., 1912.
35. Grismer, *Story of Sarasota*, 199–200.
36. *Sarasota Times*, September 9, 1920.
37. Grismer, *Story of Sarasota*, 199.
38. *Sarasota Times*, September 9, 1920.
39. General Acts and Resolutions, Volume I, 1921.
40. *Sarasota Times*, May 21, 1921.
41. *Sarasota County Times*, June 16, 1921.

Chapter V.

42. *Sarasota Herald*, October 10, 1926.
43. Edwards interview by Davis.
44. *Sarasota Times*, April 5, 1923.
45. Ibid., November 30, 1922.
46. Ibid., February 21, 1924.
47. Ibid.
48. Ibid., March 15, 1923.
49. Ibid., April 5, 1923.
50. R.L. Polk Sarasota City Directory, 1926.
51. Frank Parker Stockbridge and John Holliday Perry, *FLORIDA in the Making*, (Jacksonville: de Bower Publishing Co., 1926), vii.
52. Ibid., xv.

Chapter VI.

53. *Sarasota Herald*, October 10, 1925.
54. Ibid., October 13, 1925.
55. Ibid., October 4, 1925.
56. *Venice News*, June 3, 1927.

57. Ibid., September 20, 1925.
58. *This Week In Sarasota*, October 22, 1925.
59. Ibid., November 19, 1925.
60. Untitled booklet, 1926.
61. *Sarasota Herald*, May 2, 1926.

Chapter VII.

62. Ibid., June 12, 1927.
63. Ibid., March 13, 1927.
64. Ibid.
65. Ibid., March 15, 1927.
66. Ibid.
67. Ibid., June 12, 1927.
68. *Venice News*, June 3, 1927.
69. Flyer on file at Sarasota County History Center, not dated.
70. *Sarasota Herald*, January 1, 1928.
71. *Sarasota Times*, September 22, 1921.
72. Grismer, *Story of Sarasota*, 229–30.
73. *Sarasota Herald*, January 23, 1930.
74. Ibid., March 14, 1930.
75. Ibid., December 5, 1929.
76. Ibid., July 9, 1930.
77. Grismer, *Story of Sarasota*, 243.
78. *Sarasota Herald*, July 21, 1930.
79. Ibid., July 5, 1932.
80. *Tampa Morning Tribune*, February 9, 1937.
81. *Sarasota Herald*, May 11, 1937.

Chapter VIII.

82. Grismer, *Story of Sarasota*, 244.
83. *Tampa Bay History*, fall/winter 1987, 5.
84. *Sarasota Sunday Tribune*, March 3, 1935.
85. Grismer, *Story of Sarasota*, 244.
86. *Sarasota Herald*, September 6, 1936.
87. Ibid., September 23, 1937.
88. Grismer, *Story of Sarasota*, 245.
89. *Sarasota Herald-Tribune*, January 9, 1940.
90. Ibid., January 8, 1940.
91. Grismer, *Story of Sarasota*, 246.
92. *Sarasota Herald-Tribune*, November 20, 1955.
93. Ibid., November 11, 1941.

94. Jeff LaHurd, foreword to *The Lido Casino, Lost Treasure on the Beach*, 1992.

95. *Sarasota Herald-Tribune*, July 3, 1938.

96. *Pelican Press*, December 23, 1999.

97. *Sarasota Herald-Tribune*, April 19, 2002.

98. *Sarasota Tribune*, February 15, 1934.

99. Grismer, *Story of Sarasota*, 249.

100. *Sarasota Herald*, January 12, 1929.

101. Ibid.

102. Ibid., February 18, 1945.

103. Ibid., July 7, 1942

Chapter IX.

104. *Sarasota Times*, May 18, 1916.

105. Ibid., May 18, 1916.

106. Ibid., February 3, 1910.

107. *Sarasota Herald-Tribune*, June 9, 1999.

108. Ibid., June 3, 1978.

109. *The News*, July 21, 1957.

110. *Sarasota Herald-Tribune*, April 1, 1984.

111. Letter dated May 23, 1978, Sarasota County History Center.

112. *Sarasota Herald-Tribune*, June 8, 1978.

113. Ibid., June 8, 1978.

114. Ibid., December 4, 1982.

115. *Sarasota Times*, March 1, 1917.

116. *Sarasota Herald*, January 1, 1926 (the date should have been January 1, 1927, but the date was not rolled over to the new year).

Chapter X.

117. George I. "Pete" Esthus, *A History of Agriculture of Sarasota County, Florida* (Sarasota County Agriculture Fair Association and the Sarasota County Historical Commission, 2003), 101.

118. Ibid., 98.

119. *Fruit & Vegetable Lands In the Sarasota Bay District*, pamphlet.

120. Ibid., 58.

121. Ibid.

122. Ibid., 64.

123. Grismer, *Story of Sarasota*, 159.

124. Ibid., 121.

125. Kim Hart, *Fruitville Gazette*, January 1997.

126. Ibid.

127. *Tampa Tribune*, March 19, 1945.

128. *Sarasota Herald-Tribune*, March 10, 2004.

129. Ibid., November 20, 1983.

130. Ibid., August 28, 2005.

131. Ibid., June 11, 1989.

132. Esthus, *History of Agriculture*, 47–51.

Chapter XI.

133. Edwards, interview by Davis.

134. Annie M. McElroy, *But Your World and My World, The Struggle For Survival, A Partial History of Blacks in Sarasota County 1884–1986* (Black South Press).

135. *The News*, December 19, 1958.

136. *Sarasota Herald*, October 3, 1926.

137. Ibid., October 19, 1926.

138. Ibid.

139. National Register of Historic Places Registration Form, Overtown Historic District.

140. *Sarasota Times*, April 22, 1915.

141. National Register.

142. *Sarasota Herald*, December 15, 1926.

143. Ibid.

144. Ibid.

145. *Sarasota Herald-Tribune*, July 30, 1942.

146. Ibid., July 17, 1943.

147. Ibid., October 3, 1955.

148. *The News*, October 3, 1955.

149. *Tampa Morning Tribune*, August 26, 1953.

150. *Sarasota Herald-Tribune*, September 27, 1956.

151. *Tampa Morning Tribune*, October 29, 1955.

152. Susan Burns, "The Boycott," *SARASOTA* Magazine, June 1999.

153. *Tampa Morning Tribune*, May 10, 1956.

154. *Sarasota Herald-Tribune*, February 5, 1998 and May 23, 2002.

Chapter XII.

155. Grismer, *Story of Sarasota*, 251.

156. *Tampa Tribune*, March 10, 1940.

157. *Sarasota Herald-Tribune*, March 9, 1998.

158. Ibid., July 1, 1948.

159. Ibid., September 8, 1979.

160. *Sarasota Herald-Tribune*, October 6, 2001.

161. Ibid., December 14, 1957.

162. *SARASOTA* Magazine, April 2002.

163. Ibid., April 19, 1958.

164. Ibid., February 5, 1959.

165. Ibid., January 1, 1960.

166. *Sarasota Herald Tribune*, March 20, 1953.

167. Ibid., April 16, 1958.

168. Ibid., January 11, 1959.

169. *The News*, January 12, 1959.

170. Mark A. Smith, "Looking Back," *Sarasota Herald-Tribune*, September 9, 2002.

171. *Sarasota Herald-Tribune*, January 1, 1960.

172. *Sarasota Journal*, December 12, 1967.

173. Ibid., January 15, 1968.

174. *Sarasota Herald*, January 2, 1996.

175. *The News*, November 27, 1954.

176. Ibid., December 31, 1954.

177. Ibid., January 30, 1955.

178. *Sarasota Herald-Tribune*, March 12, 1961.

179. Ibid., November 21, 1957.

180. Ibid., January 3, 1955.

181. Ibid., October 30, 1954.

182. Ibid., April 15, 1955.

183. Ibid., February 18, 2006.

184. Ibid., November 6, 2003.

185. Jack West, *The Lives Of An Architect* (Sarasota: Fauve Publishing, 1988), 75.

186. Ibid.

187. *Sarasota Herald-Tribune*, November 10, 1968.

188. R.J. Coakley letter dated March 13, 2000, Sarasota County History Center.

189. *The News*, March 31. 1957.

190. Ibid., January 17, 1960.

191. *Sarasota Herald-Tribune*, January 30, 1960.

192. Russell, Dreamers.

193. Ibid.

194. *The News*, November 15, 1955.

195. Shank, "Look Back."

196. Ibid.

197. Ibid.

198. Undated correspondence between Owen Burns and John Ringling, Lillian Burns collection.

199. *Sarasota Herald-Tribune*, August 18, 1994.

200. *The News*, June 13, 1957.

201. Brochure on file at Sarasota County History Center.

202. *Sarasota Herald Tribune*, February 20, 1984.

203. Robert E. Perkins, *The First Fifty Years—Ringling School of Art and Design*, pamphlet.

204. Pat Ringling Buck, Marcia Corbino, Kevin Dean, *A History of Visual Art in Sarasota* (Gainesville: University Press of Florida, 2003), 35–36

205. *Sarasota Herald*, October 6, 2001.

206. *Sarasota Herald-Tribune*, September 16, 2001.

207. Ibid., September 30, 2003.
208. Interviews, January 26, 2006.
209. *Sarasota Herald-Tribune*, September 16, 2001.
210. Ibid.
211. Ibid., April 17, 2006.
212. *Sarasota Herald-Tribune*, December 12, 2000.
213. Ibid., August 30, 2003.

Chapter XIII.

214. *Sarasota Times*, November 23, 1916.
215. *Sarasota Herald-Tribune*, January 1, 1988.
216. Michael Zimny, *FLORIDA HERITAGE*, fall 1993.
217. *Sarasota Herald*, December 26, 1927.
218. *The News*, October 7, 1958.
219. Official illustrated souvenir guide, 1940.
220. Website, Ringling Bros. & Barnum and Bailey Circus.
221. *The News*, November 5, 1955.
222. Ibid.
223. *Sarasota Herald-Tribune*, March 7, 2005.
224. Fredrica Lindsay, "The History of the Sarasota Players," pamphlet, 1979.
225. *Sarasota Herald-Tribune*, April 2, 2001.
226. Shank, "Look Back."
227. Ibid.
228. *Sarasota Herald*, July 19, 2000.
229. The Official Sarasota County Guide to the Arts, presented by the Sarasota County Arts Council, 2003–2004.
230. *Sarasota Herald Tribune*, May 16, 1996.

Chapter XIV.

231. Ibid., August 8, 2005.
232. Su Byron, *SARASOTA* Magazine, October 2005.
233. Ibid.
234. *Sarasota Herald-Tribune*, February 18, 2000.
235. Ibid., November 9, 2002.
236. Ibid., May 19, 2004.
237. Ibid., October 18, 2002.
238. Revised City of Sarasota Downtown Master Plan IV-2.1.
239. Ibid., I-1.1.
240. *Sarasota Herald-Tribune*, April 13, 2004.
241. Ibid., August 6, 2005.
242. Ibid., March 14, 2006.

243. Will Rothschild, *Sarasota Herald-Tribune*, August 28, 2005.

244. Ibid.

245. Ibid.

246. Ibid, September 15, 2005.

247. Interview with Ed Hoyt on March 16, 2006.

248. Ibid.

249. *Sarasota Herald-Tribune*, June 12, 1992.

250. Ibid., January 19, 1997.

251. Ibid., March 2, 1997.

252. Ibid., 1998.

253. Ibid., March 9, 2006.

254. Ibid., February 8, 2006.

Who's Who in Sarasota

255. *American Heritage*, November 1987, 43.

256. Russell, *Dreamers*, 5.

257. Ibid., 10.

258. *Sarasota Herald-Tribune*. June 18, 1997

259. Ibid., July 17, 1998.

260. Ibid., August 25, 1998.

Appendix

261. Grismer, *Story of Sarasota*, 262

262. Ibid.

263. Ibid., 269

264. Ibid.

265. Robert Clifford Dodd Jr., *The History of the Venice Police Department, 1926–2001*, draft, January 2005.

266. These names were taken from the War Memorial at the Reverend J.D. Hamel Park and were gathered by Pete and Diane Esthus. Above the names is inscribed, "In loving memory of the valiant of Sarasota County who gave their lives to preserve for their loved ones and you the priceless heritage of liberty obtained by our forefathers."

Selected Bibliography

Browning, Alex. "Memoirs," March 21, 1932, on file at the Sarasota County History Center.

Buck, Pat Ringling, Marcia Corbino and Kevin Dean. *A History of Visual Art in Sarasota*. Gainesville: University Press of Florida, 2003.

Burns, Owen, and John Ringling. Undated correspondence.

City of Sarasota Downtown Master Plan 2020. Duany-Zyberk & Co. Revised October 25, 2000.

Curtis, Fannie Crocker. Interview by former Sarasota County Historian Dottie Davis

Edwards, A.B. Interview by former Sarasota County Historian Dottie Davis, July 23, 1958, on file at the Sarasota County History Center.

Esthus, George I. "Pete." *A History of Agriculture of Sarasota County, Florida*. Sarasota County Agriculture Fair Association and the Sarasota County Historical Commission, 2003.

Franklin, Bruce. Interview with the author.

Green, Janice. Interview with the author.

Grismer, Karl H. *The Story of Sarasota*. M.E. Russell, 1946.

Howey, John. *The Sarasota School of Architecture, 1941–1966*. Boston: MIT Press, 1997.

Lawrie, Nellie. "The Scotch Colony Comes To Sarasota," recollections on file at the Sarasota County History Center.

McElroy, Annie M. *But Your World and My World, The Struggle For Survival, A Partial History of Blacks in Sarasota County, 1884–1986*. Black South Press.

The News.

Peeples, Vernon E. "The Sarasota Democratic Vigilantes." Paper on file at Sarasota County History Center.

Selected Bibliography

Ritz, Ernest. Interview with the author.

Russell, Peg. *Dreamers of our Past*. Sarasota County Community Services, May 2000.

Sarasota Herald.

Sarasota Herald-Tribune.

SARASOTA Magazine.

Sarasota Origins, A publication of The Historical Society of Sarasota County. Summer 1988.

Sarasota Sunday Tribune.

Sarasota Times.

Smashey, Philip C. "The Founding Of Osprey, Florida." July 1, 1971.

Stockbridge, Frank Parker, and John Holliday Perry. *FLORIDA in the Making*. Jacksonville: de Bower Publishing Co., 1926.

Tampa Morning Tribune.

Tampa Tribune.

This Week In Sarasota.

Thorpe, Paul. Interview with the author.

Venice News.

Weeks, David C. *Ringling, The Florida Years, 1911–1936*. Gainesville: University Press of Florida, 1993.

West, Jack. *The Lives Of An Architect*. Sarasota: Fauve Publishing, 1988.

INDEX

ALSO BY THE AUTHOR

Come On Down: Pitching Paradise During the Roaring '20s
Gulf Coast Chronicles
The Lido Casino, Lost Treasure on the Beach
A Passion for Plants, the Marie Selby Gardens
Quintessential Sarasota
Sarasota: A Sentimental Journey in Vintage Images
Sarasota, Then and Now
Spring Training In Sarasota, 1924–1960